BASIC
WATERCOLOUR

Books by the same author

Basic Drawing: How to Draw What You See

BASIC WATERCOLOUR
HOW TO PAINT WHAT YOU SEE

CHARLES WILLIAMS

ROBERT HALE • LONDON

ISBN 978-0-7198-0741-1

Robert Hale Limited
Clerkenwell House
Clerkenwell Green
London EC1R 0HT

www.halebooks.com

A catalogue record for this book is available from the British Library

10 9 8 7 6 5 4 3 2 1

Typeset by Eurodesign
Printed in China

Contents

Acknowledgements

First, I have to thank the many students I have practised my teaching on, in Kent Adult Education, at the Royal Watercolour Society and the New English Art Club, at Canterbury College and at Canterbury Christ Church University.

I would like to thank Winsor & Newton for supplying materials and making such good paint, David Parfitt, Paul Newland, Julie Held, Anna Gardiner, Stephen Moriarty, Iain Nicholls and Kate Wilson for letting me use their images and answering my questions, David Messum's Gallery of London and Norwich Castle Museum for letting me use David Parfitt's oil painting and the two John Sell Cotman paintings respectively, Nigel Aono Billson for computer and design advice, Nathan Roll, Anna Reid, Bambi Lang and Theo and Mina Latham for sitting for me and, most of all, my wife Anna Latham for being a model and listening to me going on about this book, sometimes both at the same time, for what must have seemed like for ever.

Introduction

I went into a local shop when I was little and asked the shopkeeper if he had any colours. 'What do you mean, colours?' he asked. What I meant was coloured pencils, because that is what I used to draw with, and that is what I thought everyone used to make pictures with. My horizons were limited. I was only seven and my parents weren't artists. How was I to know about the huge variety of media available with which to make pictures?

There are many different types of paint. For example, painters and decorators used to be employed far more commonly in ordinary people's houses because without the ease of emulsion paint it was a highly skilled job, mixing lime wash, or oil-based paints. Cheap, mass-produced paint in a uniform consistency, not too runny so that it is controllable, not too stiff so that it covers well, is in fact a fairly recent innovation, leading to hours of enjoyable DIY – for some people. I don't like it much. I'm not actually much good at it.

When people want to paint pictures, though, there are lots of different paints to choose from. For example, encaustic, which is wax mixed with pigment, is an ancient type of paint, and there are many examples of encaustic painting surviving; the British Museum has some beautiful Roman-Egyptian mummy paintings, portrait faces painted to attach to mummies, that have lasted millennia. Egg tempera, pigment mixed with egg-yolk, is another long-lasting, ancient paint type. The Lascaux cave paintings are made of earth pigments in saliva. There's a lot of choice, then, although probably the latter method isn't very attractive these days. But

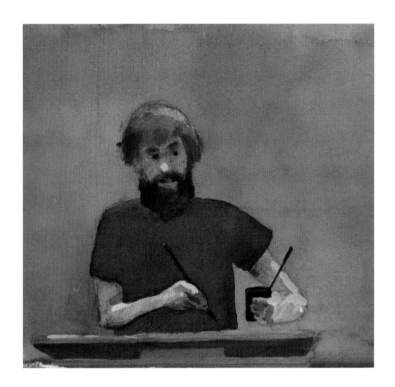

Inspired Artist, watercolour 10 x 10 cm (4 x 4 in).

watercolour is one of the most popular options for most people.

Watercolour is often seen as the 'default' paint, in Britain at least. It's the sort of paint children get to use, because it's easy to clean up afterwards, and it's only water after all. Oil paint requires mysterious solvents, probably poisonous, and acrylic paint, if you let it dry, is more or less permanent. The carpet will be ruined!

The trouble with watercolour paint is that it is very difficult to get whatever you are painting to look like it does in real life. It's so pale, for one thing, and for another, the paper goes all wrinkly

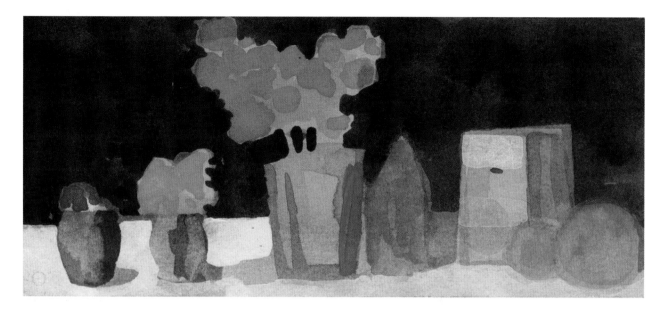

when it gets wet. And when it goes wrong, or you change your mind, you can't paint over it or rub it out, and look, I put this white paint on five minutes ago and it seems to have disappeared. Mum! Can I play on my X-box now? It must put a lot of people off art altogether. Perhaps now everyone has gone digital children won't mess around with paint any more, anyway.

The other problem is that when you start you are often reluctant to use good-quality materials. This is understandable. You might find you are no good at it, so why buy expensive stuff? At least watercolour is fairly cheap, you might think, and I can use this old drawing paper that my children had …

Well, the problem is that using poor materials is only really feasible if you are quite highly skilled and know exactly what you are doing. For example, that old drawing pad your children had is actually entirely unsuitable for watercolour painting. What is called cartridge paper now is cheaply produced, light wood-pulp paper – it's fine for drawing, but as I said, get it wet and it will wrinkle, or 'cockle'. Try to take colour off and it will rip. Try to layer the colour and it just goes soggy. It's difficult to make it look good. Not impossible, but difficult.

But transparency is the real problem with watercolour. While oil paint, the medium of the 'serious artist', can be made to reflect directly and immediately what the eye sees, watercolour can only achieve its effects indirectly.

Mastering the watercolour art, then, requires patient study and thought. There are principles to be followed which are not immediately apparent and which sometimes seem to go against common sense, but careful application will bring great rewards. Used properly, watercolour is extremely versatile and can be used to produce work which is fresh and expressive and work which is rich and detailed.

I began using watercolour in my last long vacation before leaving the Royal Academy Schools. I had a summer job as a dustman, which meant that, if we got our rounds done early, we had the afternoons off, and I would come back and paint pictures of the day's work on my kitchen table. I enjoyed pushing the paint around and finding its limitations; a few years later I started teaching Beginners' Watercolour in Adult Education and expected my students to enjoy it as well.

I found, however, that the students didn't feel confident about experimenting. What they seemed to want was instruction. I'd been getting them to find their inner artist and they didn't

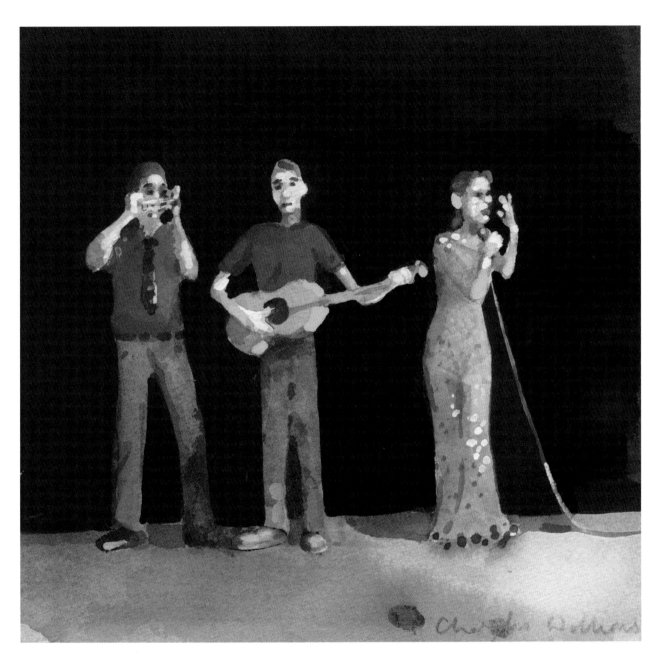

feel they had one. So I got hold of all the instruction manuals I could find, from the most recent, glossy picture books to the most ancient, and tried to assimilate the lot. I became a kind of expert. The only trouble was, I wanted my paintings to reflect this knowledge: my plan chest filled up with paintings that I had abandoned because some small thing had gone wrong early on in the proceedings and they just weren't right.

I have since got over this. And this, in a sense, is the best lesson, because while knowledge and expertise are excellent, the making of paintings is what it's really all about.

The Band, watercolour with gouache, 7 x 10 cm (2¾ x 4 in).

How to use this book

I have written the book to reflect how I teach watercolour painting. I have been teaching it, on and off, for more than twenty years now, in Adult Education classes and in private Art Schools and Societies: for the last few years I have taught a Beginners' Course at the Royal Watercolour Society at the Bankside Gallery in London, as well, and I have also noticed that when I give demonstrations on the university courses that I teach (supposedly very high-level, theoretical and contemporary), the students seem to crowd around, eager for knowledge.

I teach as 'personally' as I can – I think that you learn best from people you like, and in an environment that feels comfortable to you, so I present my courses closely wrapped up in my own experience. I use stories and examples from my own practice all the time, and make sure my students know that this knowledge is not just stuff from textbooks or learnt by rote but discovered, used, applied and changed through use.

It's very difficult to do this through the medium of a book; you can't see me grinning or poking the tip of my tongue out of the corner of my mouth as I negotiate a difficult wash, and I can't lean over your shoulder as you lay down your washes and say 'Oh well done, that's just right.'

So I suggest the most important thing is that you realize that this is *your* book – this copy of it, anyway – and you can use it how you like. You might have done enough watercolour before, for example, not to need to read the stuff about materials, and just go straight to one of the exercises that takes your fancy.

Or just look at the pictures. They're pretty good.

What I mean is, don't feel that all is lost if you get through the first three chapters and then want to read something else, or that you can't 'do people' so those chapters aren't going to help. You can pick it up where you like – the text is quite funny though, and you wouldn't want to miss any of the amusing anecdotes.

I have persuaded a few artist friends who use watercolours to let me use some of their work in a final chapter, and I hope that provides another dimension to the question of how to use this medium. My hope is that, by the time you get to the end of the book, you will be confident enough in the use of the medium to want to find your own way with it, and these exemplars might help you. Don't be afraid to imitate. It's the greatest compliment you can pay an artist, until you become more successful than they are – when it becomes rude!

What is Watercolour?

Watercolour paint is made from gum arabic and pigment, ground together, sometimes with honey. Cheaper paint is made with pigment and sugar solution, like dextrose.

What happens when you paint with watercolour is this; first, you add water to the dry paint – this melts the gum arabic, and disperses the small particles of pigment in the water.

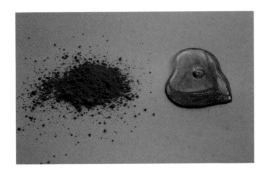

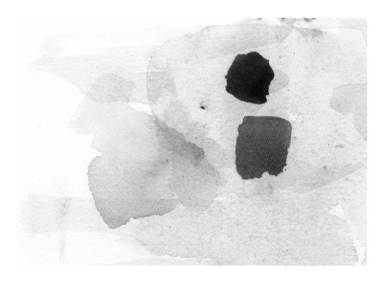

Notice how the thinner wash of red, which looks pink, is obviously transparent; you can see the greener paint behind it. The heavier weighted paint is also transparent, up to a point.

Mina Posing On The Breakwater. I try for this freshness sometimes, but my inclination is always to work away on things for too long, until my wife tells me they look like poster paint and I get in a terrible huff.

Far right
White gouache laid over white paper and over a thin greenish wash.

The more water there is, the more space between each pigment particle, so that when you apply the watery paint to a sheet of paper the depth or richness of colour is determined by the ratio of water to pigment.

The water dries out, and the pigment is left behind, a thin film spread across a flat sheet held lightly together with gum arabic.

That's it.

There is a school of thought about watercolour that would have it *that really is it*. Many successful, interesting and attractive-looking paintings are made in an apparently very simple style, with a single film of paint spread across the paper. It makes a fresh and uncomplicated statement, or, if it's had more preparation, a rather breathtaking one: 'How did they do that?'

Watercolour painting is transparent. When you look at a watercolour painting the light is penetrating the film of paint, hitting the white paper behind it and bouncing back, and this is why watercolour paintings can have the characteristic fresh look. Oil paint or acrylic just sits there, an opaque surface, and the light bounces off it, unless it's been used with a transparent technique, which is rare nowadays.

There are colours the pigments of which are more opaque than others, but they will still be transparent if applied in a wash. There are opaque water-based paints. Gouache, which used to be called body colour, is pretty well the same as watercolour, but with added chalk. These paints sit on the surface of the paper, reflecting the light like acrylic paint.

Painting with a transparent medium causes a huge problem. It is not 'the easy medium' nor the 'amateur's medium'; it's not remotely appropriate for children and it really is not for 'beginners'. In fact there is probably a PhD in the influence of watercolour in putting people off painting.

Because of this transparency, when you make a mistake you can never really go back, because you can't cover it up. That's the most

WHITE GOUACHE ON WATERCOLOUR WASH

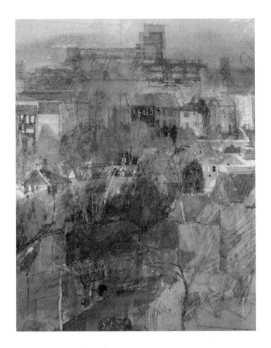

obvious thing, but it's worse than that. You are also unable to match the colours you see in the natural world directly with the colour available in watercolour.

Why not? Because when you look at the world you are seeing a dark world lit up by light, whereas when you start a watercolour you are beginning with a white world which you will gradually darken.

Is that a little obscure? Well, consider this. When you look at an object, say your hand, what colour is it? Let's simplify that, let's imagine you are wearing a bright green glove. If you wanted to paint the very brightest part of the glove you might mix up a very light green, but then you would have to place it on the white paper. As soon as you place the brush on the paper you will see the problem. That bright green you mixed is now the darkest thing on the paper.

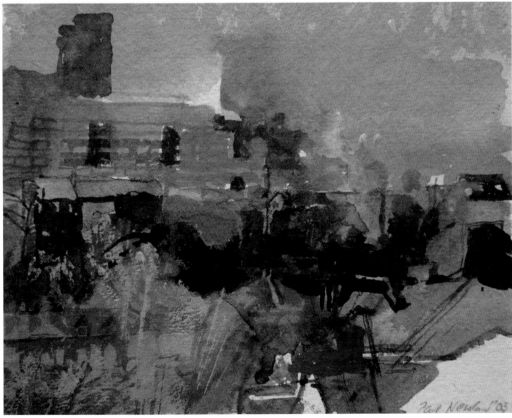

Paul Newland's studies for his painting *The Summer Suburbs* show a variety of transparent and opaque methods of paint handling.

Colour and tone are relative – the same green looks light or dark depending on what it is placed against.

John Sell Cotman's *Mountain Scene*, image courtesy of Norwich Castle Museum. (Norwich Castle Museum has a splendid collection of Cotman's paintings and they are well worth a visit.)

This would not be a problem if you were painting in oil paint. You would mix your colour on a palette, and then be able to place it on a dark or mid-tone ground, instead of on white paper. The colour would stay exactly as it was on the palette, opaque and bright. However, putting a transparent film of paint over a white ground can only darken the paper.

But you cannot get round this by using a darker paper without losing the power of the watercolour paint. Nothing underneath the film of paint can be hidden without the film of paint getting darker – which is, inevitably, less bright.

Of course, there are great advantages to the medium, and, for me, there is a great thrill in the very difficulty itself. Can you bring it off? I love artists like Patrick Proctor and John Sell Cotman, painters whose apparent simplicity matches their great sophistication. The freshness in the work almost makes me physically short of breath.

There is something glorious in a thin wash of paint, gently edging another one, looking effortless and just in the right place. I have always been in favour of the Henri Matisse approach to

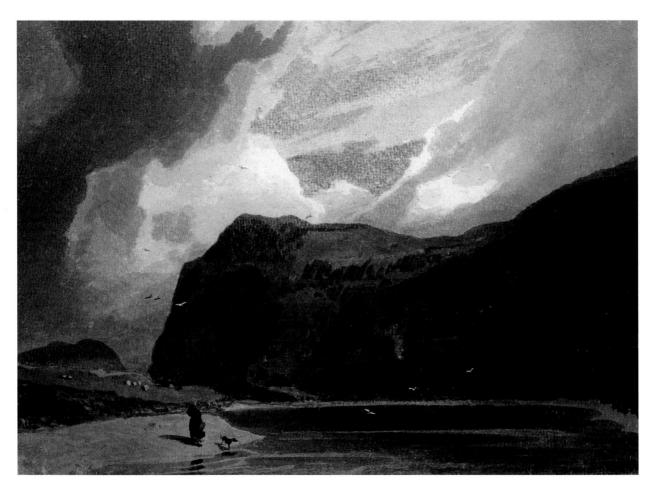

painting; I do want to be able to work away at the paintings, and enjoy the capacity of a painting to be worked on for days on end – sometimes months, once or twice for years – but the last thing I want is to show that work in the painting itself. It has to look as if it were easy. As Fred Astaire said, 'I suppose I made it look easy, but gee whiz, did I work and worry.'

There have been watercolourists who have used the medium as if it were oil paint. During the nineteenth century there was a vogue for 'exhibition pieces', made by layering colour over colour until it achieved a thick, almost glossy state. The idea was to rival the seriousness of oil painting. Watercolour painting, especially painting a particular object or view in front of you, is really coloured drawing. That is the main thrust of this book, although I will be discussing techniques to use to develop what I call studio work, work made away from the subject.

What you do in painting from life is try to record what you see. The title of this book is *Basic Watercolour: How To Paint What You See*, and it follows my other book, *Basic Drawing: How To Draw What You See*. I am not particularly interested in painting from photographs; that at any rate is not the subject of the book, although I have included a section on an artist who does work from photographs.

In order to paint what you see you need to have two things – a grasp of tone, line, space and form and an idea of why they are important, and a knowledge of the particular qualities and problems posed by this rather intractable medium.

Pigment in gum arabic, which illustrates the unfortunate paper-darkening effect I mention on the opposite page.

Materials

Paint

The first question is should you buy individual pans, tubes, or tins of paints?

I found the little gem in the picture in an antique shop. I am not sure how old it is, but it's tiny! It's what people had before they invented iPads, I expect. The little compartments would be filled up by cutting sections from the 'cakes' of watercolour paint, which was how it came at the time, and putting them in, rather than using what I can only imagine would be quarter pans – or eighths of a pan. The loop just fits over the tip of my thumb.

This object gives a clue to the traditional use of watercolours. For a long time, watercolour

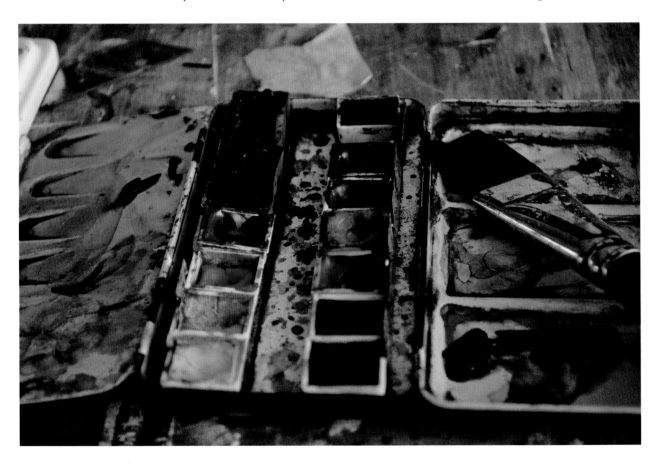

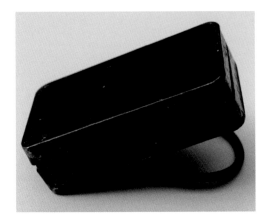

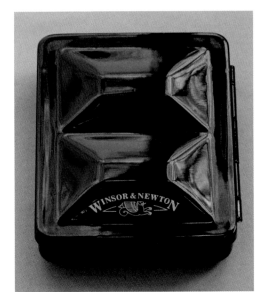

This is a more recent Winsor & Newton Bijou Box.

paintings were given more or less the same status as drawings. In Ruskin's *Elements Of Drawing* (published 1857) he actually treats watercolour as simply another part of drawing; drawing with colour.

Before Impressionism and the wider commercial availability of cheap, ready-made oil paints, it was not part of an artist's practice to exhibit work that had been made on the spot, before the motif, and, although by Ruskin's time it was heard of, it takes a long time for people to readjust their attitudes.

Watercolour was, then, another drawing medium. Officers in the Army would be trained in its use, in order to make drawings for intelligence purposes. Young ladies would go to a 'drawing master' to learn the art – John Sell Cotman, one of Britain's greatest water-

colourists, made most of his living as a drawing teacher – it was an accomplishment and a skill.

A little 'box of colours' as illustrated would be ideal for such purposes. It could go in the pocket, with a little water bottle and a travelling brush and a little sketchbook. Mistakes would be daubed off with a handkerchief, if such highly trained souls made mistakes.

The Bijou Box illustrates something that is often overlooked, and that is the joy of shopping! I can hardly bear to start using this; it's so beautiful and shiny. Bigger than the 'thumb box', it is still highly portable.

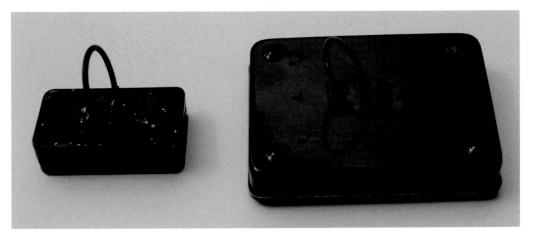

The two boxes together – comparative sizes.

Pans and half-pans.

Watercolour paint is commercially available in small, open-topped boxes called half-pans, double-sized ones called pans, and tubes, of various sizes. The colour in tubes generally seems less powerful; that may be just my own impression. Certainly the tubes have runnier paint, and the pans are, by their nature, dry.

Half-pans are what you usually find in a ready-made box of watercolours, although boxes of whole pans are available. Most people start with these, although it might be cheaper to start with tubes.

A ready-made box will usually come with six, twelve or twenty-four colours. Why they come in multiples of six I do not know. The colours will usually be obvious ones: bright yellows, reds and blues, some darker versions of these and then some oddities – very dark browns and often a green that looks unidentifiably dark but makes an insipid, thin, cold wash on the paper. Most beginners use the ones they can identify a good deal, including the 'Chinese white' if the box has one, and ignore the dark ones.

In fact the choice of colours is a very delib-

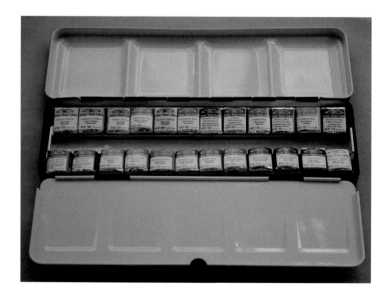

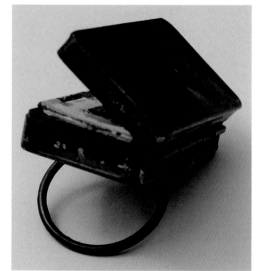

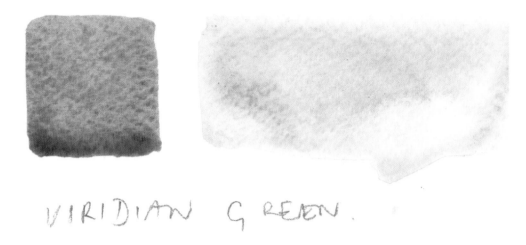

VIRIDIAN GREEN.

erate one. The viridian green illustrated is quite an expensive pigment. It comes in very handy, as a matter of fact, if used well. The whites usually fade when dry.

The boxes themselves are very handy too. They normally allow you a palette – if there is not one that folds over the half-pans and opens out, there is always the lid of the box itself, which, you'll notice, has ridges across it. They are for separating different washes of colour.

In addition to the loop to go round your finger or thumb, so that you can hold it in your

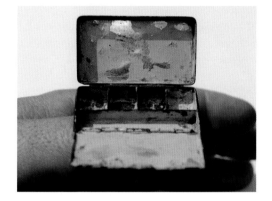

The thumb box just fits; this is how it should be used.

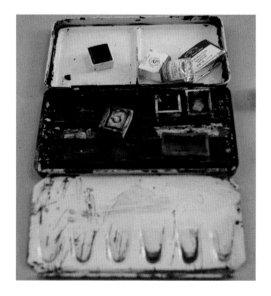

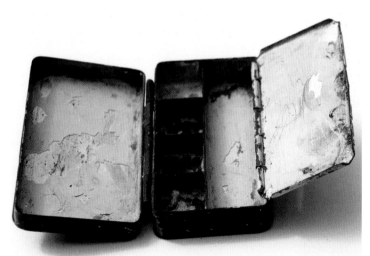

Far left, left and above Watercolour boxes are made to mix paint on.

hand when you are painting out of doors, some boxes even have water containers built into the side.

Buying paint in pans in a box means that you have a ready-made palette and the selection of colours has been made for you. If you explore the properties of all the colours as you should, you will expand your colour vocabulary. Another advantage of having pans in a box is that all your paints are together. It sounds elementary, but if you have tubes you will need to cart them around somehow; watercolour tubes are usually quite small, and easily lost.

If you really cannot bear the idea of using a palette someone else has selected, you could buy an empty box and choose your own colours. When my colours run out, I buy individual half-pans, and my own palette evolves.

Another advantage of the box is that you are able to make a visual, not a theoretical, assessment of what colours you need. By this I mean that you can look at what you are painting and then at your colours and dip your brush in the one you want. With tubes there will come a point where you have to say to yourself 'Which colour should I use?' and then have to find the tube and squeeze some out. You may not want to have that break in concentration.

Tubes are, however, the most economical way of buying paint, and they are particularly useful for the more expansive painter. If you are the kind of artist who likes to splash in and work on a big scale, then tubes are for you.

Even with tubes, you will still need a palette. An old china plate is good, if you don't want to splash out on the kind of purpose-made palette that Winsor & Newton might make. The advantage of purpose-made ones is that, like the metal boxes, they have ridges that make compartments, so one wash can be separated from another. You can buy them in plastic or china.

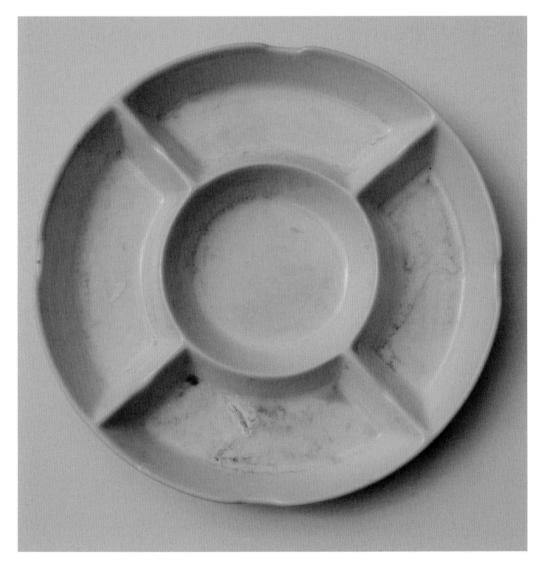

COLOURS

If you buy tubes or your own pans you will be assembling a palette. You will need at least one red (alizarin crimson is cheap and versatile), one blue (ditto ultramarine) and one yellow (ditto lemon yellow). This is a basic palette, and you can mix a lot from these. Add another red, blue and yellow if you wish. A cadmium red, cadmium yellow and a cobalt blue would all be useful, but they are quite expensive. You will also need a black. You do not need a white.

Whether or not to *buy* a black is a dilemma in painting. There are people who will see using a bought black as *the*

The palette in my old tin: Winsor lemon yellow, aureolin yellow, yellow ochre, raw sienna, raw umber, terre verte, viridian, rose, cadmium red, alizarin crimson, cerulean blue, ultramarine blue, and lamp black. It's my choice, and I have to stick one of them in the middle of the tin.

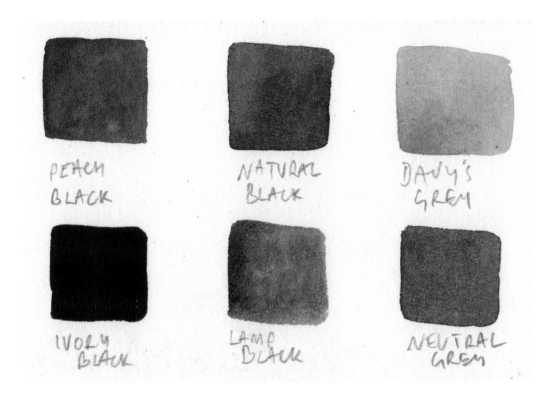

PEACH BLACK

NATURAL BLACK

DAVY'S GREY

IVORY BLACK

LAMP BLACK

NEUTRAL GREY

sign of amateurishness and incompetence. You are supposed, in their world-view, to mix your own. I suppose this is because the colour that results will be 'active', or perhaps you can moderate its temperature or something on those lines. I think it's nonsense.

The only justification I can think of is that it might discourage people from making all their darks and all their shadows out of black, without looking for colour and temperature, but it seems to me that black is so useful for other things (I'll show you later) that leaving it out to save yourself from temptation is going a little far.

Don't, however, get a white. I have never had any luck with watercolour whites; they are all too transparent. Buy a tube of white gouache.

ARTIST OR STUDENT QUALITY?
As with most things in life, when you buy paint, you get what you pay for. Expensive watercolour paint will be made from purer pigments with a stronger effect, so you will use less of them. Pigment is generally quite expensive, par-

ticularly the more powerful colours, so the cheaper brands make what they call 'hues' – cobalt blue hue, for example, is not pure cobalt but a mixture of several colours, carefully balanced and ground to get an approximation of cobalt. That is fine until you mix it with other colours – you might want a particular chalky light green, so you would use some barium lemon yellow with your cheap cobalt, but what you are actually mixing is the yellow with the three or four colours that are already in the cobalt hue. The more colours you mix, the greyer or browner the result, as I explain below. Cheaper colours lead to less accuracy.

COLOUR THEORY
The palette I have recommended above is designed for what is called 'perceptual painting'. This means trying to reproduce the colours that you see in the object or objects before you in your painting.

As I have tried to make clear several times so far, and will repeat *ad nauseam* as the book pro-

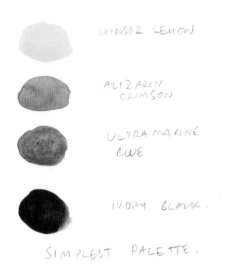

This colour wheel uses aureolin yellow, cerulean blue and cadmium red. Consequently the 'purple' is more a kind of grey.

gresses, the properties of watercolour make it very difficult indeed to reproduce the colours you see before you. The colours in this palette, though, are versatile enough to be mixed to the widest possible range of colours, when using only primary colours.

To explain the term 'primary colour' I have to explain colour theory. This, as applied to painting, is quite an old idea, and has been used as a sort of model to explain or talk about how to use colour since before Goethe or Newton wrote about it. As science has taken more and more sophisticated views of colour and light, the simple kind of colour theory with which artists deal has become less and less convincing; the colour of paint is not much like the colour of light at all. (Printing techniques have changed

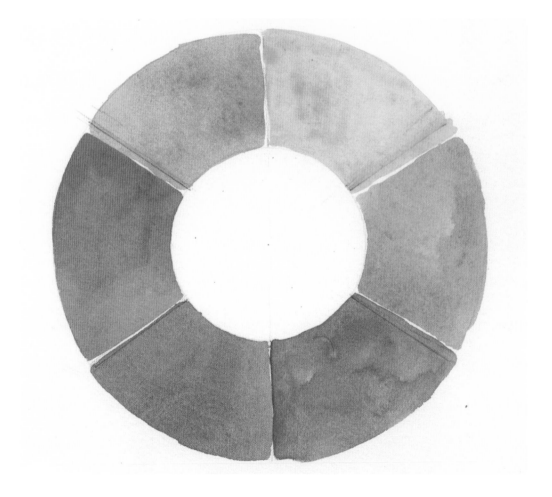

things, too; the CMYK and RGB palettes that we know from our computers are not much like the simple colour wheel of my Art College days.)

Old-fashioned colour theory does make a good start though, and, as long as it is strictly borne in mind that it is only a theory, it is useful as a way of describing how colour works.

There are, then, three primary colours. These are the colours that cannot themselves be mixed; red, yellow and blue. Mix red and yellow together, and you get orange. Mix yellow and blue together and you get green. Mix blue and red together and you get purple, and you are back round to red. This is the colour wheel.

Orange, green and purple are secondary colours, or secondaries – colours mixed from two primaries.

If you arrange these colours on a colour wheel, the next stage is to imagine what happens *inside* the wheel. In other words, what happens when you mix three primaries together? The answer is that you make a tertiary colour. Tertiary colours are shades of brown or grey.

Paper

The paper you need for watercolour painting is watercolour paper. The trouble is, it costs more than you might feel comfortable with.

For most of us, paper is a more or less cheap commodity. We have it immediately to hand; people send us letters and junk mail; we buy paper by the ream (500 sheets) to supply our computer printers. Paper is probably the first thing you made pictures on, unless you were very naughty and crayoned your bedroom wall. Paper is a far more satisfactory medium and you won't get told off for using it.

It is a ubiquitous medium – we don't really question what it is. When we get older, we are bought blocks or pads of 'cartridge paper' and we learn to draw on it, but painting on it is a little less satisfactory. It cockles when it's wet and the colours are often a bit insipid, and if you make a mistake you've had it. But it's what you 'do art' on.

Sheets of watercolour paper. Notice the 'deckle edge', which is almost torn-looking. This indicates a sheet of paper made individually in a mould, rather than one made on a continuous roller. It means it's handmade, so it's higher quality, and will take the paint better.

I am told that the only practical advice to watercolour artists recorded by Turner was 'look to your papers', and Turner certainly did. He discovered that the paper used to wrap artillery cartridges was pretty good for watercolour painting, and that's what he used. He used tinted paper too, and coloured his paper before painting on it sometimes.

What we call cartridge paper nowadays is quite cheap stuff. It's mostly made from wood pulp, and is not very stable; over time it will yellow quite badly and go brittle. Good paper is handmade from cotton waste and unlike the stuff you get in children's blocks, it can take more or less anything.

Handmade watercolour paper is made with cotton fibre and then 'sized' to stop materials soaking into it too much. The sizing is put in when the paper is in pulp form, and there is another layer put on when the paper is finished. Good sizing is terribly important. The paint must not soak in, but it must not be repelled by the surface either. Sometimes you might get paper that has been sized badly, and it will act like blotting paper. Good sizing allows you to put paint on and, to some extent, get it off, too.

Two sketchbook studies. The paper in the sketchbook has not been sized properly; if you look at the edges of the paintings you will see a change in the texture. What happens is that the paint soaks in like blotting paper. It doesn't look too bad now, but at the time it felt awful – the paint leaving the brush too fast and sinking in. The studies were abandoned. I tried to get a refund – my wife's very keen on getting your money back for faulty goods – but they wouldn't, because I'd used it already …

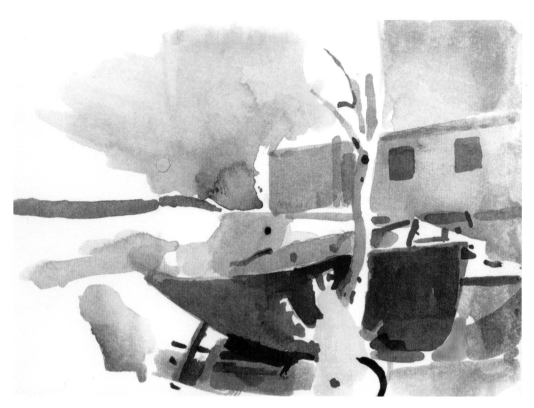

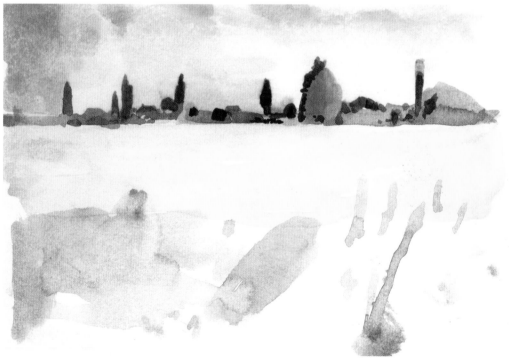

Paper comes in pads, blocks, loose sheets, packs – whatever is most comfortable for you is the best choice. I buy loose sheets, but I have the space and facilities to store them. It might be easier in terms of storage for you to buy it in blocks or pads.

Paper comes in different 'weights', either grams per square metre (gsm) or, in old-fashioned terms, pounds (lb) per ream. The weight of paper usually advised for painting on is 300 gsm or 140 lb, because it will not 'cockle' as badly as a lighter sheet. 'Cockling' is what happens when paper is wetted – it buckles itself into ridges.

You can buy all sorts of weights of paper. I have some 600 gsm (280 lb) which is like a board, and hardly cockles at all, however much water goes on it. I don't like it much though. My usual approach to paper is to buy it in sheets and tear it down to the sizes I require, and this weight of paper tends to tear quite badly, leaving an irregular edge. Also it's not sized as well as it might be – but I could only find that out by buying it and using it.

Handmade papers are made in individual sheets in moulds. This means that the edge of the paper is not sharply cut, like the paper in pads, but gently uneven. It's called a 'deckle edge'. When I tear my paper down, it's because I like the deckle edge, and I hope that my torn edge is close enough in appearance not to show, unlike a cut edge. This is a matter of personal taste though. You may want to stretch your paper, in which case, forget your deckle edge; you will have to cut it off the board.

Another thing for which you have to rely on personal taste is the surface of the paper, or its 'finish'. This comes in three options:

'Rough' is the classic watercolour paper finish, which you have probably come across before. This is produced by drying the paper without putting any pressure on it – it's the 'natural' finish. Some people like it because it seems to accentuate the colour of the painting. Perhaps this is because the paint surface is seen from slightly different angles. I am sure that some people like it simply because it looks more like what they expect from a watercolour.

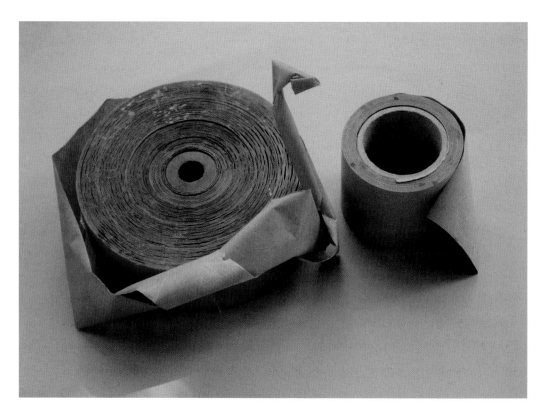

'Cold-pressed' or 'Not' surface comes about when the paper is dried under pressure of other paper on top of it, and this is a slightly rough surface.

'Hot-pressed' or 'Satin' is when the paper has been mechanically dried, and the surface is almost shiny. This is the most like cartridge paper.

Pads or blocks in most weights and surfaces are available and, like paint, the most expensive paper is often the best. Pads can be gummed on one side or all four – this provides a block, so that you don't have to remember to bring a drawing board as well when you go out into the landscape. You can also buy ring-bound pads, so that you can easily turn over a new leaf – you might want to let one painting dry and come back to it after you've started another. Or you might like the large sketchbook-type pads.

There are different sizes of sheet, as well as different sizes of pads or blocks, the most common size being the standard 56 x 76 cm (22 x 30 in) in old money, but there are sheets made in double that size, and double again.

It is impossible to give firm recommendations about paper because so much depends on personal preference. It is also difficult to work out whether buying paper by the sheet or in blocks is cheapest or best. Personally, I look out for end-of-range bargains and sales, and buy in bulk. I am a terrible hoarder. You can get very snobbish about paper, too, and this is not a good thing if it stops you painting because you don't have the right paper. In summary: expensive is usually best; look for bargains!

STRETCHING PAPER

One way to get round the problem of paper quality is to stretch it. That way you can guarantee a flattish surface to paint on, and you can even apply size yourself if the paper needs it. A very thin layer of gelatin might be applied, for example, to cheaper paper, but for thinner

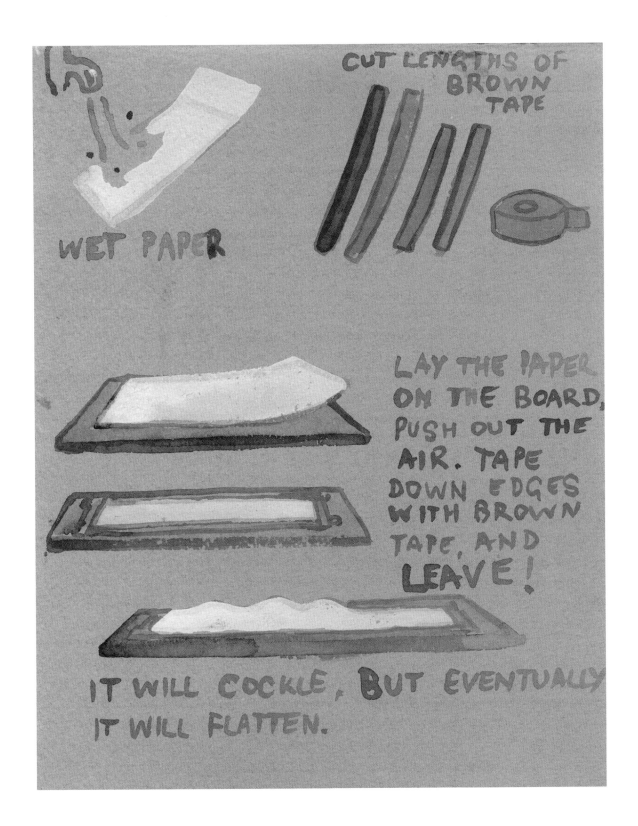

WET PAPER

CUT LENGTHS OF BROWN TAPE

LAY THE PAPER ON THE BOARD, PUSH OUT THE AIR. TAPE DOWN EDGES WITH BROWN TAPE, AND LEAVE!

IT WILL COCKLE, BUT EVENTUALLY IT WILL FLATTEN.

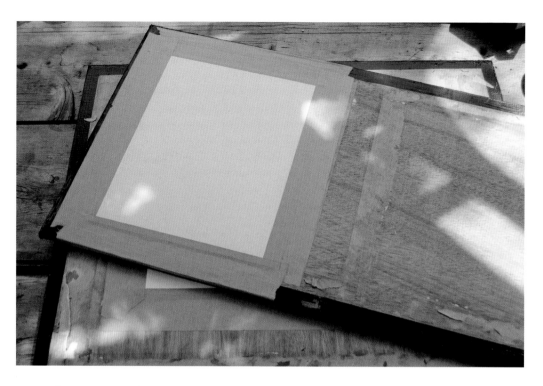

watercolour paper, simply stretching will do.

In order to do this, you will need a drawing board. You can buy lovely, yellow-edged drawing boards from art shops, or make your own. The commercially available ones are usually MDF with painted edges, but the best ones are made of blockboard. You could get blockboard, or marine ply, via a local timber supplier. Personally, I would get some duct tape to cover the edges, because both of these materials splinter. The drawing board needs to be at least 0.5 cm (about ⅕ in) thick.

Cover both surfaces with shellac or French polish – this is a particularly good idea with MDF drawing boards, as MDF does not respond well to water.

You will also need a roll of brown gum tape, the permanent, paper kind.

Stretching paper works like this: first, you wet the paper. This makes it expand. You then tape it to a board and let it dry, and as it dries, it contracts again. The tape holds its edges in place though, so that the sheet of paper is held taut against the board. (That is why you need the brown gum tape. Duct tape, sticky tape, masking tape – all other tapes really – are made to come off at some point, but gum tape is made to stay there.)

First, cut four strips of tape to match each side of the paper. Your board should be at least 5 cm (2 in) bigger all round than the paper. Get a saucer of water ready, wider than the width of the tape. A large, clean sponge or paperhanger's brush is useful too.

Wet the paper. You can soak it for ten minutes in a bath of *cold* water, but you may endanger the size. If the water is hot, the danger is past; the size has melted, forget it. Get some more paper. Personally, I just hold the paper under the tap and make sure the whole thing is wet.

Take the paper to the board, and lay it out. Use the sponge or brush to push any air bubbles out by gently swiping over the surface of the paper, from the middle out. Don't worry overmuch about this bit.

Next, take one of your four strips of tape, and run it through the water in the saucer, using two

fingers to squeeze off excess water. Lay the strip along the side of the paper so that it covers between 0.5 and 1 cm (⅕–⅖ in) of paper, and the rest is on the board. Repeat with the other three strips. Smooth the tape out with your sponge or brush, pressing down to make sure the tape is firmly fixed.

Now, leave the whole thing flat in a room where it won't be disturbed. It's got to be flat on its back so it all dries at the same time, and it's got to be out of sight, because in the next twenty-four hours it's going to cockle and buckle like mad and if you look at it you will inevitably think you've done something wrong and try to put it right and that will ruin the whole thing.

In fact, you may well have done something wrong; the tape may have failed to stick to the paper, for example, but you can't put it right, and you may still be able to paint on it anyway when it's dry. Even if it really does go wrong, you can cut it off when it's dry, wet it again and go through the whole process again, but *not until it's bone dry.*

So leave it alone!

When your painting is finished, cut it out of the tape with a craft knife and soak the tape off the board for the next one.

A lot of people don't stretch paper at all. Norman Adams RA, who was Keeper of the RA Schools when I was there, used to paint in watercolours on the Isle of Skye, on sheets of watercolour paper which he weighed down with rocks to stop them blowing away. He liked what he called 'the desperation' of painting with such a difficult medium in such a difficult place.

FEAR OF THE WHITE PAPER

There is a well-known phenomenon among artists called 'fear of the white paper', and it's about being afraid to start a painting. It's knowing that when you start a painting you have to go on; you are committed. This is a triple problem with watercolour painting, because as well as the basic anxiety there is the knowledge that because of the nature of the medium it is quite difficult to change your mind or mend mistakes

– and then the paper itself is quite expensive, so you don't want to muck it up.

When I teach beginners I always stress the fact that they will be using watercolour paper at all times, even to do simple exercises. The fact is that cheap drawing paper, or any lightweight paper, will not act in the way that watercolour paper should, so learning to do anything on cheap paper will not really help you when it comes to using the proper stuff.

SMOOTHING OUT PAPER

Paper inevitably cockles to some extent, when you paint on it with watercolour. Even the 600 gsm (280 lb) stuff will, if you get it really wet. Some people don't mind it, and when you frame paintings they are held flat anyway, but if you do want it to be flat, this is a technique my

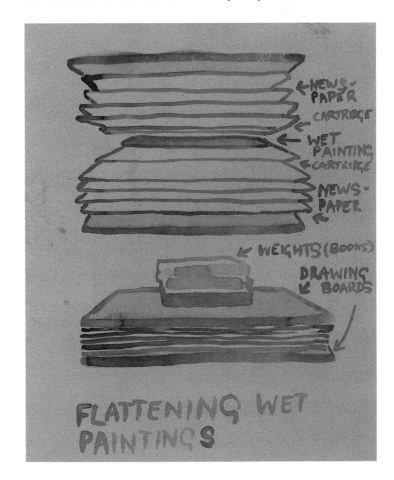

FLATTENING WET PAINTINGS

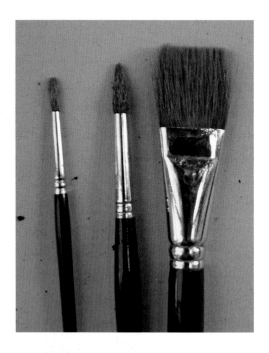

father-in-law taught me. I use it sometimes just to get a fresh look at the painting. The problem with cockling is that it makes it difficult to direct your brush accurately, because you are going over hills and into valleys, so to speak.

You will need two drawing boards for this, or simply two sheets of wood larger than the paper you are flattening. First, lay several sheets of newspaper on one board. Then a sheet of newsprint (buy it from your local art shop) or cartridge paper – the important thing is that the paper should have no print or anything on it. Now take your painting and wet the unpainted side of the paper. You can spray it or use a broad brush and cover it with clear water. Lay the painting face down, and cover the back with more clean paper, the layers of newspaper. You can put several paintings in the press to flatten at the same time, and for this just repeat the layers, newspaper, clean paper, your painting, wetted and face down, clean paper, newspaper and then the second board. Place some heavy books as a weight on the top, and leave for a couple of days.

There's a lot of 'leaving for a while' in watercolour. It's good. It teaches you patience!

Brushes

Essentially, you need three: a small round one, a medium round one, and a 12 or 25 mm (½ in or 1 in) wash brush. That's the flat, wide one. Buy expensive small brushes in sable, and nylon wash brushes if you are feeling the pinch.

A brush is a carrier of paint from the palette to the paper; the idea of the long hairs in a watercolour brush is that they can transport as much paint as possible from one place to another. This is unlike the hog brush of the oil painter, which is designed to shovel stiff paint across a lumpy canvas, or the short-haired brush used to paint a wall with emulsion paint, made to make short strokes, evenly across a wall. The tip of the brush is what you use with watercolour. There is rarely a need to 'wipe' with the brush and even less to splay its delicate

hair across the paper like a 4-year-old with some poster paint. 'Pencil' was the name of a small round brush, before M. Conté invented what we know as a pencil, and it was for pretty much the same thing. You mainly use the tip.

The wash and mop brushes are a little different, and less familiar, but they are used in a similarly delicate way, not for shoving paint but for encouraging or guiding it. You will use these brushes less, which is why it might be advisable to buy cheaper ones. They won't wear out as quickly. On the other hand, animal hair brushes do release the paint at a better rate than synthetic ones.

'Kolinsky sable' is supposed to be the best hair to use in watercolour brushes. Mop brushes are often made of, or say they are made of, squirrel or mongoose hair. I am never sure about this. I have even seen camel hair brushes for sale, but whether any actual camels were involved I do not know.

There are many other brush shapes on the market, for example 'filberts', which are flat brushes that come to a point; 'brights', which are very short flats; and 'riggers', which are very long round brushes, designed to paint the rigging in marine paintings. They all do particular things but they are limited to that thing, and a round brush can probably just about manage all of them. A rigger will do a nice long line in one go, it's true – you may well need to do that, one day. But most of them are additional to your requirements, and are best obtained as presents from relatives when they can't think of anything else to get you.

The fan brush would be an example. This is a flat brush with the hairs splayed out in a fan shape instead of a point. It is for texture and grass and heaven knows what else. I can't really operate a fan brush. I have been using watercolours for more than twenty years, and landscape painting does come into my repertoire, but I still don't use one.

Some brushes come with long handles, some with short. Some have lovely metal ferrules, or some sort of Chinese-looking string binding the tuft to the handle. It's a matter of personal

From the left: a rigger, an angle, a mop or wash brush; the big one is a squirrel hair wash brush.

When you buy brushes, look for the highest quality. The best way to work that out is by looking at the price. They are often sold with their tufts (the fluffy bit) in a plastic sleeve, and held firm in a sort of glue. Don't buy a brush if it doesn't look even and intact.

Your first move is to throw away the plastic sleeve and wash the glue out, using cold water and ordinary hand soap. The sleeve will not help much, and is more likely to result in trapped, bent hairs and the glue needs to be got rid of because you don't want it in your paint.

Sizes seem to alter with each manufacturer. You really have to visit an art supplies shop and look at the merchandise. Also, you may have a different idea of what constitutes a small brush from mine, so I cannot recommend a specific set of sizes. If you start with a small round, a medium round and a 25 mm (1 in) wide wash or mop brush, you can add brushes later as your need becomes apparent.

CARING FOR YOUR BRUSHES

My mother tells me that when she was a child her sable watercolour brush was so well-used that the handle bent to the shape of her hand. I don't really believe her. My brushes lose the paint on their handles and fall to bits before that happens. Perhaps she has a lighter touch than I.

Wash your brushes gently under *cold* water with hand soap, reshape them with your fingertips and stand them on end in a jar after each session. (Hot water will melt the glue that holds the tuft in the ferrule.) The worse thing you can do is leave them with their tips downward in a jar, or leave them for any length of time with their hair or 'tuft' distorted.

To carry your brushes, invest in a 'brushes roll'. Tubes are quite good too, but the trouble with them is that the shorter brushes might lodge themselves, tuft forwards, against the lid, whereas the roll holds the brushes both vertically and laterally.

Let me repeat – don't keep the plastic tuft-sleeves that the brushes come in. Putting them

preference, again. I hold my brushes like a pen or pencil, and draw using my fingers, hand and wrist. Some people 'draw from the shoulder'. I have no idea why.

back on individually is too risky. There are brushes that have removable handles which are placed over the tufts, and these are perfect for sketching out of doors. You need to be careful to find good-quality brushes like this though. Just because it's a small brush, used for convenience on the move, that doesn't mean it should be cheap quality.

Other kit

The thing you need more than anything else is a supply of water. The bigger your water container, the better. If not a big container, then have several containers. I use a pickled gherkin jar, washed out carefully though. For painting out of doors I use a jam jar. The containers for the yoghurts that come in two compartments also make very good water vessels, because you have two water supplies: one can be cleaner than the other. Their two-part form makes them more stable too.

As mentioned earlier, a china plate makes a good palette, if you haven't bought a specially made one. You may well need more of a palette than the watercolour boxes offer you, to make large washes.

Masking fluid is used by some people, but I don't use it and I don't recommend its use. The theory is that it is a latex-based paint that you can use to reserve your lights early on; you paint this stuff over the lights and then paint away, and when you've finished you peel it off. Great! All problems solved! Well, not really. The first thing is practicality. The stuff dries very quickly, so you need to get it on the paper, off the brush and wash the brush before the brush is more or less permanently clogged up and ruined. Apparently there are ways of dissolving it, but you won't want to be using lighter fluid while you're painting. What happens is that you ruin your brush. In order to ruin only one brush, you then decide to use only the ruined brush to apply masking fluid. Inevitably what happens is that this brush gets more and more clogged up, until you are applying your delicate reserved lights not with a brush but with a club of latex. It looks terrible. It's much better to learn how to use watercolour properly.

The other necessity is toilet paper. You can buy sponge for use in watercolour painting, and I laboured under the impression that sponge was the 'proper artist's' equivalent of toilet paper for years, until I bought some and found that watercolourist's sponge is for applying texture. It doesn't soak up unwanted paint in the same way that the sponge you use for washing-up might.

Toilet paper (hereinafter referred to as loo paper) is indispensable for watercolour painting. It is used for mopping up spillages and taking paint off the surface of the paper – correcting mistakes in other words. What you do not need is the expensive stuff – anything with patterns or cartoon animals embossed is a very bad idea, unless you want your pale sky to have the faint impression of cartoon dogs on it.

For drawing, pencils in grades B, 2B and 3B are required, and a craft knife and a plastic eraser are necessary extras.

Watercolour under-drawing is a specific technique and requires a particular pencil. You are drawing on the paper to guide your washes and other paint marks, and the pencil lines will be covered over. Do the painting convincingly and the pencil lines will disappear. But the pencil lines need to be the right 'weight'. If you use a hard pencil, an HB, H or 2H grade, say, you will be digging a line into the paper when you make your mark, and the paint will run into the groove. Conversely, if you use a soft pencil, say 4B or 7B, when your brush, loaded with wet paint, moves across the crumbly line it will pick up bits of the graphite and smear them into the paint.

It is also a good idea to keep a sketchbook, for two reasons. One is that it is good practice to draw as much as possible, and the other is that in sketching casually you often discover things that you'd like to paint in a more sustained way. You might see something, start drawing it and then realize that the subject has potential as a painting. You might also work from your sketches – I will be looking at this practice later in the book.

Of course, you might also combine sketchbook and painting by buying a watercolour sketchpad or sketchbook and work in colour in that; as I have said before, a small box of watercolours, a little water bottle, a cup, some loo paper and a travelling brush don't take up much room, and you are free to splash down your observations.

Masking tape is always useful.

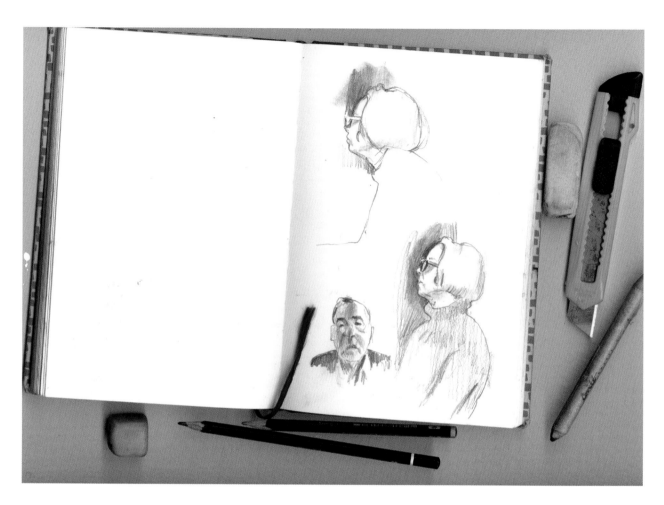

Sketchbook and drawing stuff. The grey thing that looks a bit like a pencil is a stump. It is a roll of compressed paper, used to smear pencil or graphite marks, to make an extra tonal mark.

CHAPTER THREE

Simple Washes

By now you have been to the art shop, or received some rather intriguing parcels through the post, unwrapped them and are raring to go. You have a vision of yourself in some lovely meadow, a battered panama on your brow, sitting in the sunshine and painting the trees and grasses, the cows in the pasture moving slowly about, the pretty piebald horses, and the clouds scudding overhead.

I once tried to draw some horses in a field. I was early for a class, and I could see these creatures gently chewing at the grasses, so I thought why not? I pulled the car over and got out, walked over the verge and carefully closed the five-bar gate behind me. I opened my sketchbook and looked at the horses. Scraggy things they were, and ill-assorted, two dark little ponies and a big, shaggy one. They looked at me. I started drawing. They started walking towards me; closer and closer. 'Hey, get back' I said, hopefully. They didn't. Soon, they were nibbling, quite roughly, at my coat. One of the smaller ones pushed me with its head. I backed away. Then I turned and ran. I hadn't realized that horses were carnivores. Perhaps that's why the English don't eat them.

Enough of the anecdotes. Before you start painting what you see, you need to practise with the paint and get to understand how it works, and that's what this chapter is about.

The first step

Set yourself up properly. The best thing is to sit at a table. The chair should allow you to sit at a comfortable height for a longish period, and you should not have to bend down too sharply.

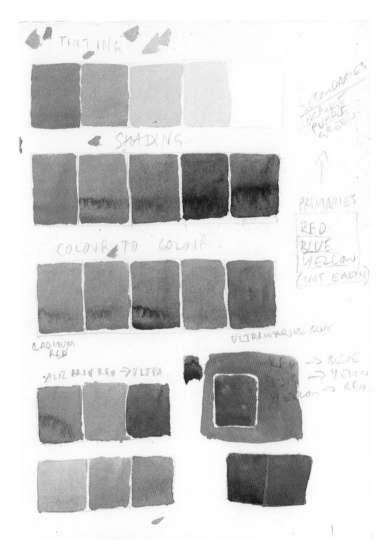

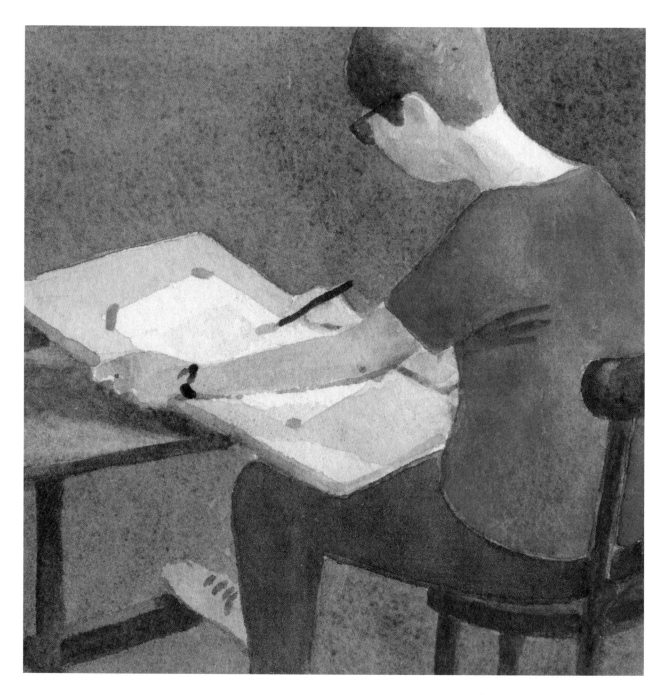

Now, set out the equipment. The most important thing is that your paintbrush needs to take the shortest journey possible between paint, water and paper, so if you are right-handed, put your paint, palette, water pot and brushes to the right, and if left-handed, to the left. Your paper, either in a pad or block, or loose and taped at all four corners to a drawing board, should be on the table more or less in front of you.

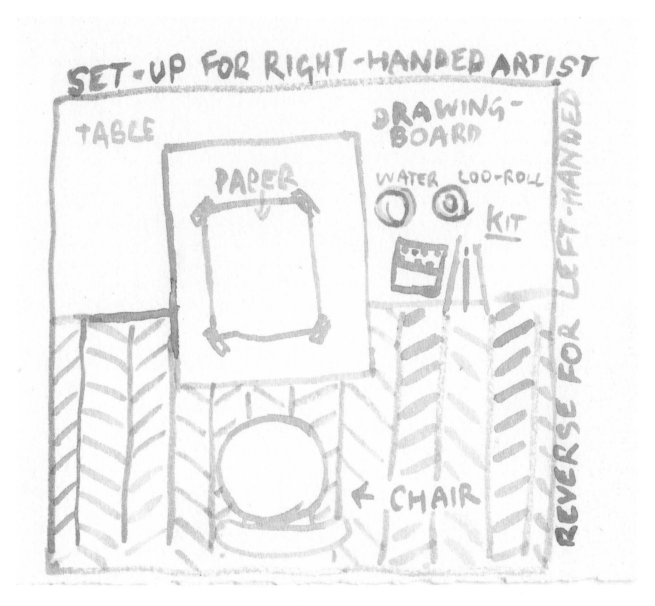

SET-UP FOR RIGHT-HANDED ARTIST

TABLE

DRAWING-BOARD

PAPER

WATER LOO-ROLL

KIT

CHAIR

REVERSE FOR LEFT-HANDED

WASH YOUR NEW WATERCOLOUR BOX

Make sure you have plenty of water and a clean palette. If you have just bought a new box of watercolours you will be using the lid and possibly a fold-out palette to mix your paint in. Before you do, give the whole box a good wash in hot water with lots of washing-up liquid in it. This is because the boxes are often a bit greasy and the paint does not mix well on such a surface.

Take the paint out first though! The metal boxes usually have a tray that the pans are fixed to and the plastic boxes have an arrangement where the pans clip in. It's a good idea to investigate thoroughly, and fiddle about until you have an empty box.

The other things you need to have plenty of are loo paper, pencils and masking tape if you are using loose sheets of paper.

Right, below and top right To my shame, it took me ages to work out that the boxes all come to bits. I had got used to replacing the pans in my little Winsor & Newton light metal box, but after a year or so of using it I decided to give it a thorough clean, and was amazed to find a whole section that came away. Pretty disgusting, eh? But you can load it up with all the colours you need.

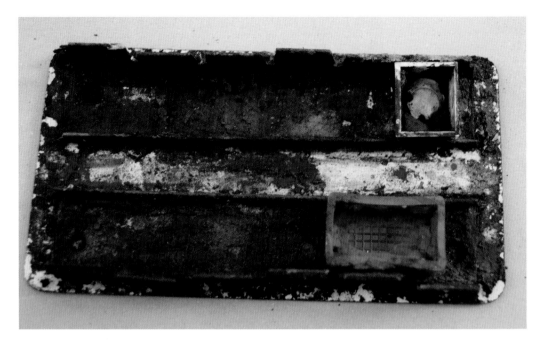

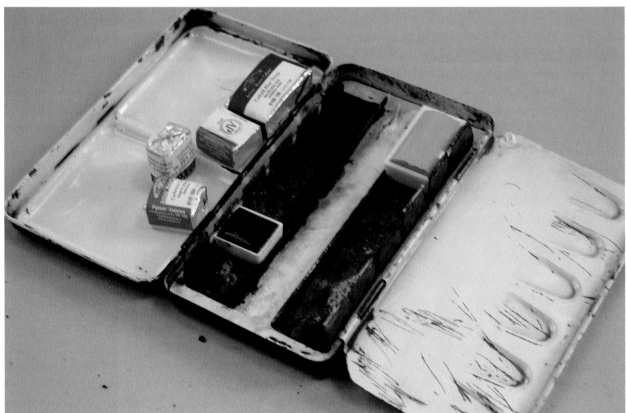

Applying a simple wash

This is the 'default' method of applying water-colour. You are aiming for a block of colour, absolutely uninflected, looking as if it has just appeared, without brush marks, lines or any unevenness. Why? Because it is best to be in control of the medium – you can learn to allow it to do its own thing later. The other question people always ask when I demonstrate this is 'Can you wet the paper first? Won't that make it easier?' To which I reply 'I will show you that later'.

The paper should be 300 gsm (140 lb) in order that it does not cockle. I am aware that you will probably feel it is a waste to use expensive paper for what is 'only an exercise', but just grit your teeth.

Hold the board or pad at an angle – it should slope gently towards you. You might rest the near edge on your knees, or prop it on a roll of masking tape. That is about the right angle.

First, draw a square, maybe 20 x 20 cm (8 x 8 in), lightly in pencil. Then, using a soft brush, choose and mix a colour. Use a lot of water. Make sure you have made a consistent mixture by mixing well.

You will need a great deal of paint. I use the expression 'reservoir of paint' at this point, with its connotations of wide expanses of water, compulsory purchases of farmland, and secret gangland drownings. A lot of water. Because you

do not want to run out of the colour halfway through, partly because it is so difficult to mix the exact colour again and partly because it will take time, and the wash you have already applied will dry before you can finish the rest.

HAVE YOU MIXED ENOUGH PAINT?

Now, lift the brush from the paint. At this point the brush should be absolutely loaded with paint, and everyone wants to wipe it against the side of the palette. *Do not wipe the brush.* You need all the paint. The brush is designed to keep a lot of paint in its tuft. That is why we just use the tip of the brush – as it moves it slowly lets out its cargo of paint.

With your paper on a sloping board, place your loaded brush on one side of the square and then, trying to keep the hairs of the brush as still as possible, gently move the brush across the square, going from one side to the other.

There should be a noticeable ridge of watery paint on the lower edge of the wash. It is held there by surface tension. The trick is to break the surface tension with the tip of the brush and tickle the film of paint downwards. You are aiming for a consistent, even film of paint, filling your drawn square. It may be slightly 'lined', but this means that you have not mixed enough water in the paint.

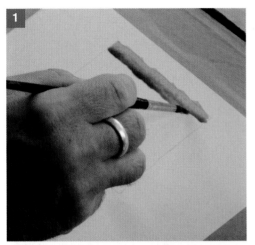

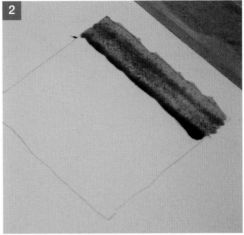

1: The wash starts in one corner, and goes across the page.

2: The ridge of paint appears.

3: Urge the ridge down the paper. Try to make it a bit more even than this!

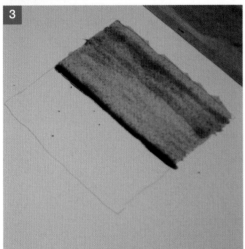

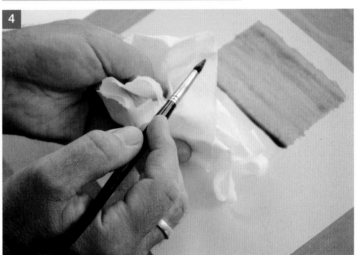

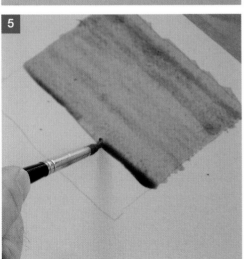

WHAT'S THE POINT?

The water is drawn slightly down the paper by gravity, which evens out inconsistencies. The film of paint dries evenly, from the top to the bottom. Any 'correction' will result in ugly layering, or wet paint going into damp paint, which makes a cauliflower pattern, so the best thing is to keep going steadily. *You cannot go back*. It's another lesson that watercolour painting teaches you; the futility of regret.

This technique should teach you a number of other things – the importance of preparation, for example. The paint must be mixed in a clean palette, and mixed thoroughly, otherwise you will get an uneven wash. If the paper is loose it

4: Wipe the brush lightly with loo paper.

5: Suck up the excess and lie the board flat. Not a very good wash – you may well find the wash comes out striped. There are many reasons for this, the usual being that the paint hasn't been mixed well enough, or that there's a problem with the paper. But the principle is the same.

If you let the paper lie flat the water will run in different directions, and will sometimes puddle; when this dries it dries unevenly. You might want this, but you might not – learning this technique will give you a choice in the matter.

THE RIDGE

When you get to the bottom of the square, you should have a ridge of paint. Have a little bit of loo paper to hand, and just wipe your brush through it – not to dry it out completely but to get rid of excess. Then dip the tip of the brush into the ridge of paint. It should suck up the paint, as if by magic. I find it helps to make a little sucking noise as you do this.

ADMONISHMENT AND ADVICE

Right, now some of you have disregarded my injunction on using paper other than watercolour paper. I know this. Someone always does.

You will notice that it hasn't entirely gone to plan, has it? And as it dries, it will get worse. It will be much more uneven, it will soak in more, it will cockle and it will generally not work. It doesn't help looking embarrassed or apologizing. You've only yourself to blame, etc.

You will notice that I have not specified a brush or a colour with which to do this exercise. This is because I do not want to give the impression that a wash is something done with a wash brush or with a particular colour, but rather that it is a general technique. It is the 'default' method. Try it with different colours and different brushes. See what happens. For example, you will find that the lighter yellows seem to make more consistent washes than other colours. This is because they are so light that you cannot really see the inconsistencies. With an ultramarine blue, on the other hand (which often seems to have quite large particles of pigment), it might be more difficult to achieve evenness.

A wash or mop brush will cover more area more quickly, but because it has such a large tuft it is harder to control. More water is often the answer.

must be taped well, and it must always be held on a slope.

THE SLOPING BOARD

People get very nervous about the sloping paper. I was once giving a demonstration of painting some flowers, with my board at quite an acute angle. I had been teaching that particular class for years, so they were quite relaxed and asked me a lot of questions as I went on, but I noticed they all suddenly went quiet. I assumed they were merely fascinated by my technique, until I realized that they were all looking at the blob of paint that had collected on the side of the painting that I was not working on at the time. They were waiting for it to run. I rescued it and they all went 'aaaah' and carried on chatting.

Soggy cockles.

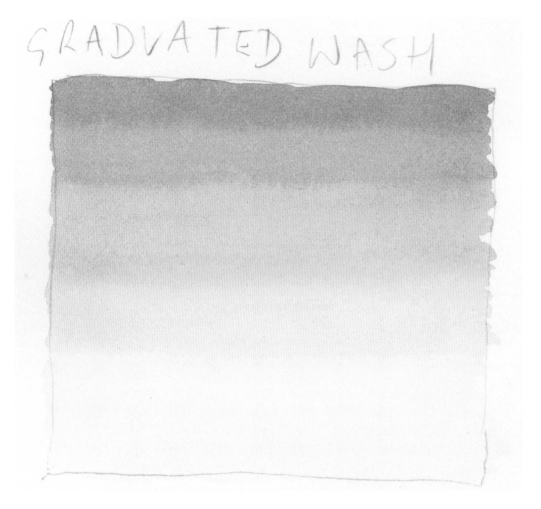

A graduated or graded wash

More water is certainly the answer to this one. What you are after here is the same strength of colour at the top of the wash and then gradually, imperceptibly, it should lighten until at the bottom it is as pale as it can be without being no colour at all.

Make sure, before you start, that you have plenty of water – a second jar might be useful. Again, draw a square 20 x 20 cm (8 x 8 in), lightly. Again, the paper should be on a slope. Again, mix up a good reservoir of colour. Not so much this time though.

Dip your brush into the mixture, and lift it without removing any paint from it. It should be absolutely loaded when you rest its tip on the paper, and then you move it gently, keeping the tuft as still as you can, across the page. When you go to reload though, dip your brush first into the water, and carry more clear water into the mixture, so that it all weakens. Now, take the brush to the paper and, breaking the surface tension of the ridge of paint that you left behind, continue as before.

What will happen is that the new, weaker paint will mix with the older paint, and gravity will even them out as you urge the ridge down the page. Repeat with more water and less paint. By the time you are down to the bottom of the square you should be just dipping your brush into clean water and using that as paint.

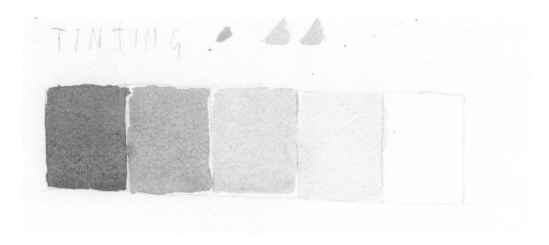

This is not an easy exercise at all. It is an elaboration of the idea that watercolour is essentially films of transparent paint over a lighter ground, and, once you have got hold of that idea, you are away! But the idea and the practice are not always the same – unfortunately.

Altering colour – tinting and shading

TINTING

To alter a colour, then, you need to add something to it. In the graded wash, it is water, and adding water is called 'tinting'.

Draw a ladder of five squares, each one 2–3 cm (an inch or so) square. Mix some red paint and fill in the first square, like a small version of the first exercise. Then add enough water to make the mixture slightly lighter, but not hugely, and fill the next one. Then more water for the next, and so on, until the last one is just plain paper. Now, look at the middle ones. What colour would you call that? It is a weaker version of red, isn't it? In fact, you could say that it is red paint mixed with white paper. Red and white? It's *pink!*

Tinting changes the tonal value of a colour, but it also adds white to it. Adding 'white' watercolour paint is perfectly possible, but to make any visible difference you have to put lots in – gouache is more effective and then what hap-pens? It is opaque, and while all the other colours are transparent the one you mixed with white sits on the surface of the paper like a lump, breaking the rules, looking out of place. That's if you've managed to keep it clean and it hasn't turned into a grey mess. It's far classier to use the white paper underneath. (I go into this a bit more in Chapter 10.)

SHADING

Shading is the next way to alter colour. Draw another ladder of five squares, and mix another colour. You could stick with red, or try another colour, maybe blue or yellow.

Once again, start with a simple block of your chosen colour. Then, in the next one, add the tiniest bit of black you can. Check on the side to see. It needs to have just changed from the original colour, just shifted slightly. (It is important to have a good black here – not blue-black, or a red-black, but lamp or ivory or something like

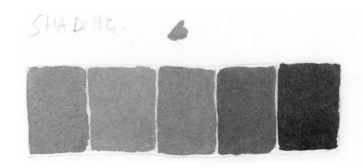

that. Certainly not Payne's grey – it's a useful colour, but not for this.)

For the next square, add just a little bit more black, and so on until you have got just black. The middle square should be exactly balanced between the colour you started with and black.

This is shading. I cannot really understand why people don't use black; it's such a useful colour. It allows you to 'cool' a colour off, to weaken it, without adding another colour to the mixture – as you will see in the next exercise.

Using colour theory

In my University and College teaching I have to write out lesson plans, and one of the things I have to do in them is to say what I hope the students will learn. This is called writing your 'learning outcomes'.

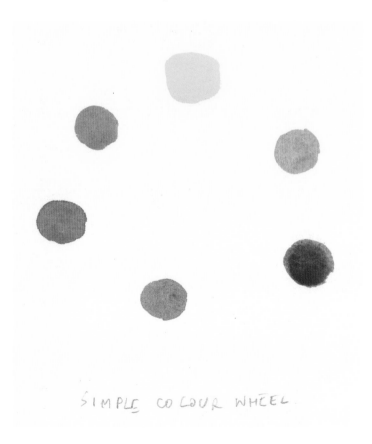

SIMPLE COLOUR WHEEL

One of the tricks of teaching is to invent lessons where the students seem to learn one thing, but learn lots of other things at the same time, and that's the secret to writing good lesson plans – working out loads of 'learning outcomes' that you are providing, while ostensibly just teaching one thing. For example, if you were teaching students to build a wall you could get them to line up to collect their bricks first and you could say that one of your 'learning outcomes', as well as teaching them to lay bricks, was getting them to queue up for things and wait their turn. Patience, in other words.

This exercise contains lots of 'learning outcomes'.

COLOUR TO COLOUR

In these exercises just use three colours – a red, a blue and a yellow – three primaries. Don't use an earth colour, like light or Venetian red, or yellow ochre, but rather cadmium yellow, lemon yellow, vermillion red or ultramarine blue. Alizarin crimson or permanent rose are also fine. We are talking of transparent primaries.

Choose two colours and draw out your five-squared ladder. Start with, say, red. Mix it well, so that it is a relatively strong colour and then fill the first square. Now, as you did previously with the black, add a very little blue. Test it to one side first. Again, you are trying to make a red with just a tiny bit of blue. Fill your square, and then add a little more blue. Keep this up until you have got to blue, so that the middle square is an exact mix of blue and red.

This is important; when I say it should be an exact mix, what I mean is a visual mix. Your eye should be able to see a colour that is halfway between the blue you have used and the red you have used. *I am not talking about physical amounts of paint.*

There is always a student in my Beginners' Watercolour class who will try to make these colours 'theoretically', and he or she always gets in a terrible fix. The rationale is usually something on the lines of 'I will dip my brush once into the red, then wash it, then dip it twice into

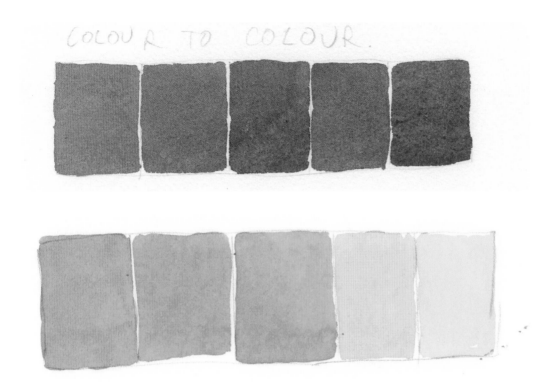

COLOUR TO COLOUR.

the blue', and it never works because the paints all act differently, and some are stronger than others.

I did a session on the colour wheel once, and one of the students had more or less finished the whole thing before she realized she'd gone wrong. She had disregarded my advice not to use light red as her red, and then she had gone through the colour wheel in the 'two dips of this, one dip of that' routine, but I don't think she had cleaned her brush well, and she certainly had not reckoned on the sheer strength of light red, which can really cover paper! The whole colour wheel had a lovely, orangey tint to it. Not what you want, though.

This story just shows the importance of looking hard at what you are doing. It is your eyes that will tell you whether you have it right, not your logic. Another lesson in life as well as watercolour!

By the way, I hope you have still got your board or pad at a slight slope.

The advanced student will have spotted two

hidden lessons in this exercise – you are learning to apply washes, and you are getting to grips with colour theory, as well as learning to make a transition evenly from one colour to another.

PRIMARIES ARE ALL DIFFERENT
Something else to notice: the blue you have chosen may make a good, clear green but a muddy-looking purple. The red might make a brown orange but a good purple. The yellow may produce a perfect orange but an indeterminate green. Why? They are supposed to be primaries, after all.

The reason is that colour theory is just theory. The secondary colours you are making are not wrong; they are simply the result of mixing specific colours rather than general colours – ultramarine blue instead of 'blue'; cadmium red instead of 'red'.

And they don't always mix in the same way. Some pigments seems to have larger particles than others. Some ultramarines, for example, seem to separate on the paper as they dry, so if

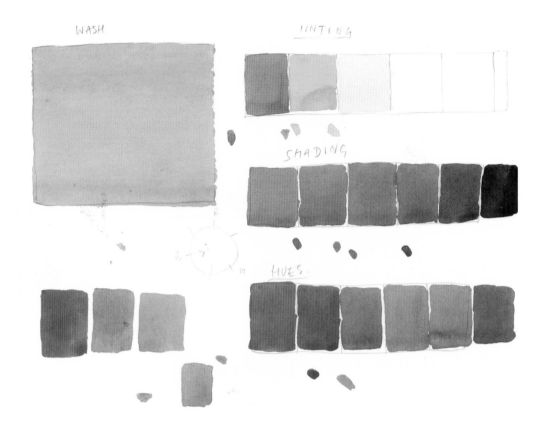

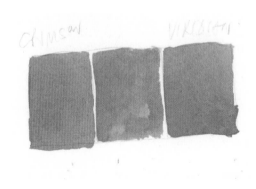

you look closely at the film of paint you can actually see the two different colours on the paper.

The other point to bear in mind is that you have made fifteen different colours. This is before you consider the effects that shading and tinting would have on the colours you have made. So that huge range of colours you have in your box – the other three, nine, twenty-one, depending on the size you bought – can be multiplied almost *ad infinitum*. You have a lot of choice.

MIX MORE COLOURS

All colours have their uses; I hope to demonstrate this further later on in the book, but for now, expand your colour exercises by choosing more pairs of colours and mixing them in the five-stage ladder system, keeping your eyes firmly on the colour values you are creating. You will find some very interesting combinations.

I was teaching this session in an Adult Education class once; we had done the primary colour ladders and the students were experimenting with different combinations, when one older lady turned to me with a worried face: 'I think I've done something wrong', she said. She had mixed alizarin crimson, which is a dark-looking red when in the pan, but turns into a cold, transparent red when applied, with viridian

green. Viridian is, like alizarin, a dark-looking paint, but when you apply it, it is a cold, clear, transparent green. Students often avoid it; you want something to make grass, don't you, or the sea, and it just looks too artificial. But by mixing the two together, if you get the mixture exactly right, you get a lovely, neutral, transparent grey. If you do it correctly, you should see no red and no green in the film of paint, and it is quite disconcerting. Where did the green go? Where's the red? That's what my student was asking, as if she'd broken something. On the contrary, she'd done it exactly right, because she'd mixed it perfectly.

Aim for that. The middle colour should be an absolute balance of the two colours at each end.

By the way, is your board still sloping? Are you wiping the brush on the edge of the palette, as if you were painting your bedroom wall in magnolia emulsion, or still using the tip of the loaded brush?

'TEMPERATURE'

Now, make another three small squares, 3 x 3 cm (about 1¼ x 1¼ in) wide. In the middle one, put a wash of alizarin crimson. Do you think it is a warm colour? Now, put a wash of ultramarine blue in the one on the left. Is the alizarin warm now? Warmer than the blue? Now, put a cadmium or bright red in the one on the right. Does the alizarin look warm now? The 'temperature' of colours is all relative.

Obstacles

By now you should be getting pretty good at washes, so I will make it a little harder for you.

Back to the larger size wash area; draw out another 20 x 20 cm (8 x 8 in) square. This time though, lightly draw out a shape in the middle of the box, to occupy perhaps a quarter of the area of the square. A triangle, perhaps, or a circle, or both – do two!

The object of this exercise is to apply your wash, while avoiding the shapes in the middle, in order to leave them white. Choose any colour,

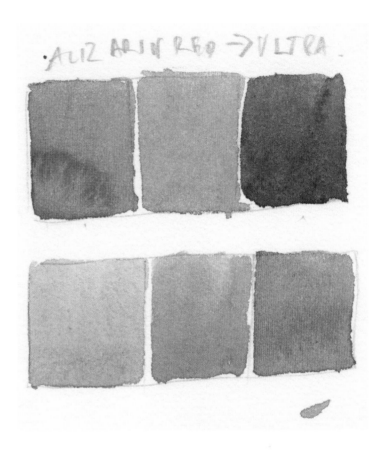

but a dark blue or earth colour might make the white shapes in the middle stand out a bit more.

Start as you did the original wash exercise. Mix up a large amount of the colour, keep your board at an angle, and then load up your brush. Use a wash brush or a round one, it does not really matter.

Again, go from one side to the other, making your ridge of paint and just tickling the film of paint down the page, until you get to the shapes.

The important thing here is that nothing dries too quickly. Paint from one edge of the square until you get to the drawn shape and then lift off and paint on the other side. You can keep going on one area as long as your ridge of paint on the other areas does not start to dry, but as soon as it does you need to paint there too. It is a matter of keeping a close eye on the whole film of paint to make sure that it is all drying at the same rate.

In this sheet of exercises you can see an obstacle wash: you can also see where I have put a small drop of water in the wash, to 'fix a mistake' – a 'cauliflower' has appeared.

Below and below right
In these sheets you can see the obstacle wash as well as colour to colour exercises, using different blues and reds and other colours. Note the effect different paper has as well.

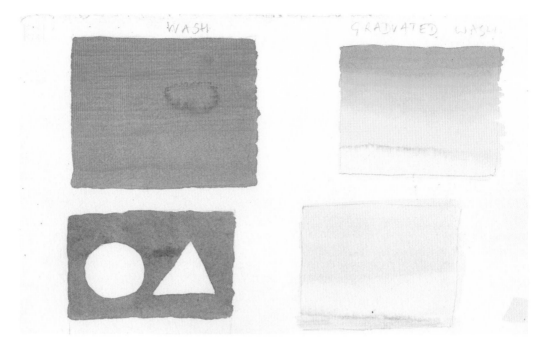

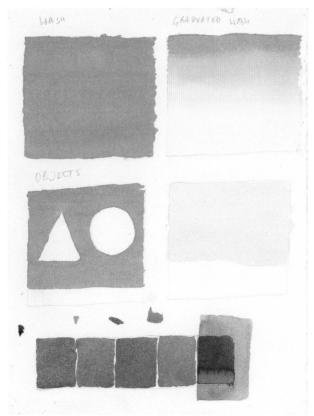

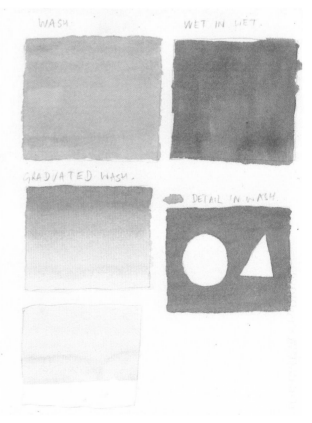

When you get to the bottom, you'll remember to wipe your brush on some loo paper or a cloth, and dip it into the ridge of paint to pick up the excess. Make a sucking-up noise if that helps – it helps me.

Tricks

You may remember my saying that I would talk about wetting the paper before putting on a wash.

Why do it at all? Well, you will have realized, with all the practice you have had putting on washes, that in a way dry paper resists paint; surface tension will hold the ridge of paint motionless. On the other hand, if the surface tension is broken, the paint will follow the path of least resistance. So it makes sense that if you wet the paper, and lightly apply your very runny wash, the paint will find its own way around the shapes you want it to.

To practise this, do exactly the same as you did in the last exercise, drawing out two shapes in the lightly drawn box. Now, using a brush loaded with clear water only, and tipping the paper so that you can see light reflected on the film of water, quickly apply the clear water to the areas you want covered.

Mix up a very thin wash, with lots of water and, keeping the paper tipped up, lightly apply your wash. You will see the paint find its own way.

SLIGHT SHIFT

Finally, just to remind yourself of what you are dealing with, try this. Make another box, maybe a bit more rectangular, say, 20 x 30 cm (8 x 12 in), in a landscape format. Put some

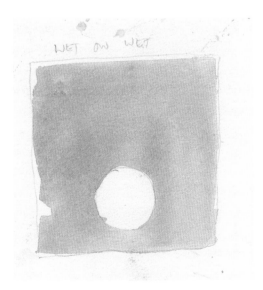

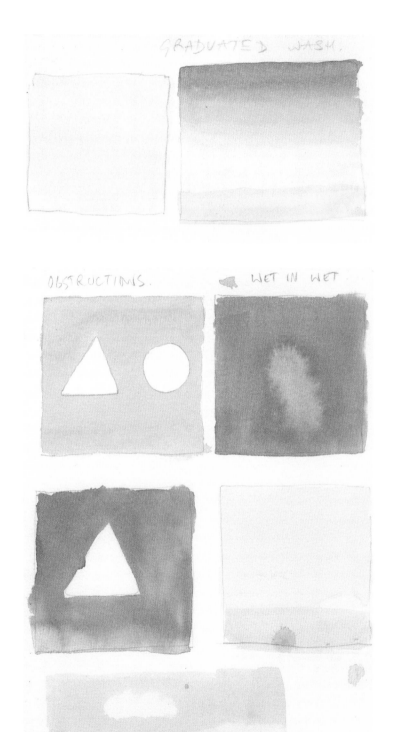

water in your palette, and just the smallest touch of some kind of dirty greyish brown colour. What I am after here is dirty water, rather than an actual colour. Now, apply it, leaving a little strip at the bottom of the rectangle.

Just a slight tint of a neutral colour, but look how effective it is. There should be a very slight difference between the paper and the painting, but it means a huge amount – instead of nothing, you have the suggestion of sky and landscape. Your eyes search for clues and they find and exaggerate them. You have started a painting.

Above and left These all look to me like wet in wet demonstrations. Look how it helps to make the obstacle clear and clean. Note again, in the black wash, how adding water to the film of paint after it has been completed never helps at all!

Again, a stripy wash. The graduated wash is okay, suggesting a sky, and the blue wash underneath it works well, as does the obstacles wash. Under that is a demonstration of removing paint with loo paper.

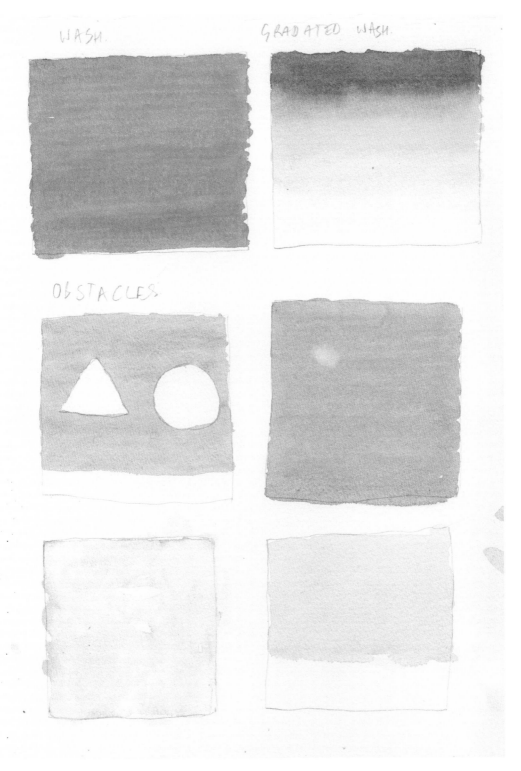

WASH.

GRADATED WASH.

OBSTACLES

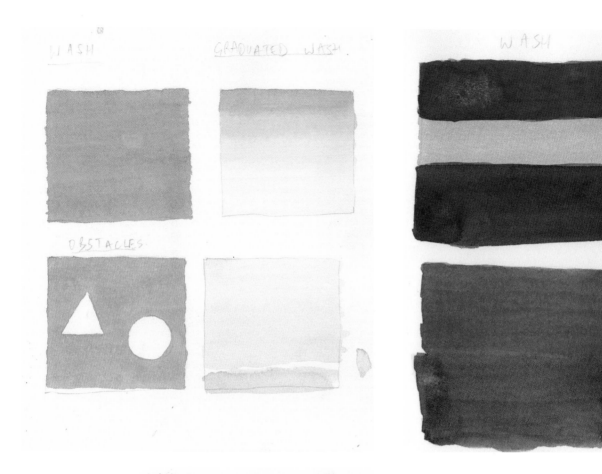

I have used these
exercises to
demonstrate
deepening colours by
layering over them.

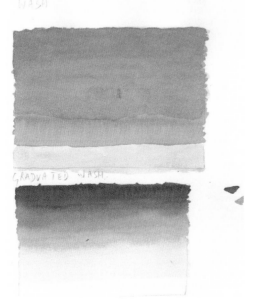

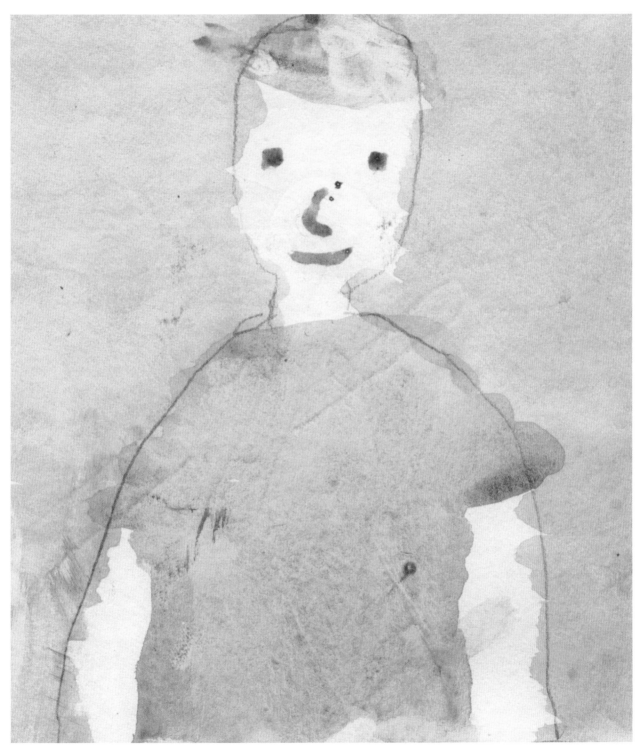

Figure, T.P. Latham. Teaching my 9-year-old nephew, Theo, to paint washes.

Drawing

The title of this book is *Basic Watercolour: How To Paint What You See*, and what I am trying to get across is how to use watercolour to paint what is in front of you. It's not about making lovely paintings – not really about how to make your photograph into a painting, for example. I can't see the point in doing that anyway. It seems to me that if you have a nice photograph you should perhaps have it enlarged, and printed on good paper, and

framed. What's wrong with a good photograph? I can't see what is being added to an image by making it into a painting. That is, unless you are making an observation on the nature of image-making or painting or something, like the artist Gerhard Richter, or the photorealists of the 1970s. They were looking at different ideas about painting itself, but most of the people I meet who paint from photographs are doing so mainly, I think, because they do not feel confident in their ability to draw. What do I mean by that? Simply that a photograph will give you the feeling that you know what the thing you want to paint looked like. Note, by the way, the past tense.

So it is understandable that people should use photographs to work from, but why does it annoy me so much? Perhaps the answer comes from Ruskin. When I was researching *Basic Drawing* I came across his book *The Elements Of Drawing* and I found it very inspiring. It is written in the form of letters to students. They are not art students, aspiring to be artists, though, but people who simply want to make their drawing better, and Ruskin's attitude to their drawing is not to make them better, more professional artists, but to make them better people. What he means is that looking carefully and for a long time at an object, be it a landscape or a tree or some other object, and trying to record how it looks, honestly and thoroughly, is a good thing in itself. It is a meditation; so many of my students tell me they enjoy life-drawing or painting in the landscape because they can think of nothing else in that time; that it is such an all-absorbing task.

The Elements Of Drawing deals as much with watercolour as it does with drawing in pen and ink, or with a pencil, too, because, to Ruskin, 'drawing' was working from observation, however you did it.

So, as much as you need to understand the principles of watercolour technique, you need to understand drawing from observation as well, and in this chapter I will give you some exercises to begin. The next chapter is also deeply indebted to John Ruskin.

Principles of drawing for watercolour

There are three ways of approaching watercolour painting. One is to do a tonal drawing, usually with a pencil, and put washes of colour over that. One is to splash straight in, as Turner is recorded as doing – drawing with watercolour. The other approach is to make a 'watercolour drawing', or 'under-drawing'. You can see this approach in John Sell Cotman's painting; he would spend a long time working out the painting in studies and drawings, tracing the image and making trial-run paintings, before making a final, delicate drawing and then using it as a guide for his paint.

An under-drawing looks a lot like those 'painting-by-numbers' kits that used to be so popular; it doesn't look expressive or bold or any of the things we prize drawings for nowadays, but it does give you a good idea of what to do next. Look at the next chapter for an example of this type of drawing.

All three of these methods are perfectly legitimate and we will be exploring all of them.

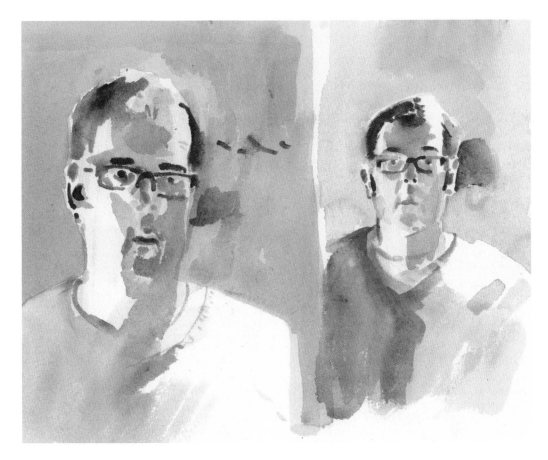

The two self-portraits in brown paint, or 'tertiaries', are made by 'splashing in', drawing with the brush, and you can see in the one here that I have started to add colour over the top of the tonal structure. In the piece on the opposite page I have made a more or less complete drawing in pencil and then laid small amounts of colour over the top. I have tried to let the paper and the tone do as much work as possible, just hinting with the colour.

The picture plane

One of the first things you need to understand is the idea of the picture plane. You can start by making a viewer.

The best way to understand the principle of the viewer is to watch the *The Draughtsman's Contract* by Peter Greenaway. It is the story of an eighteenth-century artist hired to make a series of drawings of what would now be called a stately home. The artist sits on a stool and looks through a frame, which is set up in front of him, at the various views. The frame has a series of dividing cords strung across it, so that the view is at once framed and then broken into a grid. The draughtsman has a sheet of drawing paper before him on a drawing board, itself divided into a grid. The task of drawing the confusing scene is thus made easier, first by the framing device, so he knows where his edges are, and secondly by the grid, so he can organize the scene within the frame. The story is quite saucy too.

You can actually buy viewers; you can more or less buy anything in the world of art, to be honest, but probably not like the one in *The Draughtsman's Contract*. A ready-made one should have the facility to alter the format of the viewer, and should at least have markings for a grid system.

All you need though are two L-shaped pieces of card, and possibly a paper clip. Or you can raise your hands with the forefingers and thumbs at right angles to each other, to make two L-shapes. It might look a bit strange, but so what? Golfers look pretty strange, if you ask me. And joggers, and those people on bicycles who dress up in Lycra and stick their bottoms in the air. I mean, good gracious! Anyway …

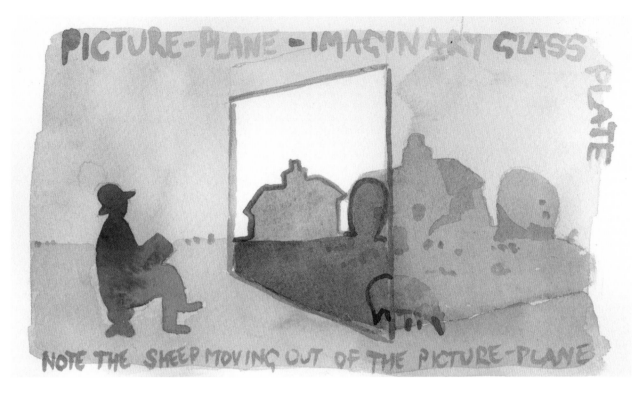

PICTURE-PLANE = IMAGINARY GLASS PLATE

NOTE THE SHEEP MOVING OUT OF THE PICTURE-PLANE

Make your viewer, and raise it up to frame a view. Close one eye and look through the viewer and you will see a 'scene'. Now, imagine that instead of an actual view, what you are looking at is a painting. The surface of the painting, the flat space in the viewer, is the picture plane.

Negative shapes

When you have grasped that idea firmly, you should be able to get this one, too.

When we draw, we tend to draw 'things'. For example, we might draw a house, a portrait, a flower and so on. We tend to isolate objects from their surroundings.

If you look through the viewer, you will see no blank spaces. There is nothing that is 'nothing'. If that sounds too gnomic, think of it this way – I see loads of paintings with white space all around figures, trees, houses, but I have never seen a truly white space – even a white-walled gallery has corners and edges, and white

is rarely absolutely white. Look through your viewer at a friend, sitting next to you; is he or she poised against a nothing, a blank whiteness, or do you see a wallpaper pattern, a café, the inside of the bus, some foliage – something?

Everything we see is seen relative to other things. Negative shapes are simply 'the other shapes', the shapes not made by the face of your friend, but by the armchair she leans against, the window he obscures. They used to be called 'the spaces left' – the shapes made by the things around the subject of the painting.

NEGATIVE SHAPE EXERCISES
Set out below are some drawing exercises, for which you will need drawing paper, and a sharp pencil, B or 2B grade.

Always use a craft knife to sharpen your pencil, cutting away from you. The reason for this is that pencil sharpeners are often used while thinking about other things, so the point is never any good, and often the lead inside breaks before you can use it. It is better to concentrate

1. Take a large sheet of white paper and lay it on a table. Place four or five objects on the white paper, so that they overlap, and so that at least one object touches the edge of the paper. You might try using cutlery and other kitchen stuff.

Now, close one eye and keep your head very still and, using your viewer to frame them, draw their outlines. Don't draw each object individually, but let your pencil slide over the edges of one object and on to another.

Don't rub out or correct. Just keep drawing the outlines until you have them all. If you go wrong, try again, but leave your

Top and above Look at the first image, and you can see a young woman falling through the air, with a wine bottle beside her. Her hair streaks out behind and she covers her face. Poor thing! Finish the image and you see what's really happening. She's just sunbathing on the grass.

on the job in hand, and make the point as you would like it. It gives you time away from looking at what you are drawing, which is often a good thing. It is easy to ruin a drawing with a blunt instrument, and when you take a little break from it, you are sharpening your vision as well as the pencil.

The paper can be in a drawing pad, or in loose sheets on a drawing board. It needn't be a big sheet, as small as perhaps 30 x 20 cm (12 x 8 in). A plastic eraser might be good too.

Spend half an hour minimum on each exercise.

mistakes. Remember to stop and sharpen your pencil when it goes blunt.

When you have finished, move the drawing away from where you have been working and take a good look at it. Look at those edges and where you went wrong. Ask yourself how you went wrong.

It is important not to be destructively self-critical at this point. Think of it as being like learning the scales on a piano.

2. Take a dining room chair, with legs that are visible. We have these bentwood chairs that pose a terrific problem, but what's really important are the four legs.

Place the chair against a wall, on a bit of the floor that has a plain carpet or covering. Under the chair put a book, and then two other books, one in front of the other so they form a sort of train coming towards you.

Now, using your viewer and closing one eye, *don't draw the books or the chair! Leave them alone!* Instead, draw what you can see of the floor and the wall. There will be these odd shapes in the way, of course, but don't worry, just draw around their outlines.

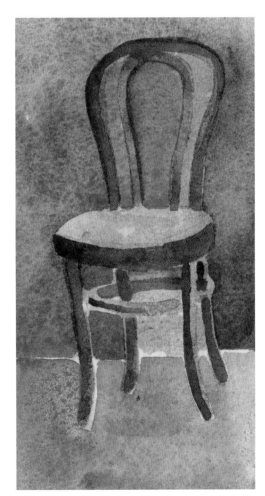

SPACE BETWEEN THE
LEGS OF THE CHAIR,
WITH BOXES.

3. This is an elaboration of Solomon J. Solomon's exercise in his excellent if wordy book *The Practice Of Oil Painting And Drawing* (R.A. Seeley, Service & Co. 1910).

Pile up some books, perhaps three or four, to a height of about 15 cm (6 in), on a large piece of white paper. Now, if you can find one, lean a plain-coloured mug against the pile, so that you can see the bottom of the mug.

Sit in front of the group, so that you can see both sides of the pile of books, as well as the top. By now you should be able to dispense with the viewer occasionally.

First, carefully outline the shapes around the mug that go to make up the pile of books. Remember not to try to interpret the shapes – don't draw anything you can't see.

Then, concentrate on the shapes of the mug. Finally, if possible, draw the edges of the paper.

In mine, the handle presented a problem. Try not to think about its function; just treat it as a lump on the side of the cone-shaped mug.

Now, try filling in the 'book-pile' shape with a thin wash of an appropriate colour, and when that's dry, a wash for the mug. When these washes are dry enough, perhaps a light wash laid on the top to indicate the darker tones. The paper will probably cockle a bit, but it will settle down later, or you can apply the flattening method I described in Chapter 2.

Shapes within shapes

When you have grasped negative shapes, the next thing is to look more closely at how you see the individual things themselves.

When beginners draw portraits they inevitably start with an eye. It seems to be 'hard-wired' into the psyche. An eye will be painstakingly drawn, followed by the space between the eyes, and then the characteristic fluffy, beginner's line will start down the nose, until the difficult 'tip of the nose' problem emerges – how do you make it look like it's coming in front of the face? – and then the nostrils and … Charles, why doesn't it look like Emma?

The answer is that we do not recognize Emma by her eyes. I can recognize my wife in a crowd, about fifty metres away. I can't see her eyes at all. What I can see is the shape of her head and the way she holds it. It's the same with portraits. The important bit is not the eyes – irises and pupils all look much the same – but the shape of the skull around the eyes, the brow and the chin and the hair. It's astonishing how much of the surface of the head is taken up by hair.

When we look at things we very often do not 'see' them properly. What we see is what we expect to see. How do I draw Emma? I'll start with the most important thing, the eyes. I want to paint that tree. How do you paint trees? Well, they have brown trunks and green leaves. Don't they? If you look closely at a tree what you will find is that they usually have green trunks. I know. It sounds crazy. But go and look at one!

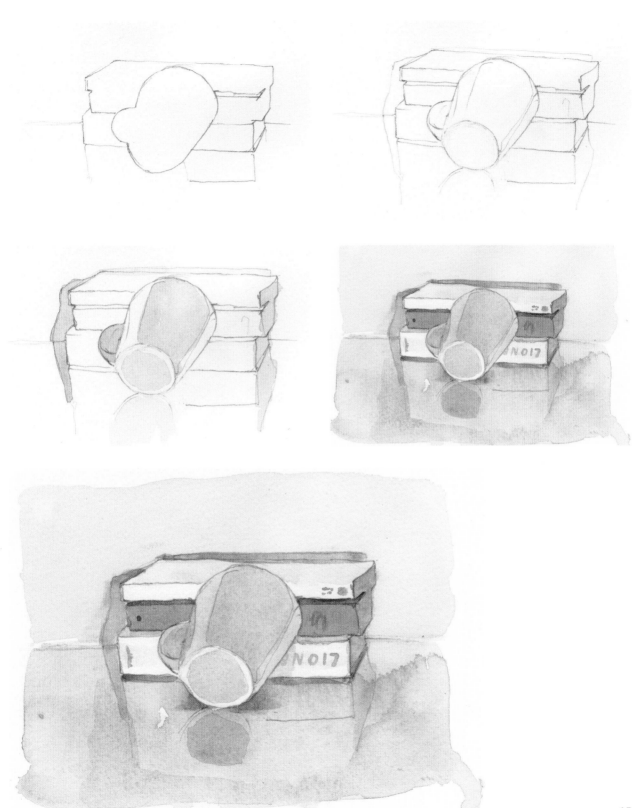

We see what we expect to see, not what we actually see. In order to see things clearly, you might try the exercise of breaking down and analysing the different shapes within an expected shape. For example, if you were drawing a figure, instead of outlining a figure, two arms, a neck, a head, two legs, and then filling it in with shading, try to break down the figure into its component parts; try to see correspondences between one part and another. Ask yourself searching questions – can you really see the neck above the two shoulders?

SHAPES WITHIN SHAPES EXERCISE

Add to the pile of books mentioned above with two or three more, and remove the mug. Now, carefully outline the whole group. Apply the line very gently and try to forget for the moment that there are several books – think of it as a single object.

When you have the whole shape, begin to work into it – separate out individual books and shapes, and notice curves, and small details. Not all books are the same. The paper falls in different ways.

STAGE 2 - LOOKING FOR SMALL SHAPES AND BEGINNING SHADING. NOTICE A BIT OF PAPER STICKING OUT OF THE LARGEST BOOK.

STAGE 3 - MORE SHADING TO DIFFERENTIATE INDIVIDUAL BOOKS - NOTICE THE EXTRA BOOK EMERGING UNDER THE LARGE ONE - I DIDN'T SEE THAT AT FIRST.

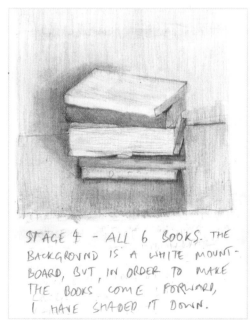

STAGE 4 - ALL 6 BOOKS. THE BACKGROUND IS A WHITE MOUNT-BOARD, BUT IN ORDER TO MAKE THE BOOKS COME FORWARD, I HAVE SHADED IT DOWN.

You might find that your original outline is wrong. If so, change it.

Keep your lines light and sensitive. As the drawing progresses, add more shading to show one area against another. Things will emerge. You will notice more detail as the drawing goes on. Make sure you describe it.

Tone

We see everything in terms of colour and light. Light falls on objects and we see them illuminated from one direction or another, with reflected light to complicate matters. The objects themselves have an intrinsic colour, and that is affected by the light, too.

Tone is the name given to the scale of values from light to dark, and its job is to define form, in other words, tone shows the three-dimensional shape of an object.

Tone is seen in *cast shadow* and in *shading* – cast shadow is the area which is obscured from the light source by the object, and shading is the parts of the object itself that are hidden from the light. There is often no clear dividing line between dark and light, and that is where the mid-tones are to be found.

Think again about the picture plane. If there is no 'nothing' in the picture plane, it follows that every part of it must register as some value of tone, as every part of it must be receiving some level of light.

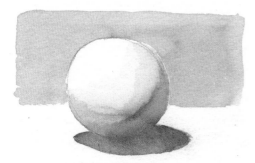

A sphere in strong light. The sphere casts a 'cast shadow', and as the form turns away from the light it is 'shaded'.

TONAL LADDER EXERCISE
Back to painting!

Draw seven squares in a ladder, each 2 or 3 cm (an inch or so) square.

The problem here is to make a ladder of tones, from very dark to very light, in equal steps. You can use ivory black or, to make a more difficult but richer-coloured ladder, you can make a dark out of three primaries. If you do so, it's a good idea to mix the colours and try them first, by dabbing on a spare part of the paper.

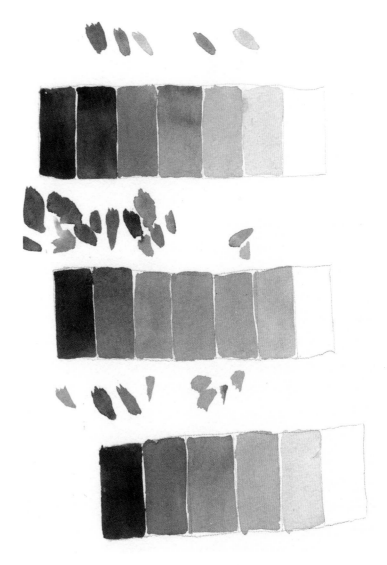

Colour

All objects have some kind of colour. Everything is to some extent coloured, even if the colour is not an obvious one like a red post box, a black taxi. The intrinsic colour of an object is called its 'local colour'.

Colours all have their own peculiarities and 'temperatures', and we often recognize things by their colour; the colour of skin for example will probably catch your eye more than the colour of grass. But it is all equally important in drawing.

Why? Because in order to draw well it is important to see the whole of the picture plane and to take it all into account, and if you start to say that this is more important than that; that you are more interested in this object and so will not draw that one, you will not learn how to represent the object that you are interested in, and will only ever draw your fixed conception of it. You will never learn to go past that.

Don't make things up

'It's artistic licence' is an expression I have learnt to loathe over my years in teaching people to paint. People who claim artistic licence are usually people who would never be given one, did such a thing exist. What it means, usually, is that 'this is too difficult for me to draw so I won't'.

Drawing is all relative, and everything is connected. Alter one thing here and it will affect all the other things over there. If there is something in the picture that you do not want, at any price, to draw, the thing to do is move so that you can't see it. It is as simple as that. Change *your* view, don't change *the* view.

If you fudge it or try to ignore it you will end up making something up; it will no longer cast the shadow that falls across the things you want to draw, or it will leave a gaping hole in the middle of the painting, and you will have to pretend that another object is bigger than it really is, and that's okay on one side, but not on the other, so you have to make that bit up and alter that and, in the end, why bother looking at it at all?

The trick, as mentioned, is to move your view. The artist in *The Draughtsman's Contract* drew everything in his gridded frame, faithfully and accurately. He even drew things he hadn't realized he had drawn and that was how he came to his sticky end.

Choose your view and be honest with yourself about it. If it's too difficult to draw, choose another one.

Perspective

The following is an extract from my book *Basic Drawing: How To Draw What You See* (Robert Hale 2011).

Ruskin refused to teach perspective, because, he said, it shows you how to draw a foreshortened plank of wood, but cannot give the rules to draw an arm as it comes toward you, so no help there. The only

You can see a masterful example of the use of perspective in this detail from Stephen Moriarty's painting in Canterbury Cathedral. Despite his misgivings (see Chapter 11), you know exactly where you are in relation to the space he describes.

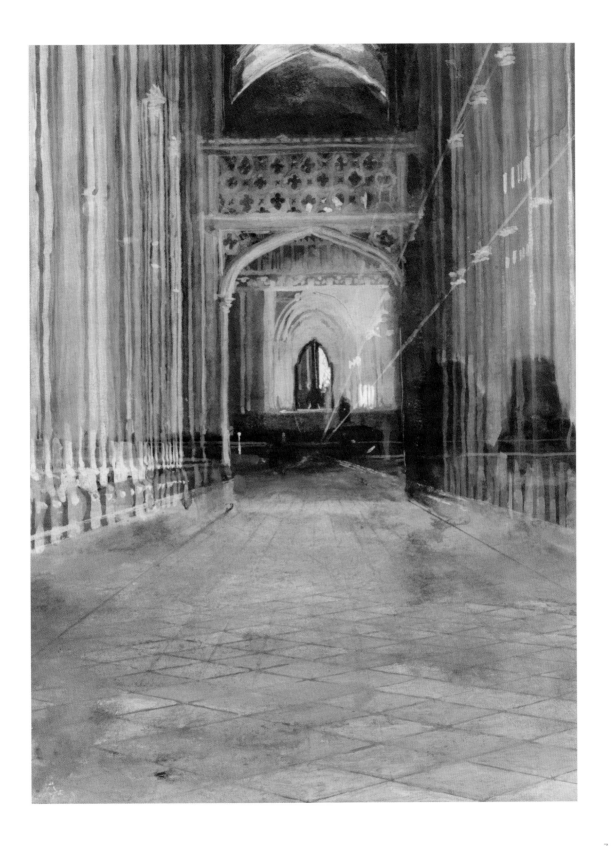

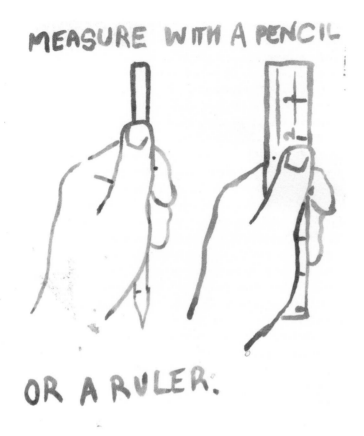

MEASURE WITH A PENCIL

OR A RULER.

proper way to work it out is by applying the lessons I have given so far; negative space, measuring, objective looking. There are some basics though …

Everything you need to know about perspective can be summed up in this drawing of an imaginary railway tunnel, with a man standing in the mouth of the tunnel, looking in. I have drawn a dotted line to indicate his eye level, because he is, quite reasonably, facing in the direction from which the train might come. Safety first. You will notice that his eye level is conveniently half of the height of the tunnel's walls, and that above him are two lines, made by the ceiling of the tunnel meeting each side wall. As the tunnel recedes and the line gets further away, you will notice that it goes down the page. On right and left, as the tunnel goes deeper into the hillside, the lines go further down. But at floor level,

where the railway line lies, it's a different story. As the lines where the walls meet the ground recede, they go further up the page.

They meet right between his eyes.

(In fact, they meet at one of his eyes, because he has the other one closed. Observational drawing depends on monocular perspective; don't worry about it, it doesn't help much to know this.)

That's the main thing you have to remember about perspective. Anything else is just complication, and will get in the way of your looking. You will expect to see things.

Ruskin was right – teaching the complex rules of linear perspective gets in the way of observation.

MEASUREMENT

In *Basic Drawing: How To Draw What You See* I also include instructions on measuring by eye. Here they are:

Lift your pencil in your right hand, and extend your arm to its maximum length. Close one eye and with the open eye, line up the top end of your pencil with the top of the object. Keeping the pencil still, and the arm extended (drawing exercises the parts other arts cannot reach!) line up your thumbnail, on the shaft of the pencil, with the bottom of the object. That's one measurement. Now, pick another object, and do the same. In this way, you can objectively compare relative sizes of objects. You must always keep your arm fully extended. If you don't, the measurements will not be right.

This is the thing you see artists doing in TV programmes and advertisements; like the film director making a square viewer with his or her two hands and saying 'beautiful, just beautiful'. Actors do a shorthand form for artists by leaning back, squinting and looking at a pencil at the end of their extended arm.

You can use a ruler if you like, instead of a pencil. But then you risk:

[When] … you start to depend on the accuracy of measurement you are simply 'upping the ante'– not content with approximations, you will start to search for absolutes, and end in a quagmire of calculation. And the thing about life is, it's impossible to calculate everything. Your model will move, she will breathe, cough, smile at some inner thought. Someone will come in and take the teapot you are drawing to make tea with, and put it back crooked; they will eat the apple and put back an orange. There is a compromise at the heart of all painting and drawing, if only in the fact of three dimensions becoming two.

It is a very interesting book, and well worth the few pounds it will cost you.

General to particular

The hardest thing to grasp in drawing – and this applies to watercolour drawing as much as any other kind – is working from the general to the particular. In fact, what you do is work from the general to the particular and then back to the general and so forth until the painting or drawing is finished, but it is always best to start from the general.

This means drawing large areas, making general decisions first and then discovering and working out the finer details. Like making a portrait – the shape of the head, the structure of the bones, comes before drawing the eye. This means that you have a place to put the eye, and sometimes it means that you don't even need to do the eye.

It is counter-intuitive to work this way; the drawing seems so formless and messy to start with and the hand yearns to demonstrate its ability to 'do a good tree' or whatever it is you are drawing. My favourite analogy when students complain is making a figure in clay. You start with an unformed lump, and mould it and pinch it. Gradually, a figure emerges. The figure is still pretty blobby and formless

though, and you keep fiddling with the clay until the features begin to emerge; the feet, the hands and then the fingers. You can even finish the figure by making fingernails. But you cannot start the figure with the fingernails. Why not? Because there would be nowhere to put them. In drawing it is *possible* to start with the fingernails, but not very clever, because you don't have anything against which to judge scale or position.

What I am suggesting is that you loosely draw in the figure first; that you establish where and how big the fingers are going to be before you get down to the cuticles.

This applies to landscape, still-life and so on, not just figures, obviously.

WASH AND LINE EXERCISE
This exercise will help.

Put a large sheet of white paper on the table and scatter over it some small objects. I have this box of very old and battered tin soldiers which I use for this exercise. The figures are often almost unrecognizable, and most of them can't stand up properly. You could use a bag of nuts, perhaps, or some other small toys.

First, with watercolour paper and a smallish brush, use a light wash to make the shapes of

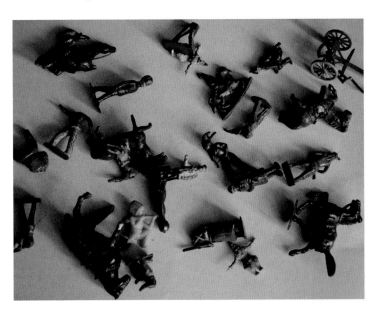

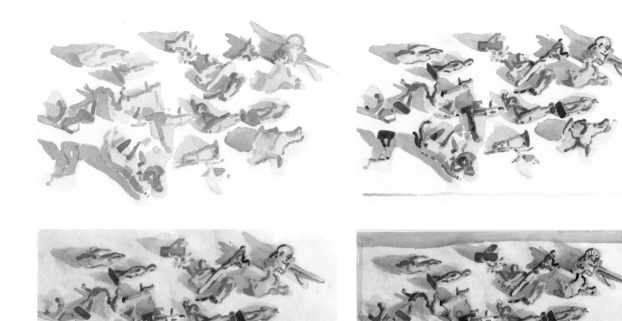

each of the objects, carefully distributed across the page. Don't worry about the colour; just use a neutral colour to make the whole shape of each object.

When the blobs are dry, use the same mixture of paint to add tone – look for the darkest bits of each object and lay on another small layer of paint to make shading. You may realize at this point that the blobs are the wrong shape. Don't worry – just try to get the layers of darker tone in the right place.

Wait until this layer is dry – there's a lot of waiting around in watercolour painting, but use the time to look carefully at your drawing and at the subject. (You can use a hairdryer if you like, but I frown on this.) Then, just use the sharp point of the brush to make small details, rather than confining the edges.

There may be places where an outline is appropriate, but the idea here is to record visual phenomena, not to make 'signs' for things, and there are no outlines in nature (unless my glasses are defective).

Now, add colour, very thinly. Don't overdo it, but hint. I have started with a wash of viridian over the background, which is the paper the objects are resting on, leaving the objects alone. This makes the objects more distinct without being too heavy-handed.

Gradually, I add more colour, but not to make local colour, more to make one object different from another. These old tin soldiers have nice highlights, which I leave as white paper. The lovely plastic Native American stays a yellow blob throughout though.

This exercise comes from a formative moment in my schooldays. My art teacher set astonishingly dull still-life homework assignments and I, like most of my contemporaries, thought that the correct way to do them was to use my pencils and do all the shading and so on. One particular homework was drawing conkers. I had a handful of the things and I found myself on Sunday night (art was on Monday mornings) 'doing my homework', pencilling in the shading. They were old, dull ones, and I was deeply bored. I just couldn't do it. No matter how I tried, it just seemed so dull. I looked at them and as I looked I realized that some brown drawing ink I had would dry to almost that exact shade of old conkers. I went and got the ink. I blobbed a dozen conker shapes down on the paper. Then I carried on watching TV.

Half an hour later the ink had dried, and gratifyingly where it had dried unevenly it looked even more like an old conker, very dark brown against the lighter brown of the rest.

Excellent. I shaded in some cast shadow with my pencil. Then I put a little yellow soft pastel on the top of some of them, so it looked like highlights.

Brilliant. Here is the key point though. My main feeling was 'Will I get away with it?'

Somehow, I thought that what I'd done was wrong. I was very worried that the art teacher would realize how easy it had been. I was very worried that he would smudge the pastel highlights, too, because he was fond of touching the work when he talked about it and I thought if he did the game would be up.

He loved it though. I got away with it.

Tracing

Tracing is a good way of taking your sketch and making it into a painting. John Sell Cotman used this technique a lot to develop and refine his compositions.

First, trace your drawing on a good piece of tracing paper. The key to a good tracing is to keep the original and the tracing paper firmly anchored. I use masking tape on all four corners of each sheet. It's dull but it prevents tears – both kinds.

When you have a tracing, turn it over onto a piece of paper (watercolour paper if possible), tape both elements again, and carefully go over the tracing with a pencil. You are drawing on the reverse side of the tracing paper.

This prints an 'off-set' of the image onto the watercolour paper. It also puts graphite on the reverse side, so that when you turn the tracing

A Sign In Canterbury
9 x 6 cm (3½ x 2⅓ in).
I did this little sketch
one sunny day, and
kept looking at it in my
sketchbook. One day
I decided to paint it.
I liked its simplicity,
the strong light and
the signage sticking
out. Notice the off-set
image on the same
sheet.

paper over and stick it to another piece of water-colour paper and carefully go over the drawing once again, you will print out a positive of your drawing on the watercolour paper.

Then you will have a drawing that you can paint over. The added advantages are that you will still have the drawing on the tracing paper, so that if you muck up your painting you can have another go, and that you will have an off-set version of the drawing on which to practise or try ideas out. John Sell Cotman used to do this: there are extant versions of his paintings in reverse, apparently, which are the tracings used as trial runs.

CHAPTER FIVE

Ruskin Exercise

I devised this exercise years ago, as a way of introducing some of the basic concepts of watercolour painting. I have used it in my Beginners' Watercolour classes at the RWS for years, for example, and I think it carries some very useful learning outcomes.

Imagine my feelings of surprise and vindication when I came across more or less exactly the same exercise suggested in Ruskin's *The Elements Of Drawing*! Ruskin does not place the same emphasis on the under-drawing, it is true, and he suggests using a stone instead of a simple still-life, but it is essentially the same thing.

I included this exercise, using pencil, in my book *Basic Drawing: How To Draw What You See*, but, if you have read that and feel you are

going over old ground, think again. That was easy – this is the full-blown one!

Stage one

1. The first step is to set up your simple still-life. You will need three smallish objects. Items like cups, little jugs, plates or pieces of fruit work well.

I try to find very simple objects, with plain decoration. I look for mid-tones, as well – that is not bright white or yellow, or excessively shiny. A handle on a cup or jug would be good, but probably not irregular or decorative edges.

Set them up, grouped quite close together, on a grey piece of sugar paper, folded in half, with one half at right angles to the table, supported by a bottle or book or something, so as to form a background for the objects. The background is very important: it is there to control your view of the objects.

Think back to the viewer mentioned in the previous chapter; everything in the viewer is in the picture plane, so everything must be accounted for. If you set up your still-life without a background you will be looking at objects with a background that you cannot control.

'I'll make it up', you say. 'I'll leave it out!', 'Paint it grey!', 'Ignore it!' But you will not be drawing from observation any more.

Believe me, it makes it much easier in the long run. Make sure that the light source is constant, too.

2. Make a tonal study or studies of the still-life. A simple pencil drawing, looking at the tonal distribution and the placement of the objects.

What you are really doing here is having a good look. You are spending time weighing up which object is biggest, how they sit together, how the light falls on them. Look at the direction of the light first; work from the general to the particular; think about the negative spaces and the shapes that the objects are made of, rather than outlining each object before filling it in.

The set-up – small objects on a piece of grey card, supported by a bottle behind. The lamp is optional, but the light source must be constant. The red parallelogram is the picture plane. You are not interested in the edges of the grey card or anything else but the three objects, what they stand on and what's behind them.

Notice that I am beginning to look at shadows and shading.

Now is also the moment to change things. If one of the objects overlaps the edge of the background, for example, or if something is just too difficult to draw, then move the objects around; prepare the still-life properly.

Do not worry too much at this point about local colour, or patterns or texture, either – just get the shapes and the tonal values. It's all good preparation for …

3. The watercolour under-drawing. Do this on proper watercolour paper. By now you should have a good idea of the shape of the painting, because you will have drawn it already, so lightly draw in a frame on your watercolour paper. These are the edges of your drawing. Now, instead of shading in the lights and darks and using your pencil as a tonal instrument, this time use it as a point, defining the different light and dark shapes

by outlining them. Draw around the edges of shadows and shading – anything that changes. Again, try not to look only at the shapes of the objects themselves but find ways to both break them down – into light, medium and dark areas, for example – and to connect them with each other, drawing the whole group as a single object, perhaps.

What you have after this is what is called an 'uninflected' drawing. This means a drawing without any particular emphasis or any of the things we tend to prize in drawing nowadays – nice shading, signs of emotional commitment or intensity. It is a drawing made for a purpose. This doesn't mean it has to be like a technical drawing or engineering plan, though – it does need to be sensitive to the visual phenomena that it is recording. It has a function – that is to guide you in laying on tonal washes.

I am treating the edges of shadows in the same way as I am treating the edges of the objects – it's like the negative shape exercises.

In particular, watch out for the highlights, the very lightest bits of the still-life. *But remember; don't do any shading at all!*

4. This is because the shading is done with watercolour washes. First, mix a very light wash of a neutral colour. If you are feeling confident, mix a grey from viridian and alizarin, or some other cool tertiary, but you can simply use black with a lot of water. Make a great deal of it. Now, starting in the top left-hand corner if you are right-handed and top right-hand if you are not, apply your very thin wash, all over the drawing, from one side of the frame to the other. The only areas that should not be washed over are the very lightest areas of the drawing. So, if you have reserved the highlights, it is those that will still be white paper when you have finished, and nothing else. This is terribly important. It is the technique that used to be known as 'reserving your whites'.

If you think about it, you will realize that the lightest possible thing in a watercolour painting is the white paper. There is nothing that can be lighter. In fact, even white gouache, which is opaque and will just sit there on the surface of the painting, is the same tonal value as paper.

So, when the first wash is finished, you should have a painting that is a very light grey, with a few spots of white distributed over it.

5. Wait until it's dry, then put on layer two. Use the same mixture of paint (I did suggest making a lot, didn't I?) and this time you are covering everything except the whites that you reserved and the next lightest areas. Go calmly and carefully, and make sure that your wash is nice and even.

After two layers of washes, it looks flat and rather unartistic.

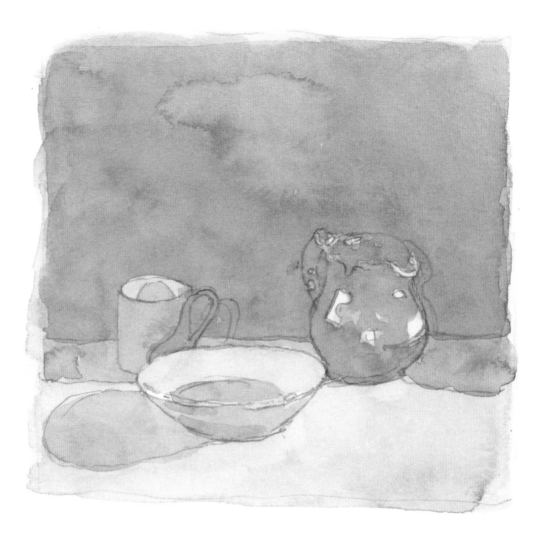

At this point it is quite usual for students to panic and imagine that their painting should look more like a painting. Remember the clay-modelling analogy. You will get there, but you can't expect it to be just right straight away. Don't panic. Keep it light, too – the lighter the colours the better, the more space you have to get it right.

6. Wait until that's dry and then add the next layer. This time it's everything except the highlights, the lightest bits and the next lightest – the mid-tones. You won't be using so much paint now – each time you lay on a wash it will cover less space.

7. Now the next layer. You should be putting on the lower mid-tones now.

8. For the final layer you will be putting on the last, darkest areas, and using only very small amounts of paint. It should 'tie up' the image. If it doesn't, perhaps one more layer?

By this point, the three objects should be fairly convincingly resolved. Your highlights have been preserved and the last few touches will have made the very darkest areas. There should be some good cast shadows – if you have been able to see the three objects as three parts of a whole rather than three different objects you

will have managed to get the tonal arrangement convincingly. Well done. The other thing is that it should still be quite pale.

So stage two should be easy.

Stage two

What you have at the end of stage one is a tonal painting: it should look like a painting in greys. Tone is the best way to see form – in other words, it describes shapes very clearly.

But what about colour? Colour can do two things. One is that it can help to define space, to differentiate one area from another. For example, in this case you might decide to make the objects different from the background, so that their 'objectness' becomes more apparent, by laying a colour over everything that is not one of the three objects.

This is perfectly fine. You are giving information. It may not be the exact colour you are looking at, but are you sure it's very far away from it?

The beginnings of local colour. This is 'carnival ware', and very shiny and difficult. My poor students always complain when this stuff comes out.

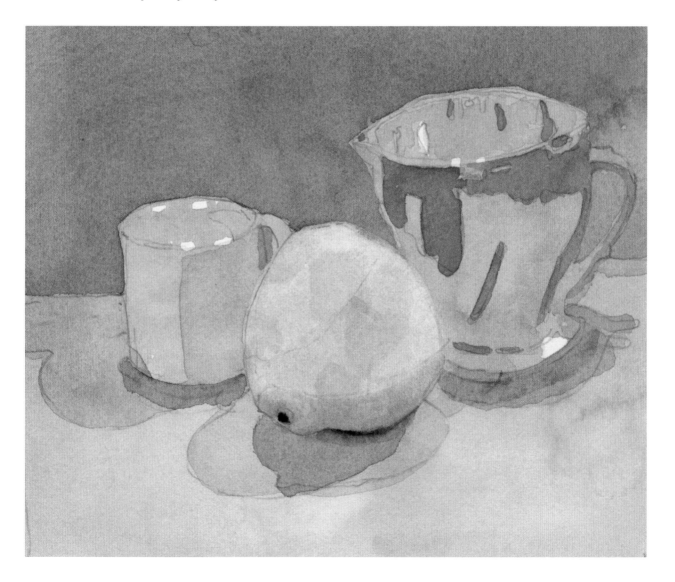

A sheet of two Ruskin
exercises. The lower
one remains tonal, and
somehow flatter. The
colour seems to add
'body'.

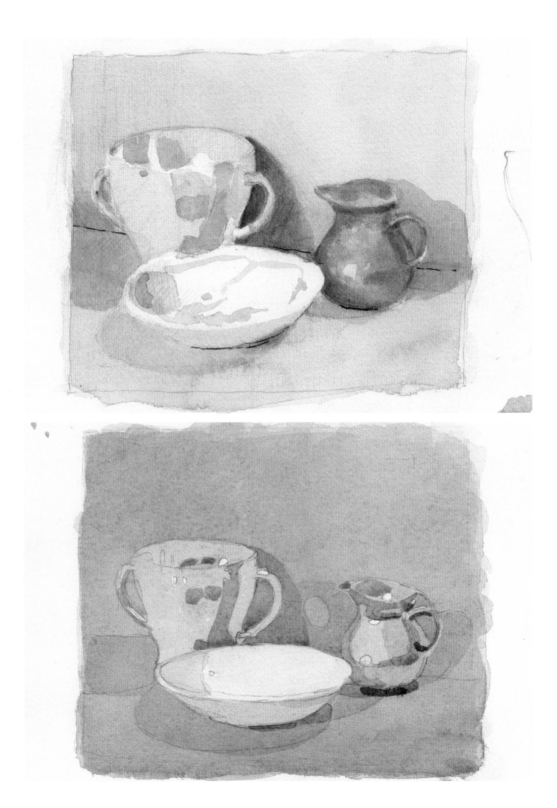

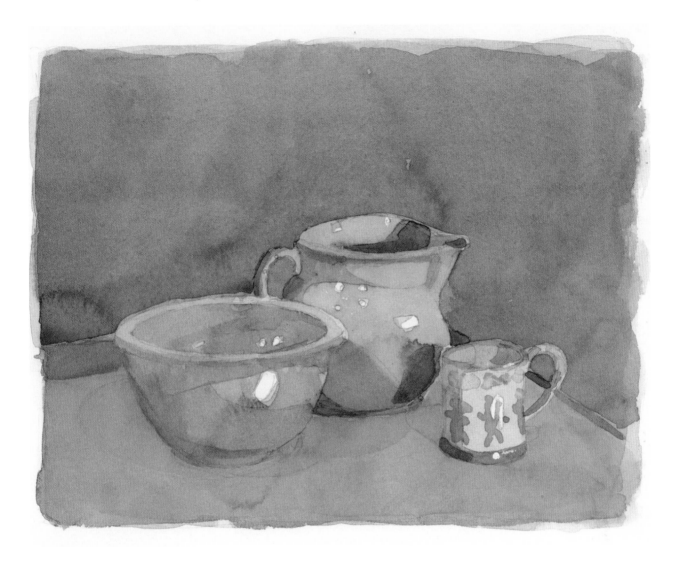

The other thing it can do, of course, is represent local colour. If you have been light enough with the washes, you could lay on colours that at least come close to what you can see. Furthermore, if there is a pattern or design on the cup or the jug, you could lay them on now.

It will be easier now, and more convincing, because you have already made the objects three-dimensional and solid-seeming.

This exercise shows how tone shows form, and how colour can help to clarify it. It also shows how the illusion of space and form is determined by how you manipulate tone across the picture plane. If you have not reserved your whites, or you have left huge areas of white, your tonal arrangement will not be convincing and the image will not work.

This study is, more or less, painted in reds and greens. If you look at the edges of the image you can see the layers that have been applied to get to this point.

85

Both these sheets show the Ruskin exercise in development. Notice the use of gouache in the top ones: in one, the very lightest highlights have been made with small spots of pure white, which bring up the shiny texture of the glazed ceramic. In the other top study, which is not finished, gouache has also been used to reinforce the lightest part of the ground on which the objects stand. This gouache area, when thoroughly dry, can be lightly washed over to add local colour. But be careful: it must be applied very lightly, and care must be taken not to disturb the gouache layer.

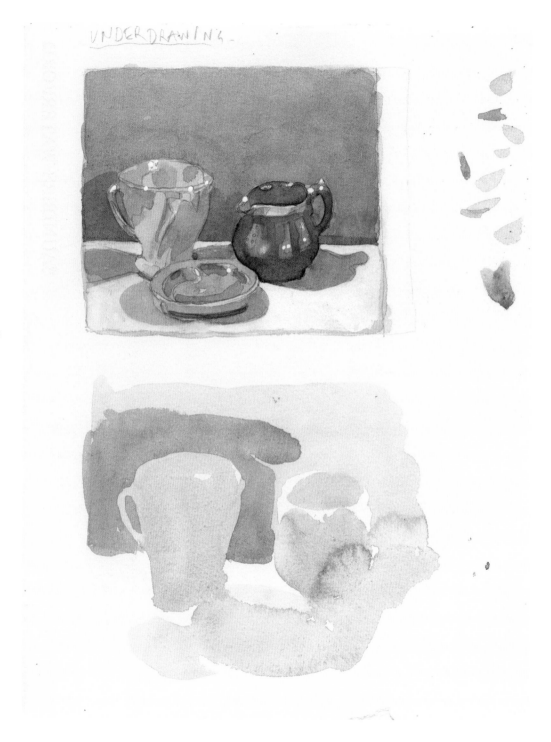

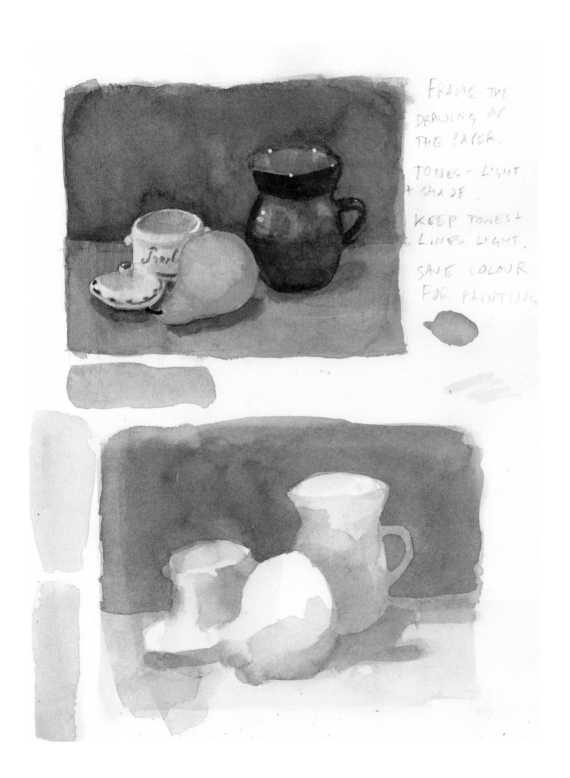

FRAME THE
DRAWING ON
THE PAPER.

TONES - LIGHT
+ SHADE

KEEP TONES+
LINES LIGHT.

SAVE COLOUR
FOR PAINTING

The gouache is used again in the foreground to 'repair' a mistake, and washed over lightly with red, making a pink ground. Shadows will be added later, but lightly – the application needs to be exact, and there is no going back!

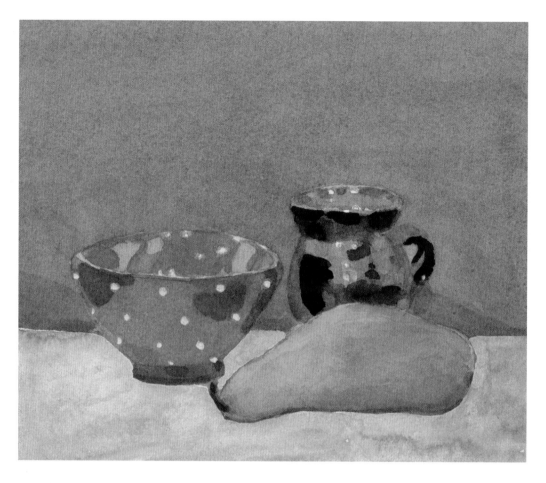

Gouache for the foreground; the light tone bringing the foreground forward.

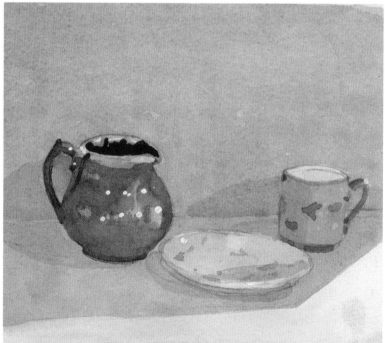

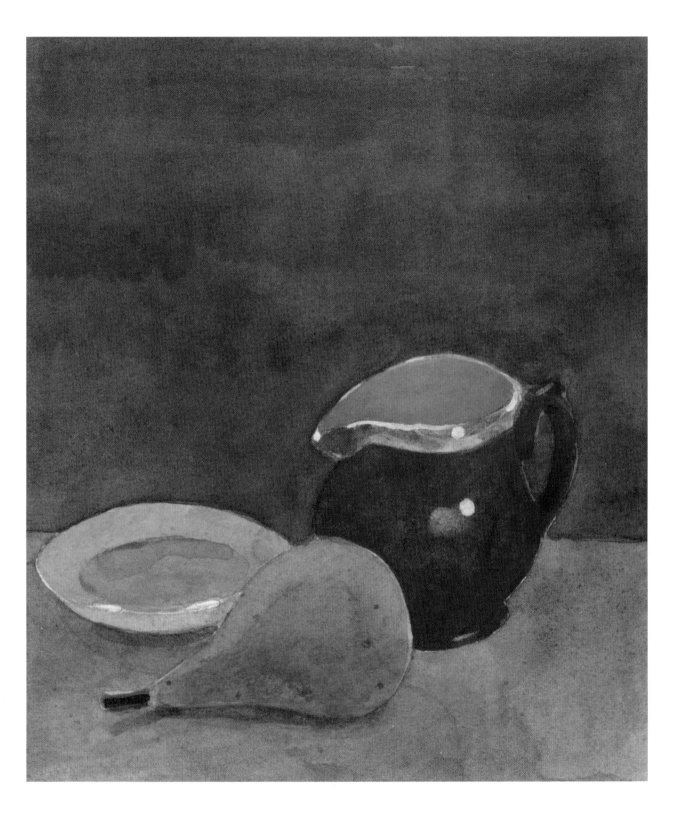

CHAPTER SIX

Landscape

With the Ruskin exercise in mind, it might be a good idea to go for a walk. Take minimal kit with you; a pencil, a small watercolour sketchbook or just a few small pieces of watercolour paper, a jar of water, one brush and a little box of paints, or a couple of tubes, say one black and one yellow – and some loo paper. If you really need to sit, maybe take a folding stool, but it's best not to be too weighed down.

My suggestion is that you find some open space. You are going to be looking at mid-ground and background, and not at all at the foreground.

Foreground, middle ground, background

Foreground is the stuff at the front of a picture. It is often the place in which the artist places 'the subject' of the painting. The painting might be called *Cows in a Meadow* for example, and the cows would be milling about in the front, close to the bottom edge. If the artist is unsure about cows' hooves there might be a bit of grass and so on, and then the frame.

Behind the cows you might see trees bordering the meadow. A greater part of them might emerge from behind the cows' backs, but there may be gaps where you can see the trunks of the trees and perhaps the edge of the field. The trees are in the 'mid-ground' or middle ground.

Behind them is the background, including sky, far-away fields and perhaps even the sea. What an idyllic picture! It is not always as simple as this, of course.

The foreground is often the source of the biggest difficulty; because it is the closest thing in the picture, it has the most detail. It has to be

Grain Across The Estuary. No real foreground at all, which lets you concentrate on the background.

right, we feel, otherwise the rest of the picture won't be convincing. So we worry away at it, forgetting the rest of our composition. The trouble with this is that it's so discouraging.

But go to your local museum and have a look at some old landscapes, and notice how often they leave out the foreground. It's astonishing. Instead of painting in things a couple of metres

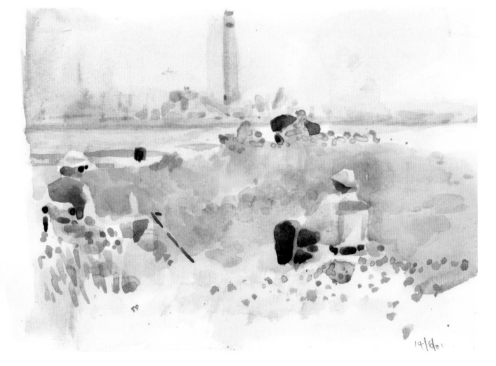

The Isle Of Grain With Artists. A little sketch made on site. You have foreground, which is the artists sitting painting; mid-ground, the vegetation; and background, which is the landscape and power station.

7/6/01

away and then working up, they will start twenty, thirty, fifty metres away. Not the fence and then the field, but the other edge of the field, even the next field.

This way you don't have to worry so much – if you can't see detail, you don't have to paint it. You can concentrate on 'atmospheric perspective'.

Perspective

There are two kinds of perspective, linear and atmospheric, and they are both conventions. Linear perspective is the well-known system to give the illusion of space, invented or perhaps codified by Piero della Francesca or Brunelleschi in the fifteenth century, and atmospheric perspective is making space by putting

warm, strong colours in the foreground and gradually fading them out to cool, weaker colours in the background.

I said they were conventions, and conventions they are. There was a purpose to linear perspective – it was to make a coherent, comprehensible system to express the urban experience visually. The straight lines and vanishing points and complex systems to describe regular spaces were developed in order to represent the beautiful, classical building work of the Renaissance.

They were not developed to aid observational drawing, and knowledge of perspective does not help observational drawing at all.

This comes as a huge shock to a lot of people, and leaves many of my students shaking their heads in disbelief. But think of it this

way; say you are going to paint a landscape, perhaps even one with two houses in it, and even a road. There might be a low rise, a field and a hedge on one side of the road, a house in the foreground, surrounded by a few trees and bushes, and, as the road curves away behind the slope of the field, another house in the distance against a stand of trees. Hills in the background. They will be bluish – atmospheric perspective!

How will vanishing points help you here? You don't know how far away the second house is, and can barely separate the side walls from the frontage. The road curves away behind the sloping field, so you can't really use perspective for that, especially where it's hidden behind the hedge. What about the house in the foreground? Well, you might use it to make sure you are the right distance from it, but with all the trees and foliage what you will see of the house in reality will be one or two patches of brickwork or tiles through foliage.

Atmospheric perspective, on the other hand, is quite useful in a case like this. In order to make the house in the foreground come forward in the picture, using warmer, stronger colours will probably help a great deal, and allowing our eye to wander deeper into the illusory space by

Tuscan Hills. The idea was to give a sense of depth using only colour and overlapping, and no linear perspective.

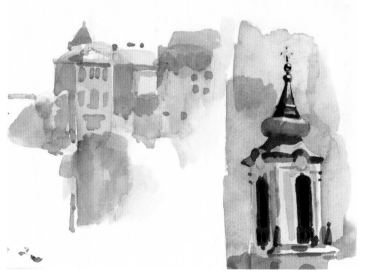

Above, left, right top, right bottom **The Town Hall At Szentendre**, and studies of Hungarian church spires. Using linear perspective to describe form.

gently grading the colours through greens to blues will certainly do a great deal to establish the space.

Linear perspective, of course, tells us that the house in the foreground is going to be bigger than the house in the background. It tells us that things get smaller as they get further away. But the point is, do you actually know how big the house in the background is, compared to the one in the foreground? Mostly, I would suggest, you don't. Not if you've been walking along and you see an interesting composition and you want to paint it.

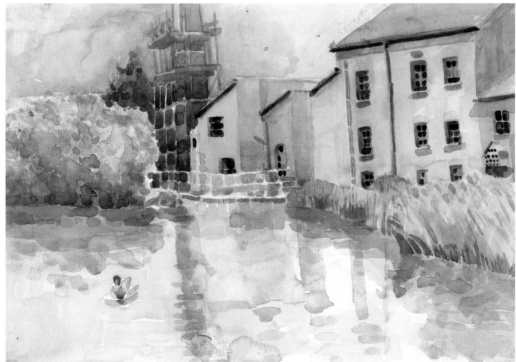

Tonge Mill. Even here, the linear perspective isn't telling you that much. The windows, for example, don't really line up properly. But you get the impression of the old building.

A House On Stalisfield Green.

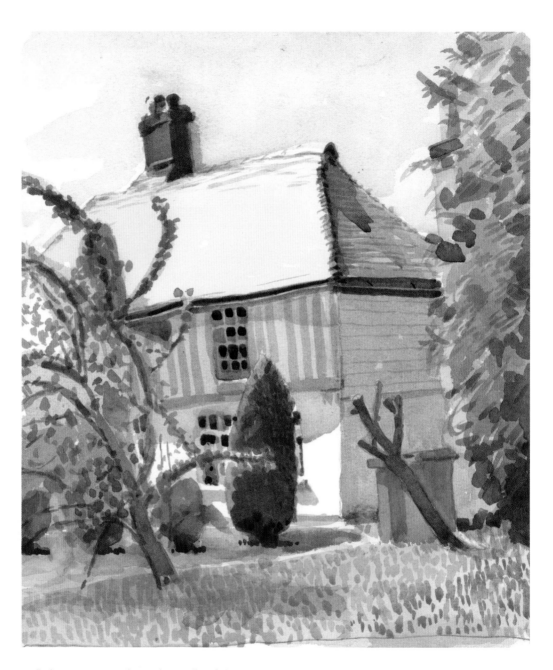

Rules are not much good, usually. If there *is* a rule in drawing and painting from observation it is this; trust your eyes, not your knowledge. Draw what you can see, not what you *think* you see.

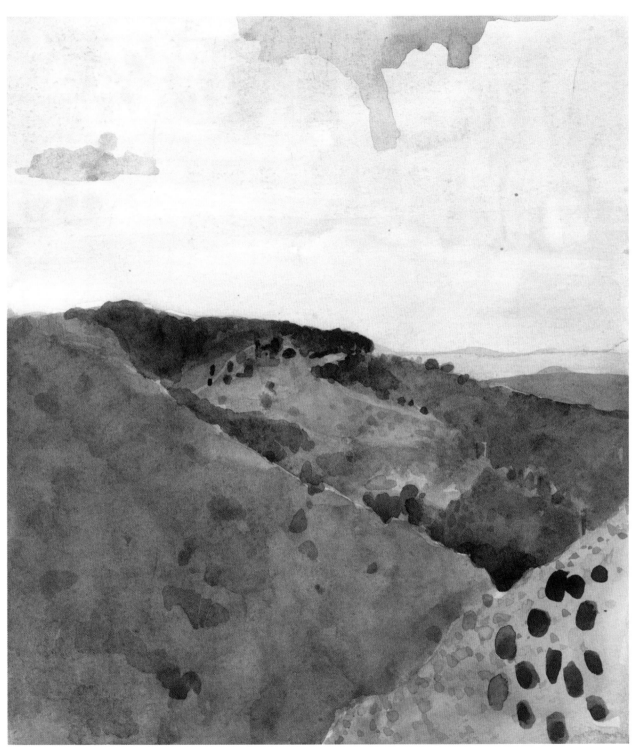

A Tuscan Village in the Hills.

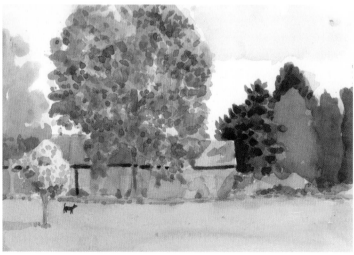

Top and above **Two studies in the Kent landscape:** very simple compositions.

Look around you: first outdoor exercise

Sorry, I have been going on and you are halfway out of the door, with your painting stuff in your pocket.

Look for a piece of open space. If you live in the country that should be easy, but if not, a park is probably the best bet.

Do not worry too much about finding 'a view'. My friend Peter Brown, whose paintings of townscapes and landscapes grace the walls of more houses than you or I have had hot dinners, tells me the secret is not to look too hard. Find something you like, even just a little bit, and start painting, rather than wandering around for ages trying to find the perfect picture. Stephen Moriarty, in his replies to my questions in the final chapter, warns against looking for interesting or unusual angles or views, although this may be advice specifically for architecture.

Anyway, for this exercise you really need a not particularly interesting view, so find an open space where you can see quite a distance, with a change in the background. For example, an open field with a hedge at its furthest side. If you are in a park, a view of open space bordered as far away as you can get.

The exercise is this: use a viewer, which can simply be your thumbs and forefingers in two 'L-shapes', to find a view of the space in front of you, starting say fifty metres away. The idea is that you are starting your picture in the midground. There should be flattish space, then a change, a strip of stuff in the distance, and then sky.

Draw a small rectangle in landscape format, maybe 10 x 20 cm (4 x 8 in), in light pencil. Then mix a very light wash of a neutral colour, a grey or a cold brown, and use it to lay in the stuff in the distance. Do it lightly, and don't be too hard on yourself if you get it wrong. Put this in below the centre of the picture.

Don't try to 'get the colour' yet. Next, look at the sky. Screw up your eyes. You will find that the sky is rarely the absolute brightest thing you can see. Mix up a lighter wash still and, starting

at the top, lay in the sky. You are looking for a general tone, so don't be too distracted by clouds. Now look at your painting. You will notice that the middle ground, which is at the bottom of the painting, comes forward; it gives the illusion of space.

Now, try it again, only this time make the sky a small part of the composition and the middle ground much bigger, by putting the stuff in the distance higher up the picture plane.

And again, with a bigger sky. You might try a slightly different view.

Now you have three different compositional ideas. Spend some time looking at them. Try to keep the self-criticism on 'low' for a while.

One of the points about this exercise is that it

should demonstrate how little you need to make a painting – what a small amount of detail and 'work' are necessary to make a convincing illusion of space. Which is what painting is, in a way.

This page *Studies of Lake Balaton in Hungary*. Simple colour washes making a large space, with swimmers and buoys bobbing in the warm, milky water.

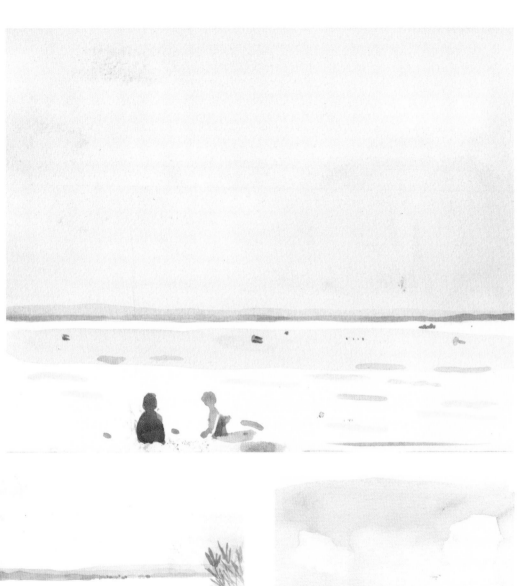

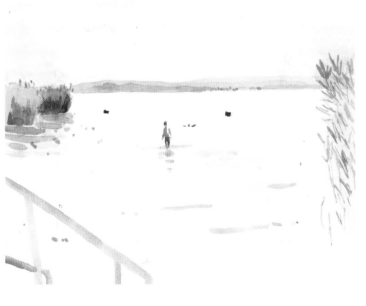

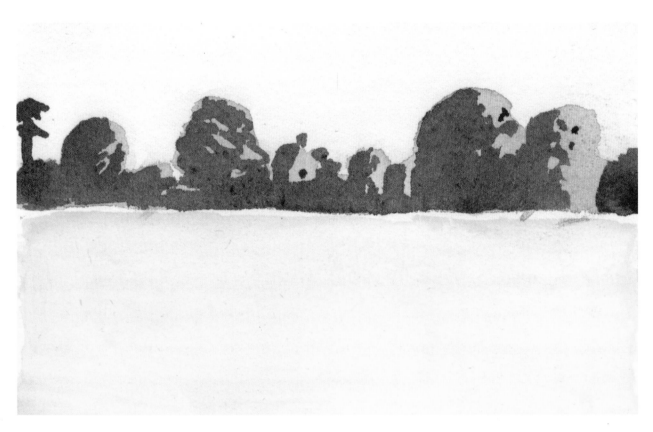

This speculation should have made enough time for the first piece to have dried, and to allow you to go back into the painting. If you make sure to keep your paint thin, and laid on delicately, you might try adding small details to the area on the horizon. Nothing too exact; hint rather than state. Watercolour is a medium that gives best results if not over-worked. That does not mean 'leave patches of white paper', but it does mean do not try to get too much in.

You could go home now. But if you're not too cold and you feel you are getting started, stay and do the next one.

This page The three exercise pieces in their second stage. You could go further: maybe choose one and make it larger and add detail.

This page Two
landscape studies in
Hungary, in the hills
north of Lake Balaton. I
painted these in a
hurry, and I was trying
to get a lot of detail in
– too much, I think.
The sun was very hot,
and insects infested
my watercolour box.

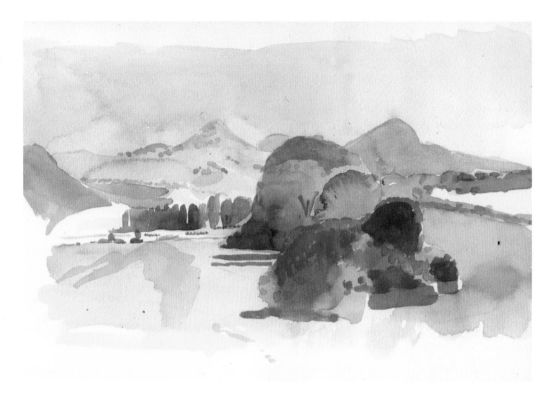

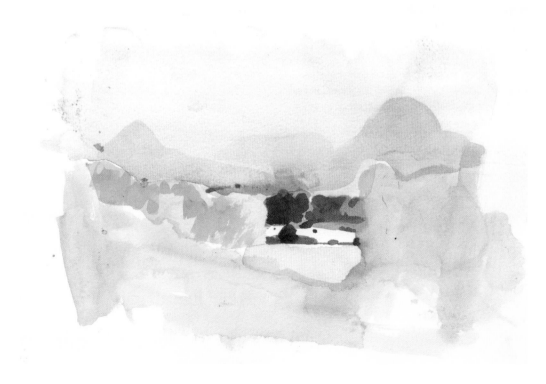

Tree: second outdoor exercise

Find a tree. Again, don't spend too long finding it.

Draw out another frame, this time in portrait format, maybe 20 x 15 cm (8 x 6 in) high. Now, using very thin, grey paint, lightly lay in the overall shape of the tree. You might find this difficult. What I am suggesting is that you analyse the general shape of the tree, from where the roots hit the ground, up the trunk, to the spread of branches and foliage. (If it's winter, best to find an evergreen tree, or one with leaves still on it, by the way.)

A tree is a superb example of an object made up of many different objects. All objects are like that, if you think about it, but trees particularly so. So there has to be a point where you look at the whole rather than individual parts – the bough of the tree, not the individual leaves. In a way, I am asking you to simplify, but not to generalize. Look for the exact shape of the tree. You are flattening the shape, too: while some of the branches stick out to the side and some come forward, you are simply analysing the shape made by the profile of the tree. But you are filling it in too – not making an outline.

It's best to start in the middle and work out, rather than making an outline and working inwards. This should give you a better overall conception of the shape. It helps to keep you aware, simultaneously, of its three- and two-dimensional nature.

When you have the whole shape, stop, wipe your brush and look at the painting.

The aim here is to produce one, flat, lightly laid-in shape, with the trunk and the leaves and the branches all treated in the same way. There should be no gaps.

Leave it at that for the moment.

LOOK AROUND A BIT MORE

Painting from observation is translating the three-dimensional world you see out there into a two-dimensional world on your piece of paper. There is always some compromise and simplifi-

cation. We create the illusion of space in three ways. We have previously talked about linear and atmospheric perspective. The other way is 'overlapping'.

It may seem absurdly simple, but if you look at a child's drawing you will see that it's not necessarily obvious. A child's drawing of a room is often made like a visual list of the objects in the room, spread about the page in a more or less agreeable way, and linked by details from the wall. But the world does not look like that.

Things overlap. You might know, for example, that there are two trees in that field, but what can you actually see, if one is slightly

Tuscan Landscape. Unfinished, but notice how the space is made with one object overlapping another. I painted this one morning before breakfast, trying to get the morning light.

behind the other? In fact, you can probably see a mass of leaves and, if you're lucky, two trunks at the bottom. More often, you can't even see one trunk, as vegetation and detritus have a habit of building up around the base of trees.

There will be something behind the clump of trees though, and something behind that. Remember the viewer you made earlier – there are no holes in vision, no spaces of 'nothing'.

The seventeenth-century artist Claude Lorrain's paintings were all made in this fashion, like stage sets, one plane over another, making a recessive impression. Things get smaller as they recede, and they become obscured. He blurred the edges of his 'flats' with a golden atmosphere, but analyse them carefully and that's what you see.

BACK TO YOUR TREE

Which should have dried by now. You made it in a very light grey, so what you have on your page is a pale, ghostly shape of a tree. Now, adding a little green to the grey mixture, use it to lay in the darkest areas of the tree.

Be honest with yourself. Screw up your eyes and try to work out the darkest patches in the tree, and wash them in flat – don't try to make leaves. If there is a cast shadow on the ground, wash that in too.

When that is dry, you might go in with a thin brush and 'dot' leaves about, to get some idea of the foliage. Don't try to be too accurate.

Pay attention to what is behind and below the tree. How does its trunk hit the ground? Use your thin brush to make that clearer. You might have made a mistake with the drawing – it might be too wide, for example, but use this layer to correct that and you won't notice the mistake later on.

Making sure that, if it isn't dry, then at least the last paint you put down won't connect with this layer, wash in the stuff behind the tree, if there is any. This should help to locate the tree and give it an illusion of three-dimensions.

You might want to stop there.

Mistakes

I should probably have talked about mistakes before you started the exercises above. Sorry.

There are two fail-proof ways of dealing with mistakes in watercolour. One is to ignore them and the other is to dab them off with your loo paper before they dry.

Ignoring them is a pretty good option if you paint in a pale enough manner. Start out with light washes and get darker as the painting goes on and the mistakes you make early on in the process will not show up. The darker it gets the more insignificant they get. The principle operates in the pencil under-drawing techniques as well, as you will see later.

It may also be that the more assured you are

Olive Tree In Tuscany.

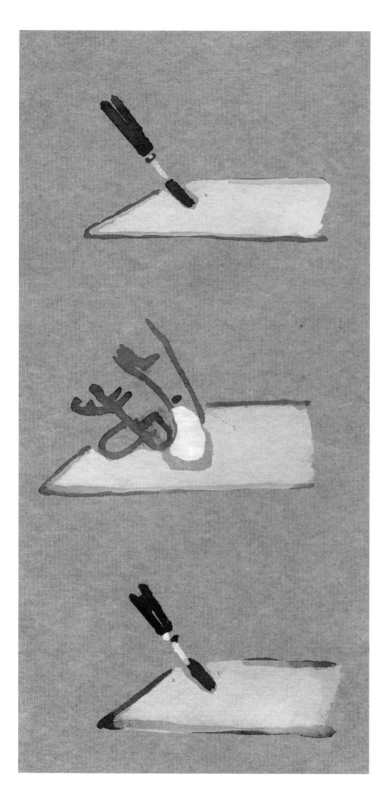

in the painting, the less the mistakes seem to matter.

Dabbing them off is also fine while they are wet, and again, much easier if the wash is very watery. If the pigment content is high then the paper will get stained. You might find that mistakes will fade, dissolve or weaken if you simply rub at them lightly with a soft, wet brush, making sure to keep wiping the brush so as not to put the colour back on.

There are ways of getting rid of mistakes that are dryer or more permanent. The first port of call is to wet the paper, and then, preferably with a stiffer brush, perhaps a hog-hair, gently rub at the surface of the paint. Stop and dab it with your loo paper, and then if it hasn't lifted, more water and more rubbing.

Do not overdo this, though, because you will damage the sizing on the surface of the paper and the next layer of paint will not be crisp and accurate.

Intransigent marks might be removed – it's not an accurate method – by running the offending area under a cold tap and gently rubbing with a soft brush.

WHEN IT ALL GOES WRONG

For more drastic revisions, put the paper in the bath. It should really be cold water, and it needs a bit of a soak. When it is saturated, use a soft brush to lift off the colour while it's still submerged. If you have bought nice expensive paper, and use cold water and brush off lightly, it should be okay – it won't be white, but any image that's left will be a ghost of its former self and you can dry it as I recommended in Chapter 2, between two boards with a lot of newsprint, and paint on it again.

Use a brush to flood the offending area. Then gently dab it off with loo paper. If that doesn't work, return with the brush. Gently urge the paint off with the tip of the brush, and repeat with the loo paper.

Don't use the hot tap!

Hills above Lake Balaton. I haven't finished this yet, but notice how the foreground, which is a vineyard in spring, comes forward.

Last exercise

Before you head home, look again at the tree you were painting. Using your viewer (and remember, it can just be your four fingers, or it could be two L-shaped bits of cardboard, or some kind of frame), try to arrange the view so that the tree goes to one side of the picture plane, and acts as a kind of 'stage flat', with the rest of the scene receding behind it, and paint it in a very small scale – a 10 x 15 cm (4 x 6 in) frame, roughly. Don't spend ages measuring and ruling; just lightly pencil the frame in, and then, using a very thin grey, start with the stuff on the far edge of the field, and then a blob for the tree, and then the sky. All lightly done and leaving the foreground, which is really the middle ground remember, until last.

I hope that you have enjoyed this session. I have deliberately given exercises for quite simple paintings, in the hope that a little success might spur you on. In a way they are simply an extension of the idea I suggested in Chapter 3, where I painted a wash with just dirty water, to show how much one can suggest with how little.

Two studies done on a beach in North Cornwall in a small watercolour sketchbook. We'd walked a long way to get to this stony, windy beach, with its crashing, hissing surf. The air was full of salt water, spraying up around us. I could only paint it in this dotted way; it seemed the only way to make that twinkly, wet light. We thought we saw the head of a seal above the waves, for a second. Then it was gone – if it was ever there at all.

Budapest From The Gellert Hill.

The key points here are not to get too detailed; to work out what's going into the painting before you start; to pay attention to how a sense of space is suggested, with linear and atmospheric perspective and overlapping; to keep your paint as thin as possible for as long as possible; and not to get too worried about detail.

Detail is for later ...

Garden

In the previous chapter I suggested you use a broad technique, and concentrate on large areas within the picture: starting with the middle ground and working further away meant that you were able to avoid detail and look at broad areas. Painting a tree by looking at its overall shape, using very pale grey paint, and then going in with detail gave a method of working from the general to the particular – you work out where to put the detail and at what scale to do it before starting to focus on it.

In this chapter I will go a bit further into ways of using watercolour to draw with, and into how to deal with the foreground.

Drawing with a brush

The trouble with the word 'drawing' is that it is used to mean several different things. For a lot of people it is 'the thing done with a pencil'. This is why, when I started at Art College, I had to use charcoal – its blunt edges are hard to control, and it smears and breaks. You have to be

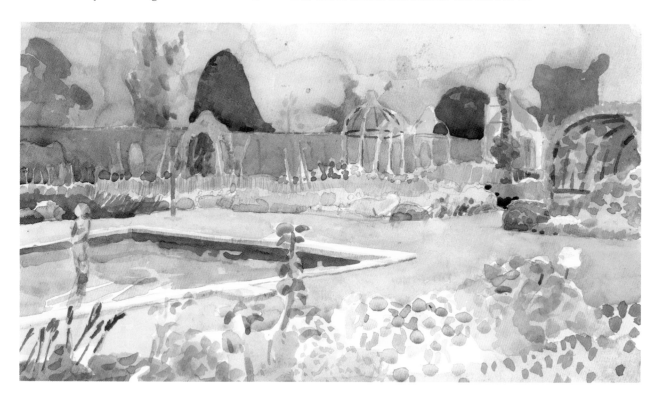

careful not to smear it, and you can't really rely on lines to make your drawing. This makes you reconsider how you represent what you see in front of you, and what the whole point of 'drawing' might be. It's a useful thing for an art student to go through.

This chapter is about using the brush to draw – not making a pencil drawing and then filling it in. I find that the hardest thing in teaching people to draw is to get over their preconceptions about what good drawing might be, and what value their own, sometimes faltering but often quite acutely observed, first attempts might have. It seems to me that an honest and direct approach to describing the objects and space in front of you is the best possible start, and that just 'getting it down' and trying not to be too self-conscious or self-critical is always going to advance your ability. Worrying about what other people might think or comparing it to the work of slick professionals is just pointless.

Cultivate your own garden, as Rousseau might have said.

Getting started

You don't *have* to have your own garden – a garden is good; but you can probably find a relatively private place out of doors somewhere. What I am suggesting essentially is that you find a spot where you can see foliage and greenery quite close to, with a bit of space behind, and where you will not be disturbed. You can, however, take more kit, if it's your own garden.

For this you will need a small round brush as well as a larger one.

Begin by finding a spot with a good view. Use your viewer, which by now will be your two hands or, indeed, just your eyes, to make a composition that includes some shrubbery or foliage in the foreground, some space in the middle ground and something else of interest; a fence in the distance, another bush perhaps.

In this scenario the foreground, middle ground and background might well be much closer to each other than for the landscape exercises – unless you have a massive garden. (If the latter is the case, you might be interested in

The Allotment.

buying one of my paintings to decorate your large house. Look up my work on the internet. It is sure to be a good investment.)

Work out what constitutes the fore, middle and background. You will notice that the objects in the foreground are larger, more clearly defined and possibly brighter or stronger in colour than elsewhere. If you are painting a rose bush, for example, you will notice that each leaf and flowerhead is distinct – in the background the leaves and petals seem to merge into general shapes.

Establish where your edges are, where your picture plane begins and ends. You can do this with a thumbnail sketch, a small study in pencil. This will give you an idea of the composition.

THUMBNAIL SKETCHES

It often helps to make several thumbnail sketches first: small studies, perhaps 5 cm (2 in) across, to establish where things will go, but not to attempt any kind of resemblance.

Use the pencil to outline each general shape, and see how they all interlock; the bush in the foreground overlapping one in the middle ground and so on. Keep the pencil sharp, and try different shapes for the painting – portrait format, square, landscape format. This is a good way of not painting things you find frightening.

When you are happy, or as happy as you will be, lightly pencil in the edges on some watercolour paper. Start with a painting at least 15 cm (6 in) in size in one direction.

This page A series of studies made before embarking on the final piece *The Allotment*. Paul Newland will work from life with the studies and complete the larger piece in the studio, using the studies and his memory. For more details on Paul's methodology, see Chapter 11.

MOVE CLOSER - BOX GOES
FURTHER DOWN THE
PICTURE PLANE

BOX WITH SHED BEHIND

COMPOSITION

Composition is how you compose the different elements across the picture plane. What goes where, in other words. There are many ideas, theories and rules about composition, but the best one is this; if you want to put something in the painting, make sure it is in the painting, and if you don't, make sure it isn't.

I have developed this theme elsewhere; compose your view so that the things you want to paint are visible and the things you don't want to paint are either hidden from view, or seen from an angle that makes them easier to paint.

For example, if you are quite happy about painting foliage but the whole idea of painting the garden shed makes you feel ill, get in a position from which you cannot see the shed. If that

is impossible, try this – move so that what is difficult about painting the shed is no longer visible. This might be that you find perspective difficult. Seeing the shed from a position where you can't see the top of the roof or the part where it meets the ground will turn it into a patch of texture, a flat area that is much easier to paint.

The absolute no-no is to 'just leave it out'. Your artistic licence has not been issued.

No going back

Now, mix up a thin grey wash again. You can do this with ivory black, or mix viridian and alizarin, but you need a neutral grey, neither hot nor cold, but leaning to the cold side. It must be very watery.

Notice how I have used a red to pinpoint the geraniums – it's a thin red, and I could alter it if it turns out to be in the wrong place.

I begin to add local colour to differentiate one area from another.

The next step calls for a bit of a leap in a lot of people's imaginations. Use a small, round brush to draw your view, but do not use it in a linear way – in other words, not like you have made the thumbnail sketches. You are not trying to separate one shape from another, but rather to imitate the textures, and the tones across the picture plane.

You can use your loo paper to correct, but I would advise not doing that too often. Don't be too self-critical.

One of the things you may find is that the brush, and the thin wash you are using, will not be quite sharp or dark enough to represent what you see; the tonal range will be very narrow. This is fine.

TONAL PAINTING

Now, bearing in mind the Ruskin exercise and the tonal ladder you made in Chapter 4, continue the painting as a tonal drawing. You are using the paint as if it were graphite, gradually darkening the tones. You will find that the tonal arrangement gets more and more satisfactory as the process goes on.

At a certain point, though, the image will be finished, and it will be time to add colour. This is the point where the darks start to emerge, as they did in the Ruskin exercise, sharply and clearly.

The next step is to add colour, but wait for it … let it dry before bashing on. It's a good idea to have several paintings on the go, so perhaps you should start another, looking in a different direction.

ADDING COLOUR

The next stage is much as you did with the tree in the park in the previous chapter, only this time a little more closely detailed. Remember negative shapes – rather than trying to paint light objects, paint the darker areas around them. So, in painting bright green leaves and stalks, it is best to paint the darker space between the stalks and leaves and let the washed-in shadow bring out the brightness of the foliage.

Colour builds up – but notice the deepening of the tonal range. This increases the sense of space.

Do not try to reproduce the colours you see straight away. It is almost impossible, but if you have a strong tonal structure you will have a solid base to build up from. The colours will emerge gradually. Build them up with layer on layer. Use them lightly, and try to mix by layering the colours – for example, instead of mixing a green, wash a transparent yellow over the tonal structure, and look at it to see what kind of colour it makes. It will probably look green – yellow and black make a kind of green; yellow and grey may do too.

Try to work out what particular green it is you are looking at – is it a bluey green, or a dense green, is it very dark? – or sometimes green can be almost luminous with light coming from behind. Work out, just by looking at it, what colours will bring out these qualities.

Painting is a contemplative business. Enjoy the challenge – this colour against that, that texture against this. You are out of doors, the birds are singing, it's all very pleasant.

KEEP GOING

Or stop. You should really be looking for two things. The first is, does the painting make a convincing illusion of space? In other words, does it look like a place, a bit of a garden? Not necessarily this particular one, but does the overlapping of forms and the linear and atmospheric perspective do its job? The stuff in the foreground should be sharper and more distinct than the stuff in the background; there should be forms and shapes in the front of the picture that overlap forms and shapes in the middle and the back of the picture – and no arbitrary areas of white.

Secondly, the individual forms, the leaves and flowers, the details, should be convincingly made. You don't need photographic reality, but something approaching what is there. Look for cast shadow and shading.

You don't really need to look for exact colour reproduction though. We will look at that later.

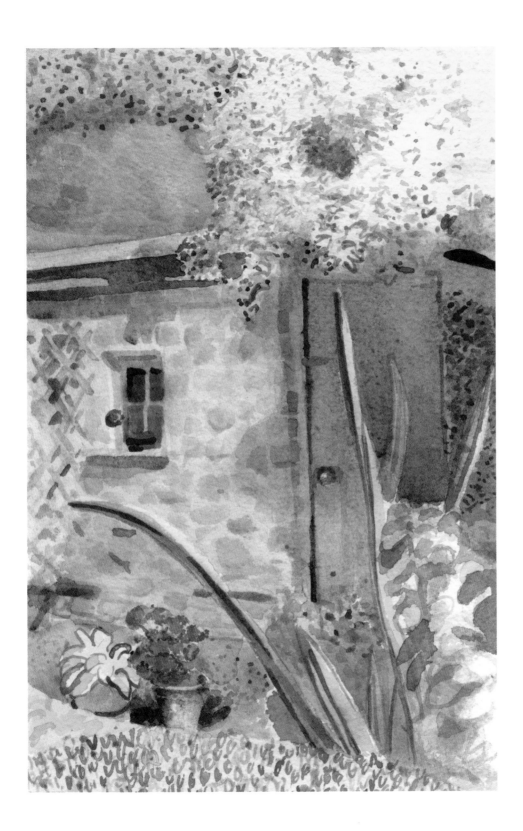

Corner Of The Garden.
The last stage: colour
and tone working
together.

Still-life

In this chapter I would like to explore drawing for watercolour a bit more. The point of the Ruskin exercise was to explain the way tone works in painting, and the previous two chapters have been about exploring the use of colour in a very limited way; building up tone first and gradually adding colour.

The Ruskin exercise also introduced 'watercolour under-drawing', which is a classic technique for watercolour, although it is quite difficult to use in direct painting.

There is another way to use drawing, and that is the old-fashioned, pencil drawing in tone, which is then painted over. This is a perfectly valid technique, and one I have used many

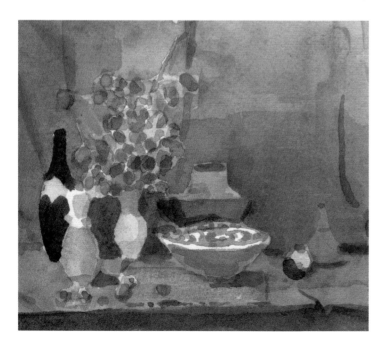

times, but it does go against a particular idea about watercolour painting, which is that it should be immediate, fresh and simple. It's a reasonable objection and, as I have said before, a few simple washes just coming together to make an image can be wonderful – but sometimes the sureness that comes with a well-realized tonal drawing can result in a freshly applied layer of paint, too.

It may work best for you. So far, I have deliberately given exercises that make you use watercolour for tone first, so that you see the capacity of watercolour, and also to make the point that 'drawing' is not 'the thing you do with pencils' but *how you represent form,* which is much more important and something you can do with more or less any image-making technology, from a piece of charcoal to a piece of drawing software. Now I would like you to concentrate again on drawing, and consolidate your ideas about it.

Still-life is excellent for this kind of work. It doesn't move, for one thing, and you can control the light and the background, and you can choose what goes in the picture and how it is arranged.

Setting up

Choose a group of up to six objects, and I would go for objects that you are not too intimidated by. If you want to give some wildly coloured and textured things a go, then by all means do, but remember, it's you that's painting them, not me.

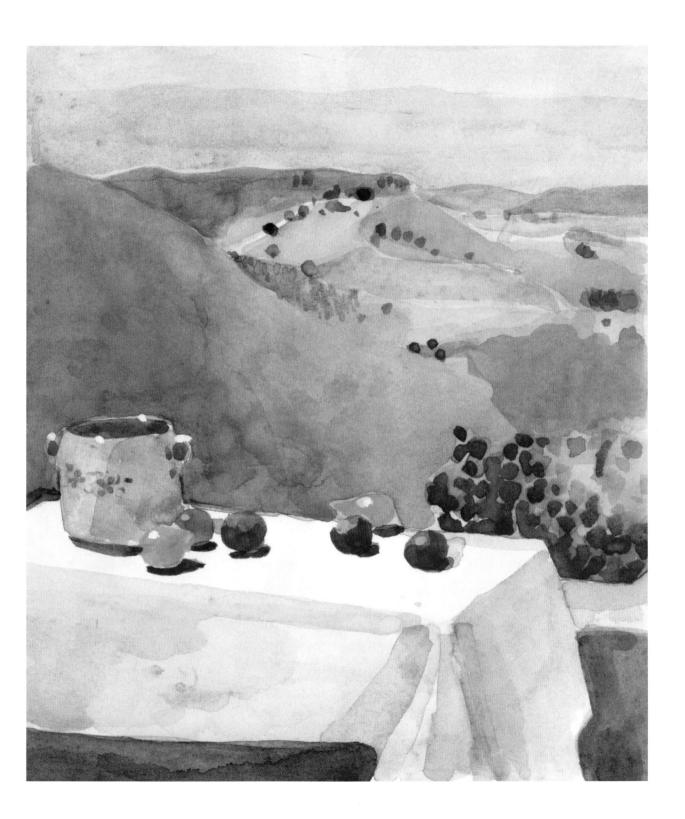

There is a tendency to suggest that people use objects that mean something to them, that have a personal significance, but I would go for the opposite. You don't want any other considerations here than 'What does it look like and how do I make it look like that?'; we don't want tears over our inability to render an object of special sentimental interest. You are learning to draw. On the other hand, you need to be engaged by the subject.

Set up the objects in a spot that will not get disturbed.

Next, consider the background. I would suggest that you use a very plain, simple background, making sure that it is big enough to extend over the entire picture plane. You do not want to be dealing with irrelevant edges and corners. Try a large sheet of grey cardboard, or a sheet of hardboard. If you don't like the colour, paint it in emulsion or pin some cloth over it. I recommend a neutral, grey background, rather than a strongly coloured one, or a white one, which will confuse you.

THE ISSUE WITH WHITE

The colour white is a very good example of how important it is to see clearly, without prejudice, and how difficult.

This demonstration works best in the daytime. If you are inside, and have white-painted window frames, look at them carefully. What colour are they?

White.

What colour do you see?

White.

You don't. I can prove it with the Local-Colour Lollipop. The following is from my book *Basic Drawing: How To Draw What You See* and if you haven't read it yet, it's very good – many copies still available.

Take a grey piece of card, and cut it into a circle, about 15 cm across. In the middle, cut another circle, making a hole about half a cm wide. Then, get a lollipop stick and tape it to the bottom of the card, to make a handle. Closing one eye, hold the (Local-Colour) Lol-

lipop up in front of you, to isolate a small bit of the objects you are drawing. For example, if you are drawing something on a window ledge, use it to isolate a patch of the white-painted window frame. You will see it's not white at all.

You don't need to make a (Local-Colour) Lollipop, of course. You could just cut a small hole in a bit of grey card, like the backing of a block of paper, and hold that up, or even simply make a little hole between your fingers, but it's nice to have another useful tool in your kit!

So, looking through the little hole, either between your fingers or in your Local-Colour Lollipop, you can see the colour isolated and you will see that it has been strongly affected by the quality of light. I said it works best in the daytime, but you might need to convince yourself that the yellow light of our light-bulbs makes what it touches yellower.

Look at a white-painted wall. Look at the whites of someone's eyes. Look at the white lines down the middle of the road. They are all different versions of white and most are not white at all. Most are a kind of grey.

I taught Fine Art in a Further Education College for a short while and I remember saying to a young female student who was painting her best friend 'You know, the whites of the eyes aren't actually white' and she answered 'Yes they are', and I had to walk away. Sometimes the struggle is not really worth it. I had no Local-Colour Lollipop, but I think she would probably have denied it even if she had been actually looking at it.

You believe me, don't you?

CHECKING YOUR VIEW

You have chosen your objects, and you have set up the background so that you are not having to make anything up (you remember about not making things up?). The plane on which the objects sit has been taken into account – perhaps another sheet of grey cardboard, or a sheet of paper. The objects get

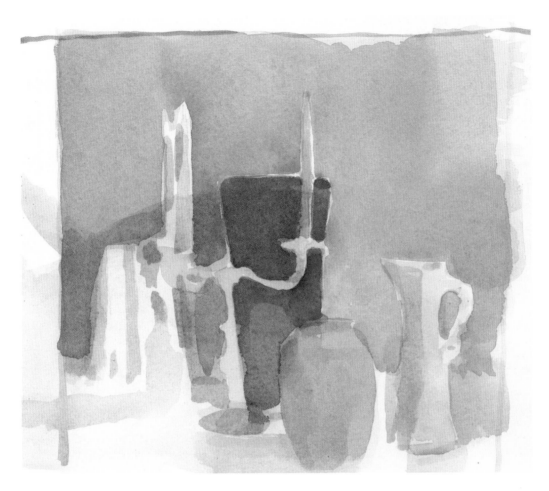

shuffled around to the point where you are happy to draw them – nothing that you know is going to appal you or be so difficult that you will want to leave it out (you remember about not leaving things out?).

LIGHT
You will be drawing for a while, so it might be a good idea to consider the light now. If it's late in the day and the natural light is going to change, then you should set it up so that you are not too badly affected by it. Do this by fixing a reading lamp or spotlight so that it casts a strong light across the set-up.

If it is mid-morning on a relatively still day, there will be no problem, but it is important that the light remains stable.

YOU AND YOUR KIT
The next thing is your sitting arrangement. First, it's important to be comfortable. Sit at a good angle. You must be in the same position for some time, with your eyes at the same level every time you look at the still-life arrangement, so don't slump or lean, because you will find that a relaxed pose does not stay relaxed. Also, leaning makes it harder to be sure that your head has returned to the same level if you move it.

Either have your paper on an easel or on your knees, but make sure it is tilted or sloped down towards you. It is best that the paintbrush takes the shortest journey possible, so have all the things it needs to be dipped into on the same side, which should be the side of the hand in

which you are holding the paintbrush. You could put them all on a little stool or a low table.

All much more comfortable than going outside, isn't it?

Make sure you have your brushes, your water in a large jar, your loo paper, your paint and something to mix the paint on. But before you use all that, you will need a 2B pencil, an eraser and a craft knife to sharpen your pencil with. A 3B and a B pencil might be useful, too.

Sketching in pencil

First, make sketches – examine your subject with rough sketching, moving ideas around on a piece of paper. This drawing is for your benefit only, so don't worry about whether it's presentable.

The aim of this exercise is to make a tonal pencil drawing of the still-life arrangement, and then add thin washes of paint over the top to colour the drawing. The more paint that goes on, the less you will see the drawing, and the more like a painting it will become, so it is imperative that the pencil doesn't intrude too much; use it lightly. You may remember that I suggested earlier that 2B or 3B pencils were the most appropriate grades of pencil to buy, and this is where it matters.

Start by using the pencil to shade in the darker shapes lightly. Resist the temptation to use the pencil as a linear tool, outlining and making measurements, and just use a loose, shading mark to block in dark and light areas. It's like the Ruskin exercise – you are not looking at the individual shapes, but the whole group as one tonal arrangement.

You will make mistakes – that's the great thing about this method. You are able to make mistakes and correct them because you have not spent ages trying to make nice outlines and edges only to find they're in the wrong place. Instead you have treated each shape loosely, and gradually established the shape of the object as you went along.

This is not an easy thing to grasp. Most people feel they need to 'get things right first'. When I demonstrate this technique to students there is always a moment when what looked like a scribbled mess suddenly comes into focus; here's the edge of this cup, that's the bottom of the jug. There is often an intake of breath, 'Oh, I *see*' they say. It's very gratifying.

It looks a bit like magic, but it's not at all. In fact it's the easiest way to draw, once you have grasped it.

As the main shapes emerge, start to make them more specific – go from trying to get the general shape of an object against another to getting its particular shape, but try to keep from outlining or making many decisions about where one object begins and another ends. Always concentrate on tone.

Now, start to put in edges, but instead of outlining each discrete object, remember what I

This page *Cherries*.
This sequence shows
the process at its
simplest. The shapes
gradually emerge and
then the texture, the
shiny surfaces. I could
now just wash a layer
of alizarin over the
group for a satisfactory
painting, because the
tonal structure is set
up nicely. Reproduced
by kind permission of
The Artist magazine.

said in Chapter 4 and try to identify lines that
connect objects. Remember negative spaces and
shapes.

Your drawing should start to take shape.

THE WHITE PAPER

You will not have forgotten that drawing or
painting is adding darkness to an overwhelming
light. When you look around, what you are
seeing is darkness, illuminated by light. Draw-
ing works in the opposite way from seeing.

Your paper is the lightest thing you can have
in your drawing. The more untouched white
paper you leave, the less the objects in it will
look three-dimensional. You don't agree? Nine
times out of ten, a drawing with a lot of white
paper left will be relying entirely on perspective

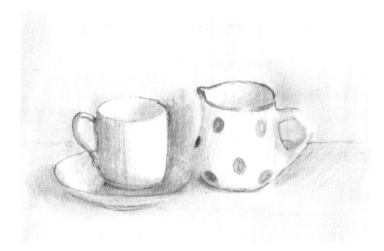

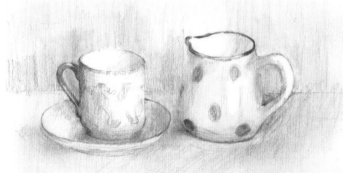

for its illusion of three-dimensionality. That's fine, but we are talking here about a tonal drawing for a painting. The paint will be relying on the pencil for its tonal structure, so everything in the drawing needs to be considered *tonally*. If there is a white area it must be because that is the very lightest bit in the arrangement.

The implication of this is that it must be very clear where the edges of the drawing are: where the picture plane begins and ends.

LOCAL COLOUR, PATTERN

Use the pencil to itemize local colour and pattern, too – don't stint. The more work you can do now, the less the paint will have to do later. But don't go in too hard. You do not want great dark, graphite blobs all over the drawing. You are aiming for a positive but lightly applied, tonal drawing, in which all the elements have been explained.

This page Tea. Notice the local colour and patterning emerging across this short sequence. Again, a light wash would be enough to finish the painting. Reproduced by kind permission of *The Artist* magazine.

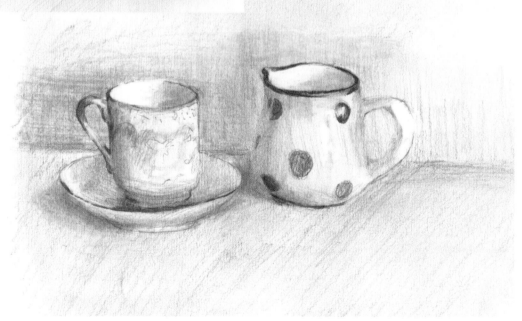

FINISHING THE DRAWING

When the drawing is finished, you can start to lay colours over it. But first make sure the drawing *is* finished.

This is why it is such a long process, particularly at this stage. It is important that the drawing is finished to your satisfaction, and a beginner will have difficulty recognizing when a drawing is finished. Remember, you are not trying to make a heavy, over-worked drawing, but you are trying to make a resolved drawing.

You will develop an instinct about this. Much like the moment in the demonstration when the students say 'I *see*', there is a moment when the drawing seems to coalesce. It may not be apparent to you to start with.

Look at the drawing – you should have every part of the picture plane 'working', or accounted for. There should be no doubt about any part of it.

Painting

Start by isolating large areas of similar colours. For example, the base or ground plane and the background might well be similar in colour, and laying a wash of one, unobtrusive colour over them both will serve to throw the objects in the still-life arrangement into a stronger relief. They will start to look more three-dimensional.

Now, look at the objects themselves. Are any 'like' each other? Are there objects with similar coloration or tonality? Look out for correspondences like this, and lay over thin washes of light versions of the colours you see. For example, a bright solid orange, modulated by shading and with a highlight, might be best started with red in the unhighlighted areas. Later, stronger colours may be laid over.

Local colour may be laid over the drawing; a pattern made by laying thin washes of local colour where the pattern is drawn.

TEXTURE

Still-life is often a good place to start looking at texture and how to describe it. The main thing to remember with texture, though, is that watercolour is not great at describing it. It's a hinting medium; it doesn't respond well to being scraped and bashed about. Not for my taste anyway. A battered piece of paper with scratching and scraping designed to imitate the texture of an old flint wall or clay pots just looks a bit desperate to me.

There are good textural short cuts though.

Toothbrush method. This is a well-known method. Get an old toothbrush, mix a very wet wash and dip the toothbrush into it. Making sure that the areas you don't want the texture on are masked out, hold the toothbrush so the bristles point upwards, and run your thumbnail down them. This should produce a fine spray which results in small, irregular-sized dots randomly applied on your paper. These are great for making cobblestones, beaches, speckled ceramics or a whole world of other things.

Rollers, sponges, loo paper, your finger and more. You can make texture by all sorts of other methods, but the thing to remember, as in all things to do with watercolour, is to keep it light. For example, you can use a roller, as long as you mask out areas you don't want to cover. The packets of natural sponge you can buy at great expense from art material suppliers are mainly useful for making a 'natural' print – remember, they are not the posh equivalent of loo paper for taking mistakes off. (Although I have come across a 'magic sponge' that is used for that purpose, it was man-made sponge.)

Loo paper will take paint off, and that does produce a nice, uneven, natural texture if worked on. You can use your fingernail to scrape through a wash to make lighter lines, and the point of the brush handle can be used in a similar way. There are many ways of mishandling watercolour paint. The structure of this method of drawing and then painting over might allow you to experiment with the textures within the group of objects.

But all of this experimentation is only a substitute for looking hard and trying to record visual phenomena carefully and exactly. The danger is that you get carried away with your textural experiments and stop looking.

Being careful

This pencil/watercolour process looks easy. In fact it is. What you are doing is painting according to a rigid system – first the tonal drawing, and then the build-up of colours. The disadvantage it has over the looser techniques I have described so far is that you have to make up your mind about the drawing, which is another way of saying 'the form', before adding the colour, and if you notice that you've gone wrong in the drawing you cannot go back and change it, because erasers do not work through layers of paint.

Another disadvantage is more psychological. If you use a rigid system like this the temptation is to lose concentration. While the other methods keep you guessing until the last minute – 'Will this wash do the trick?' 'Will it be dark enough to suggest the space?' – this method produces a satisfactory tonal result, which you then 'colour in', and the colouring-in part might seem easy.

It isn't. The more paint that goes on, the muddier the painting gets – if you get too definite, or too heavy-handed, the colouring-in risks contradicting the tonal structure beneath it, and flattening the image out.

It's easy to make this mistake. You have to keep your eyes peeled for the moment when you don't need to add any more paint at all. Then you're finished.

STOP – LEAVE IT

It's always a good idea to do two paintings at the same time. But even if you haven't done that, the trick is to know when to stop, get up and go and do something else. You could go away for a long time – turn off the lamp, put the still-life stuff back on the shelf and go and have supper before watching a film and going to bed – or for ten minutes while you boil the kettle, grind some coffee beans, make a coffee and drink it in the garden with a biscuit.

Or, if you have another painting started, get on with that. But don't look at 'the' painting for a while.

When you come back to it, the painting will look different. Sometimes you will know exactly what to do next, and sometimes you will be utterly frustrated, in which case put it away in a folio or a drawer.

What you do to finish it might be to add a couple of dark spots that pull an object down on the floor plane, or it might be a light, cold wash to separate one half of the painting from the other. But it will have to be subtle, because you are right at the end of the painting and the time for large-scale changes is over.

Remember – if in doubt, do nowt. And if you want to get it right, keep it light.

In summary

Still-life is an excellent way to approach painting. Richard Pikesley RWS NEAC advises that if you have difficulty choosing a subject or making a composition while in the landscape you might try looking for still-life arrangements in the landscape itself – a gate for example, or a particular clump of vegetation. The rest of the painting is what is behind or around the still-life.

You might set up a still-life in the garden, and include the view behind, or set up in front of a window. Or 'go macro' and paint a group of tiny objects, investigating their different textures and forms. Or paint the corner of a room. It's all controllable, private, and you are left to concentrate on the painting itself. William Nicholson, one of my favourite painters, painted the most excellent still-lifes, as did Chardin, Braque, Morandi – it's a wonderful tradition.

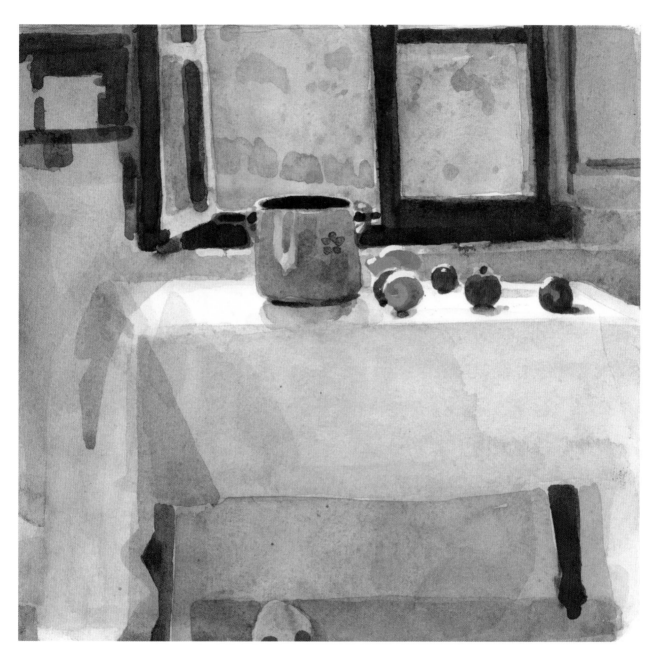

*Tuscan Still Life Before
The Window.*

A corner of a room
still-life. I painted this
as a demonstration in a
class, and just carried
it on. The next painting
shows how many
layers of washes are
involved.

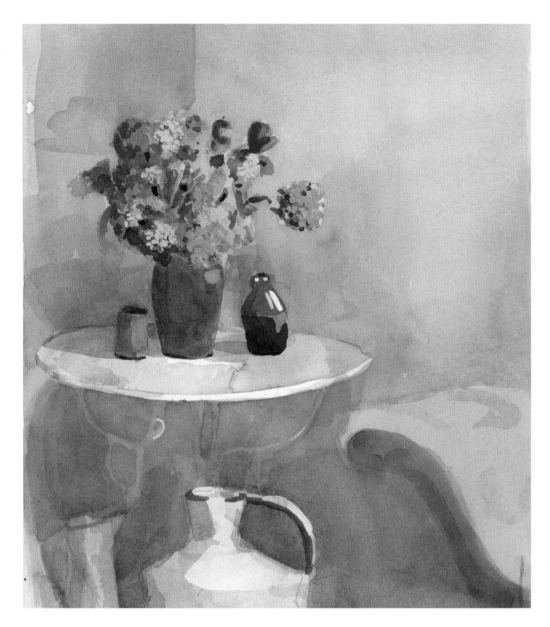

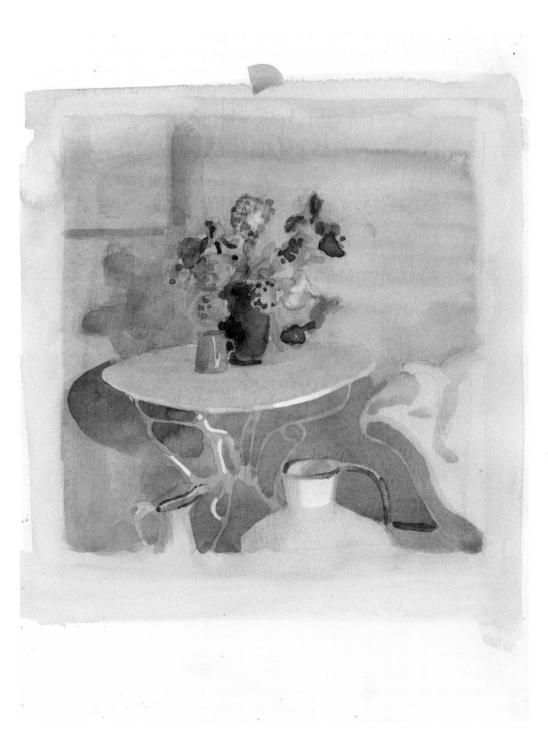

Each wash serves to separate the background from the objects, or to bring out the shape of the table. They are thin washes, as you can tell from the edge of the image. I have also used small, diluted areas of gouache, but not in the legs of the table – they were just carefully left each time the wash went on.

The following small still-life arrangements show the use of gouache more clearly.

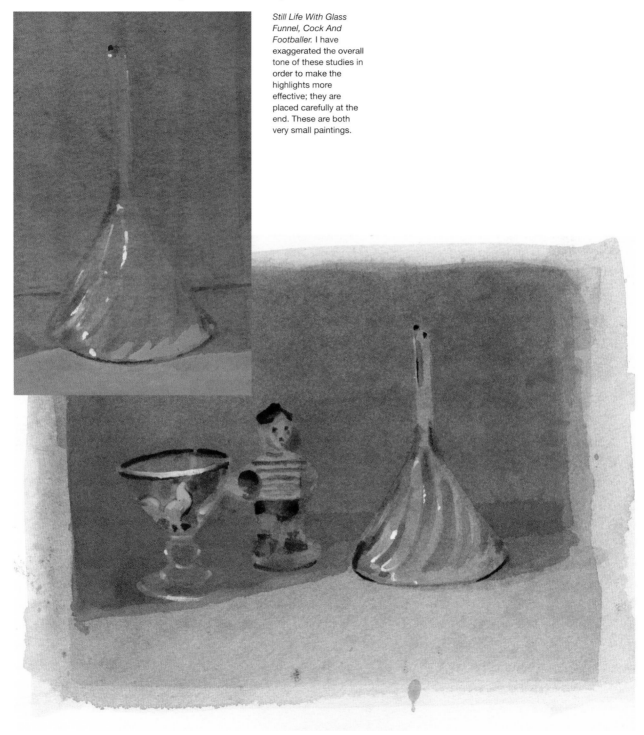

Still Life With Glass Funnel, Cock And Footballer. I have exaggerated the overall tone of these studies in order to make the highlights more effective; they are placed carefully at the end. These are both very small paintings.

This is small too –
painting glass is
daunting, but actually
simple. If you follow
the guidelines I have
suggested, you should
end up with a clearly
defined idea of where
the lightest bits are,
and that is the key to
painting shiny or
transparent objects.

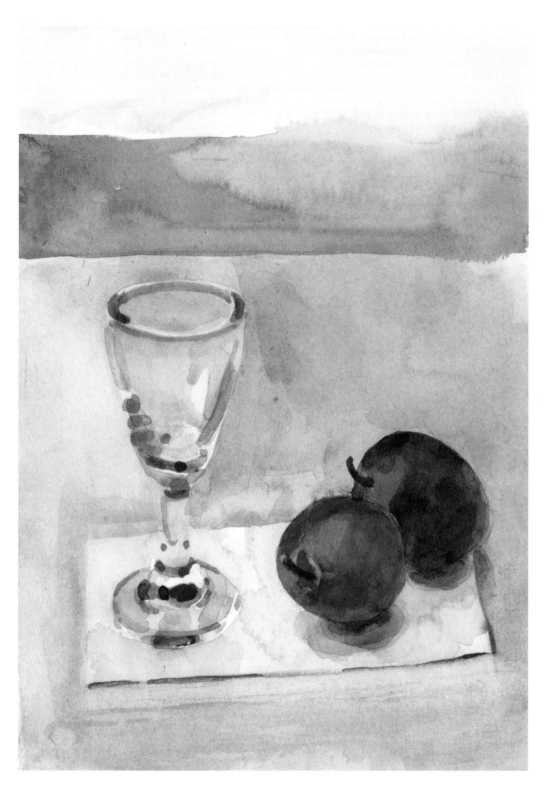

Figure and Portrait

Painting people is what I do, mainly. I would like to paint landscapes and still-lifes – actually I'd like to paint abstract paintings – but I can never seem to find enough interest in them. When I decide to give other things a go, I set out to do it in all good faith, but I always end up feeling the whole thing is somehow wrong.

I spent a long time in the life-drawing studio at the Royal Academy Schools when I was a student, and before that I got my friends at Art College to sit for me. I draw my friends, passers-by, people in cafés, my wife, my 9-year-old nephew (he can't sit still long) and my niece, his twin (she can, if I pay her).

The year before I wrote this, we went on holiday to Hungary, where my niece and nephew

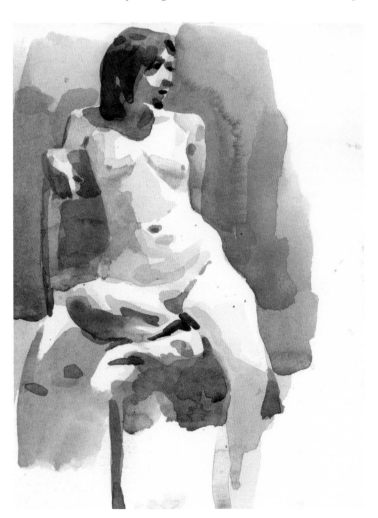

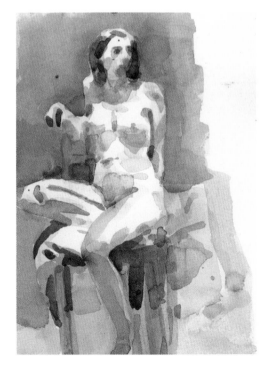

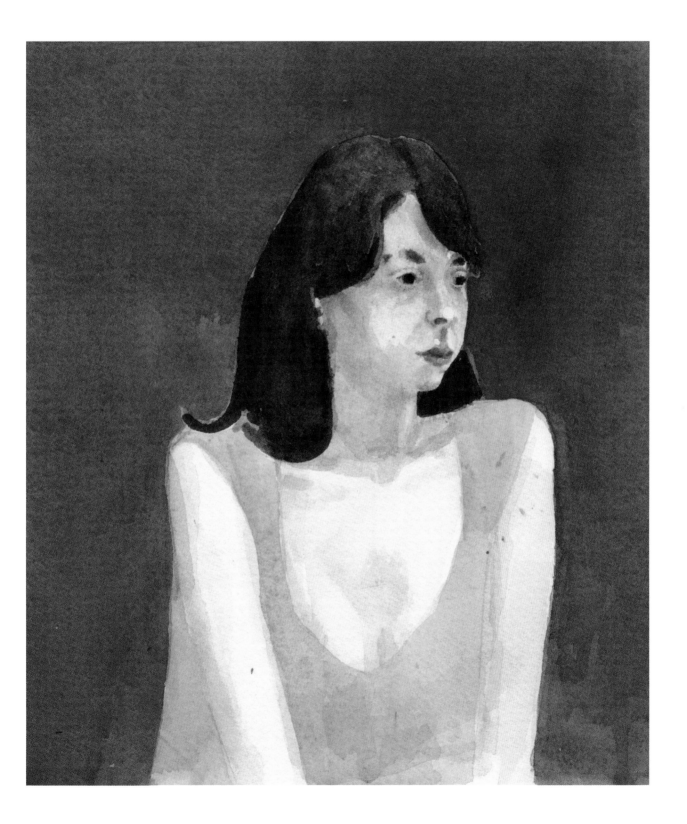

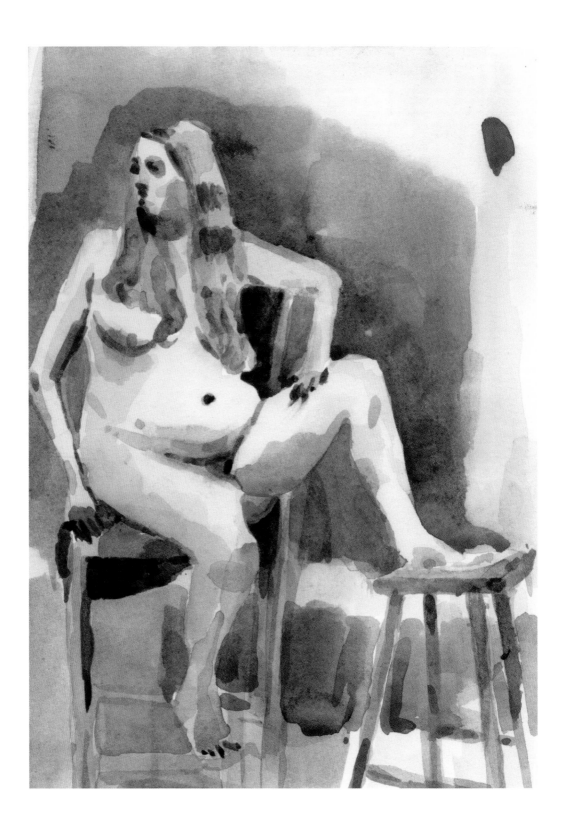

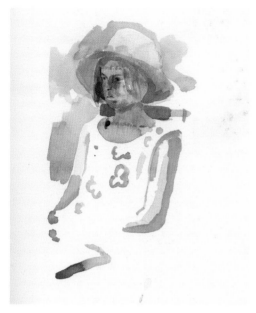

Mina.

My Mother-In-Law In The Shade.

live. We spent a couple of weeks in the most extraordinary countryside, on the north side of Lake Balaton, with great sweeping views of the landscape, vineyards, woods and hills, which are volcanic plugs and look like children's drawings of hills, great blue skies full of wheeling buzzards and the lake shimmering silver in the distance. I did two paintings in the landscape – the day before we left for home, I took my watercolour sketchbooks and paints and a bottle of water and strode off down the path. Two rather desperate paintings later, I decided it was time to head back, disappointed and fed up. Even in that landscape I couldn't be bothered. I did lots of paintings of my family though.

Painting figures is difficult, because it is quite

Studies of Swimmers.

Another picture of Mina. She rather likes being drawn, I think. She doesn't usually look this grumpy, though. Notice the white of the tee-shirt (white paper) and the white of the highlight on her nose (gouache).

This page My friend Anna Gardiner uses watercolour in the street, as a way of drawing passing people quickly, catching the colour of their clothes, their stance, how they move. They might emerge in later studio paintings, or she might not use them directly at all. Sketching in the street is a breathless and challenging activity, not for the faint-hearted.

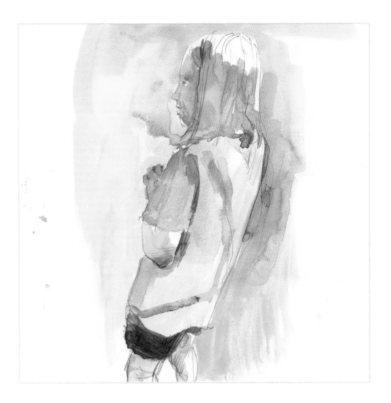

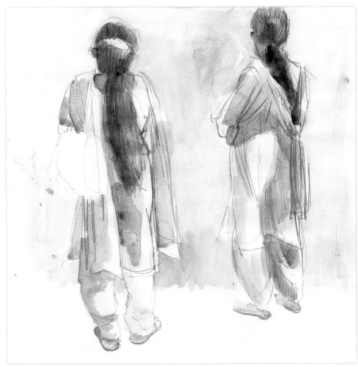

easy to go horribly wrong; the viewer is very sensitive to distortions in images of people, much more so than in other things. A tree's branch can be painted in all sorts of ways and still be convincing, but an arm has to be in the right place, and be of the right length, to be convincing.

It is tempting for the beginner to think that he or she should start by 'learning to draw' the human figure, before embarking on painting it, as it is such a difficult subject, but in my opinion this is to misunderstand the process of learning, seeing and drawing.

Why not learn to draw using watercolour on its own? It is certainly an intractable medium, but it will teach you about tone, much more than pencil drawing will. That is because pencil drawing uses two methods to build up shapes. One is linear perspective, which means, essentially, just using lines for changes in form, and the other is building up tone by hatching. Both these methods ignore the fundamental truth of how we see shapes, which is all of a sudden, in

masses. We see large shapes first, then we interpret them (a chair, a book, a curtain) and then we see them in detail. Watercolour allows us to comprehend these large shapes, to wash in tonal areas, and thus to show the large masses first, and then to develop detail. So in some ways it is actually easier to draw with watercolour. It is a lot more satisfying as well, when you can make a figure against a dark tonal area quickly and lucidly.

There are disadvantages, of course. The fact that the medium has to dry, for example, and that it is so difficult to rectify errors means that painting someone from life seems a lot more risky than drawing them with a pencil. 'Oh, got that wrong' means you just have to rub it out and do it again with a pencil, but with watercolour there is a huge wet surface that you might disrupt and destroy if you start using your loo paper. But if you follow the guidelines I have suggested so far you should be fine. Keep the washes thin and you should be able to correct as you go along. Maybe do two paintings at the same time, to allow each one to dry before you correct it.

There is also the problem that you cannot make light areas positively; you have to 'reserve' your lights. But this is just part of the process – it should become second nature after a while.

Exercise one – figure against the light

Contre jour means 'against the daylight' – why we have to speak in French I do not know, but there it is. Placing the figure against the light means that details and tonal rendering on the figure are not so important – it's easier to create a convincing illusion of the space and the figure.

The first thing is to bribe someone to pose for you. They will have to be prepared to sit or stand there for at least half an hour, and you could get them to return to the same pose, so they could have a break. But they must try to keep still – and not look at your drawing, or painting, or whatever you want to call it.

SETTING UP
Get your model to sit or stand in front of a window. You must manoeuvre yourself so that your model is right in the middle of the window. The aim is to make a painting framed by the edges of the window, with the model making a dark shape in the middle.

You will be better off sitting, and set up as you did for the still-life pencil and wash exercise in the previous chapter, with your kit on the same side as your painting hand.

AIM
The aim of this exercise is to make three paintings of the figure against the light, so you will need three separate pieces of paper. This is where using large sheets that are torn to the required shape comes into its own, although if you have three different blocks or pads of paper you could use all of them. Slightly different formats might also be a good idea; one more square than the others, and one longer and thinner.

STARTING
Start by mixing a thin grey wash and use your brush to lay in the frame of the window – remember, it's going to be dark against light, because, although the local colour may be white, the light coming through the window will make it much, much darker – and then, loosely, lay in the general shape of the figure.

The process follows just the same principles as the landscape and still-life work. Make sure there are no 'gaps', no 'nothings', that the picture plane is all accounted for. That is the most important thing. Do not worry about the features of the face, the hands or the clothes, because actually you can't see them that well, can you? This is because your model is against the light. But, more importantly, because you are trying to get the overall shape first.

HOW WE SEE PEOPLE
We see and recognize people by the shape of their heads, the way they stand or sit, the general colour and attitude. You can spot people

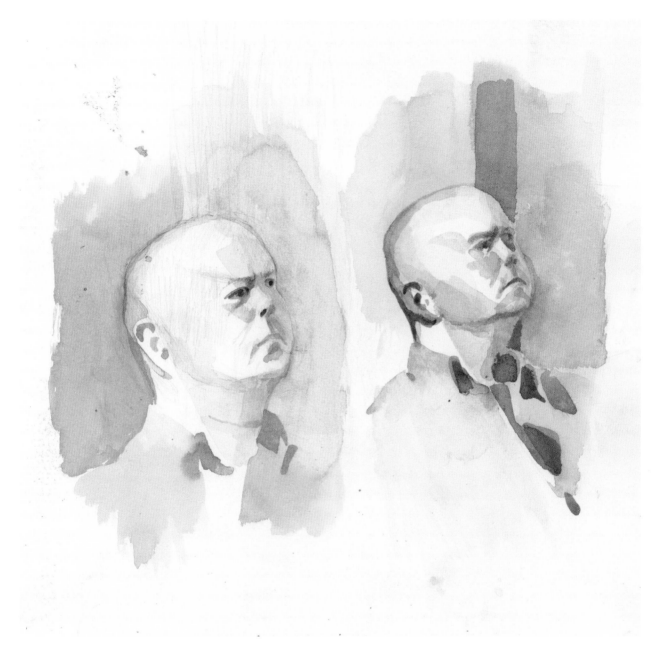

you know in a crowd, or walking towards you on an empty beach, a long time before you see the shape of their nose or the colour of their eyes.

But, as I said in the chapter on drawing, everyone wants to start painting and drawing figures and portraits with an eye. If they're life-drawing, a little eye right in the middle of a big piece of paper; if they're doing a portrait they start with a big eye. I don't know why. I do know that it makes drawing a convincing figure or portrait very difficult, for several reasons.

One is that if you concentrate on a single feature you will tend to see it from several slightly

A couple of studies of Bambi, who is Mina's mother. I didn't really succeed with the ear on the top one.

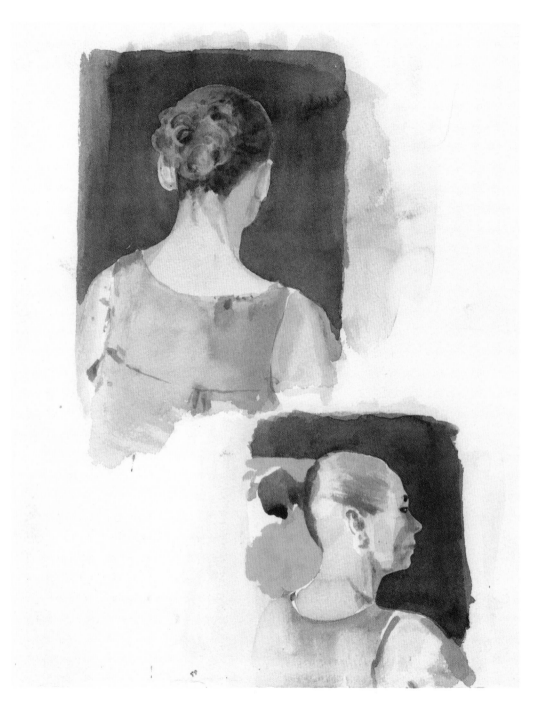

different angles. This means that as you spread your view you will not know from what angle to draw the rest of the material. Another is that your choice of scale has been determined for you; if the eye is that big, the rest of the face must be that big, too. If the scale you have forced yourself to adopt is too big, you are stuck with it.

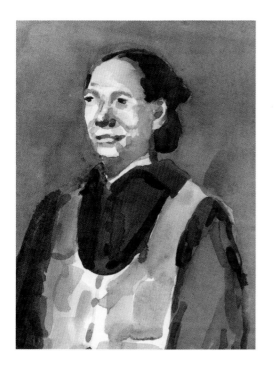

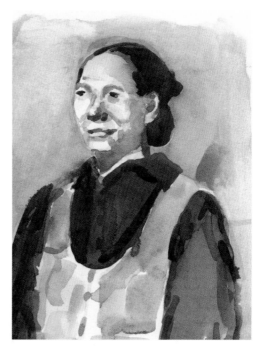

Left and far left Two stages of a portrait. As it gets darker, the form is defined more clearly.

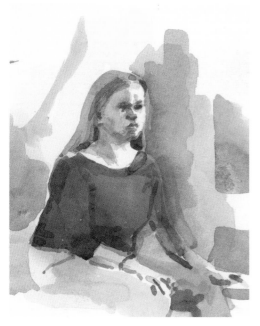

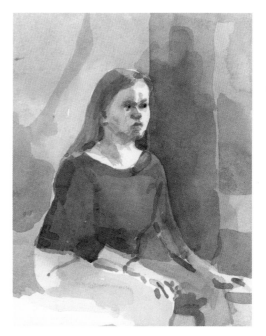

Left and far left The same again. Look at the right arm – the drawing is made by using the background.

Another is that, if you have got it wrong, you will be unwilling to change it, because you will have so much invested in it. If you realize on reflection that the eye is not that particular shape, you will have wasted so much time on it that it feels dreadful rubbing it out.

The main reason though is this. We see things not in isolation but as a whole. The whole

figure, with a window behind. There are no actual gaps in vision, unless you have a serious neurological problem, and even then the brain tends to make something up to fill the gaps.

Starting with the eye is a symptom of the way we are taught to deal with things, breaking them down into their constituent parts, but it is the wrong way to go. Instead of breaking the task down into different symbolic parts (the eye, the nose, the cheeks), break it down into different formal parts (this large area of dark, this slightly smaller area of dark, this lighter area) and save the naming of parts until the end.

What this means in practice is that you make the shape of the head, the shoulders, the chest

and then look at how the face fits onto the front of the head, and then look at the dips, the shaded holes into which the eyeballs are placed, and then, at the end, paint the eyes. As you see them, which, in this case, is probably two smudgy dark blurs.

THREE PAINTINGS

Make sure you do three paintings. Each time look harder at the model, and try to be exact about the shape of the figure against the window. Ask yourself how large the figure is compared to the window, within your picture plane. Can you see as much dark as you can see light? Less dark? More dark than light?

When you have done three paintings, look again at the first.

JUDGEMENT

For an artist, I think judgement is the most difficult thing to acquire, and the most important. What I mean by this is being able to judge for yourself what the potential of a piece of work might be, without being over-concerned about whether it is 'any good' or not. All artists have difficulty with this.

Some years ago I made a painting from a drawing I had done while teaching a class. I had set a still-life and told them what the aim was, and there was a little time free for me, while they got engaged with it, so I made one or two sketches of the students painting. Next time I was in the studio I looked at one of the sketches and saw something in the recession of forms, and the way the light fell, and so I painted it. I don't often do that.

I must have photographed it. A few days later I decided that it just did not fit in with the rest of the work I was doing at the time and I needed the canvas so I scraped it off and painted over it. Much later I was trawling through my photographs of paintings and I came across the photo again. I could have wept. Although it didn't fit in with what I had been doing at the time, that wasn't such great shakes anyway. At least I have the digital image.

That is an example of judgement. Sometimes

Nathan Roll.

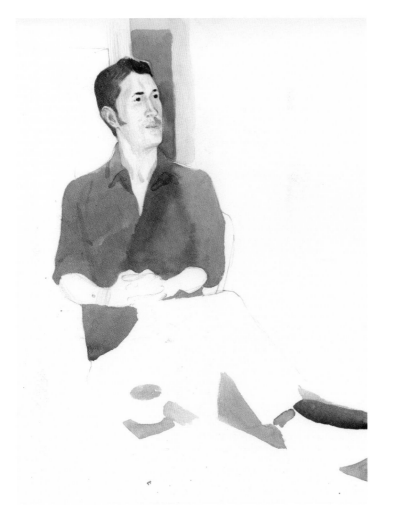

it does lead you astray, but to be honest, it's pretty well all you've got, unless you have on hand someone whose opinion you trust more than your own.

That is why people go to Art College.

What happens is that, eventually, you get fed up with other people's opinions and strike out on your own.

LOOK CAREFULLY

What you are looking for is the tonal distribution: dark areas in the right places, against the light of the window behind. It is not absolutely vital that the whole thing is correct. Perhaps the best thing you could have at this point would be a sense of ambiguity. As long as the wash is nice and thin, nothing too much is lost.

The next move is to take your brush and build up the darker areas with the same wash. Look carefully for these; resist the temptation to paint hair, nose, eyes – just apply dark areas.

ASSESSING THE OTHER TWO PAINTINGS

While that painting dries, have another look at the other two. Again, apply your dark wash where you see darker areas.

Each time you look again, look at the model

This page Three options – rapid assessments of the tonal distribution. Light enough to continue and correct over the top.

This page A page from a small watercolour sketchbook: my wife reading in the sun, sitting at our stone table in the garden. The grey wash serves as a drawing, and then layers of colour are washed over, making the image sharper and clearer as well as richer in colour.

first. You may see things differently each time. It may be that a different composition, changed by the different format, allows you to see things in a new way. Don't try for consistency over all three paintings, but instead try to forget each one as you take up the next. It's hard to do, but it's possible.

KEEP GOING
Each time you take up the brush the marks you will be making, the area you will cover with your washes, will get smaller and more precise. But try to resist the temptation to describe – not a collar, or a hairstyle, or blue eyes, but a dark tri-

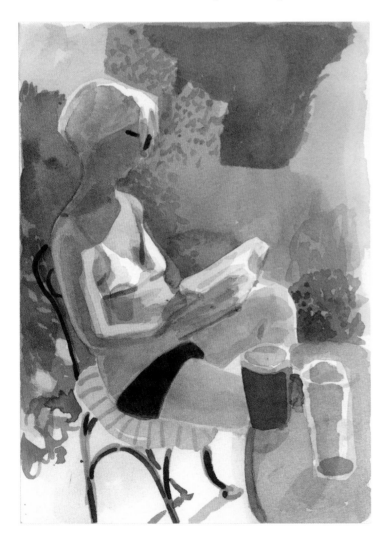

angular mark around a lighter one, a flat shape, two hollows in the dark shape of the face. In *Basic Drawing* I illustrated this with an anecdote.

> There is a story about Courbet, that a friend congratulated him on the excellent rendering that he had made of a horse and cart in the distance in a landscape he was painting *en plein air*. 'Horse and cart?' he said. 'All I can see is a few shapes!' Short-sightedly, he had simply brushed in the shapes he saw at the edge of a wood.

I think this is absolutely true of drawing.

LOOKING THROUGH YOUR LASHES
There's a good technique for this, if you find it difficult. Screw up your eyes so that you can almost not see through them. It's called 'looking through your lashes' and it seems to cut out extraneous detail and reduce things to simply tone and colour. Look through your lashes to see the overall shape and form of what you are viewing.

tells you how the ideal figure is constructed.

These rules are there to help you make paintings and sculptures that fit into a strict canon; Ruskin, in *The Elements Of Drawing*, says that the point of drawing is to see *without* a canon, an ideal. As with perspective, the rules of proportion will tell you what you *ought* to see. They won't tell you what you *do* see. So I will not help you with proportion.

Here's why. A head is usually either one-seventh or one-eighth the length of the body; the arms should reach to just below the hips; the eyes are on a line with the ears … the trouble is, look at someone sitting for you for any length

This page A page from a larger sketchbook, the same subject. Notice how I have 'corrected' the dark glasses, using the original frame as a shadow on her face in the end result.

PROPORTIONS

The human figure has been mapped, coded and formalized by artists from the time someone smeared spit and mud on a cave wall to make a painting. There was a sign that corresponded to a human figure in the Stone Age, and there are signs for a human figure now. Think of those strange CGI people you see in ads. They give you the impression of 'realism' the first time you see them, but the more you look the more unlike it they get. The Egyptians and Greeks drew, painted and sculpted human form according to their ideals as much as, if not more than, from life. I have seen figures in Roman frescos that look like the product of observation, or at least memory – a fisherman, some people walking down the street – and not constructed, as Indian miniatures are, from a formalized schema of how form ought to look. Medieval and Byzantine art is all schema, too, and then Leonardo and the rest of the Renaissance artists looked again at how the world is visually constructed, and almost the first thing they did was make rules – Leonardo's Vitruvian man, for example,

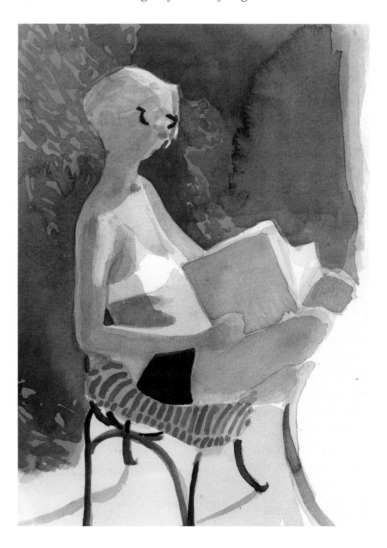

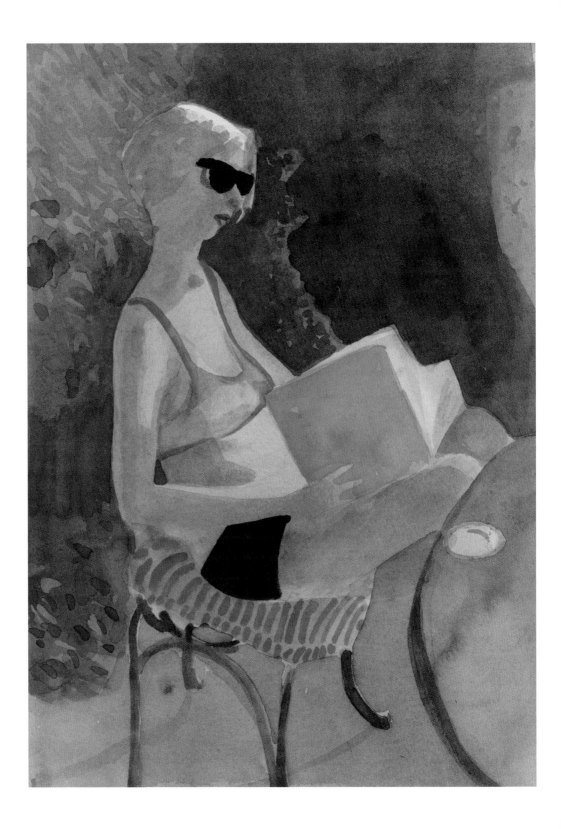

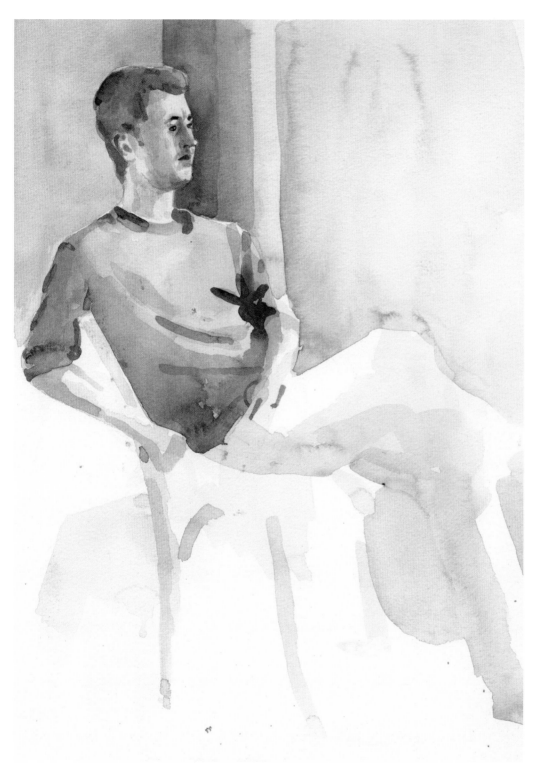

Nathan, Legs Crossed

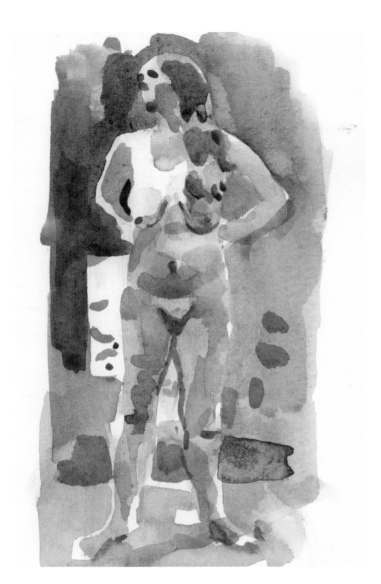

forward; is the eye that you can see higher or lower than the ear? And so on. Using the measuring techniques I described in Chapter 4 will be of great help to you in the next exercise.

Standing figure

This is the most daunting project, and one from which you may well learn the most.

You might try the pencil and wash technique with this exercise. Remember the still-life set-up; I suggested that you spend some time preparing the set-up first, looking at the background and the floor plane, and sorting out the light source.

If you can get your model to agree to stand for you for an hour the best thing to do is to get him or her to stand for short periods of time, rest and resume. Say three lots of twenty minutes. Get your model to stand holding on to

of time, and if you can see clearly, without prejudice, you'll notice that few of these rules apply. Your model will hold his or her head at an angle, probably – most of us do – and the likelihood is that you will try to make things line up that actually do not line up.

CORRESPONDENCES
But things do line up!

Use your paintbrush or a pencil to see what relates to what – is one shoulder higher than the other, for example? If the head is tipped

a sideboard or chair or something, and in a position easy to recapture.

You will need to be in a room large enough to get well back from your model: you may well suffer from parallax otherwise. To explain parallax, again, I quote myself:

> It's a very common problem, and it seems to operate in two ways. One is most obvious in the life room, and results from being too close to the model, so that your view of one part of the model is from a different angle to your view of another. It's natural, and helps to give an idea of the space between the artist and the model, but you need to be aware of it, because it causes straight lines to appear curved, and will distort your drawing.
>
> The other is more pernicious, and comes from the artist not concentrating enough on his or her posture. I'm sorry if I sound like a Victorian governess, but if you slouch at your board, and get too close to it, one part of your drawing will be closer to you than another. Again, in the life room this produces enormous heads, as the student compensates for the fact that the head part of the drawing is sixty centimetres away from her eyes while the midriff is fifteen centimetres away.

So, prepare well. Start by looking through your lashes and finding the large areas of dark and light. Use your pencil to hatch them in lightly, without getting into the heavy outlines and definite decisions that you might well regret later.

You will need to find edges, eventually, but instead of outlining each object or even part of the body, try to find corresponding lines – the line at the neck of a jersey might connect with the edge of a painting on the wall behind, for example; or carry the line of the arm on down into the chair it is resting on.

FORESHORTENING

One of the big problems in drawing figures is foreshortening.

This is because we are so used to 'naming the

Portrait Study.

parts' – a foot, a hand, a leg – and we know what they look like. At least, we know what they look like from our own perspective. When it comes to looking at someone else's feet we seem so often to go to pot.

Hold one of your fingers up in front of your face. No doubt you are looking at a relatively long, thin object, with a couple of knuckles and a nail. We both accept that. Now, slowly lower your finger so that you are pointing at yourself. Gradually, the finger is appearing to get shorter, isn't it? By the time you are pointing directly at

Look at the model's
thighs – a good
example of
foreshortening.

yourself you can only see a sort of circular shape, with a nail on the top, which is a curved shape. That is foreshortening. You shouldn't get too much of it in the standing pose, but you might, so look out for it.

LINE, TONE AND DETAIL

Continue to alternate between edges and tone, and look hard at things like where the feet meet the ground, where the hand touches the object, the angle of the head – can you see a neck? Are the ears on the same level? Look also at any other correspondences you can see. Don't worry about the shape of the eyes, or the fingers or buttons on a shirt, but do worry about the over-all shape the legs make, the angle of the head, and which foot bears the most weight.

Then let your model have a break, making sure that he or she knows where to put their feet when the break is over.

Remember not to make the drawing too heavy; you don't want the watercolour to be affected too much by the pencil work, but simply to use it as a tonal structure over which to lay your colour.

Portraiture

A friend of mine says that although he is a painter of the human figure, he is not a portrait painter and cannot 'get a likeness'. On the other hand, David Parfitt (see Chapter 11) says that he doesn't do 'life-drawing' or 'life-painting', but rather tries to draw a particular person in a particular space. I agree with David, really. What else do you do when you are painting a person except paint that person?

A while ago I decided to get my friend Nigel Aono Billson, the graphic designer, to sit for me. He had grown a pretty good beard and I thought he might get rid of it when the summer got too hot. As I drove to his house I thought to myself: 'I know exactly how this will go. I will do three drawings. The first one will be good, the second will be more questionable and the third one will make the first one look shallow and like a cari-

cature. Then I will know enough about him to paint him.'

I drew the first one, and India, his 11-year-old daughter, came in and said, very gratifyingly, 'That's my Dad!', and she was right, it wasn't bad. The next one was a little bit more difficult, I was mucking about with a pen, but the third one was much better – somehow deeper, more complex. And then I painted him.

I was quite pleased with the result. Somehow it all seemed to go to plan. But it is interesting how the more I looked, the more I was able to refine and develop the image.

I reproduce these drawings courtesy of *The Artist* magazine, because I featured them in an article about drawing in 2012.

A quick study of one of my students. Notice that, even though there are no discernible features, you still have a good idea of what she looks like. Also, notice the work on the back of the neck, where I redefine it with the paint.

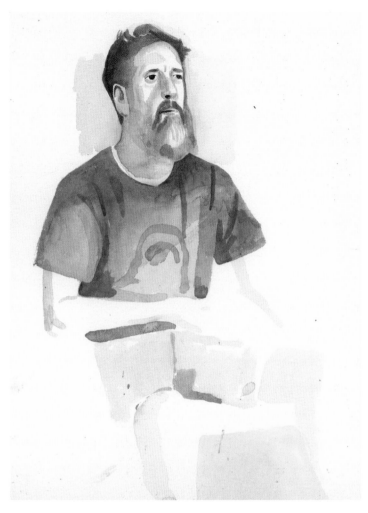

Using the principles that I have set out thus far, a portrait should be viewed and dealt with in exactly the same way as any other watercolour painting. Take your choice about how you start it: pencil tones, light washes, tonal or direct colour, or an under-drawing.

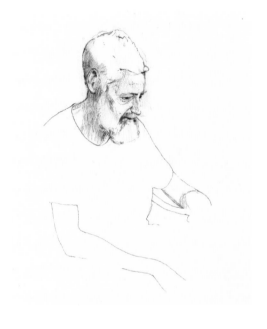

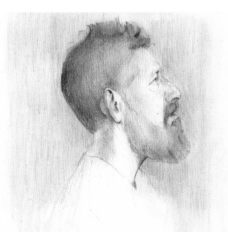

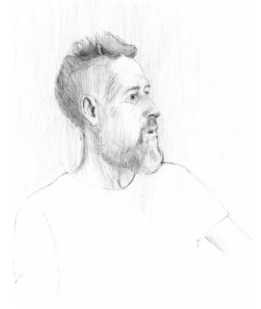

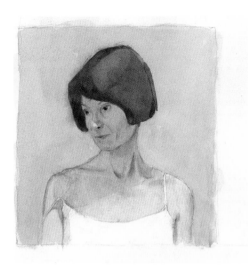
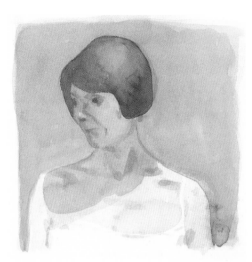

This page The study on the top left is a light tonal drawing, which I have washed over. The top right is direct painting, and the bottom is the end result of the top right. Notice how I have used the background to 'sharpen up' the drawing of the shoulders. Also, that the more you do, the darker it gets. I think the third one is the best, but you may not!

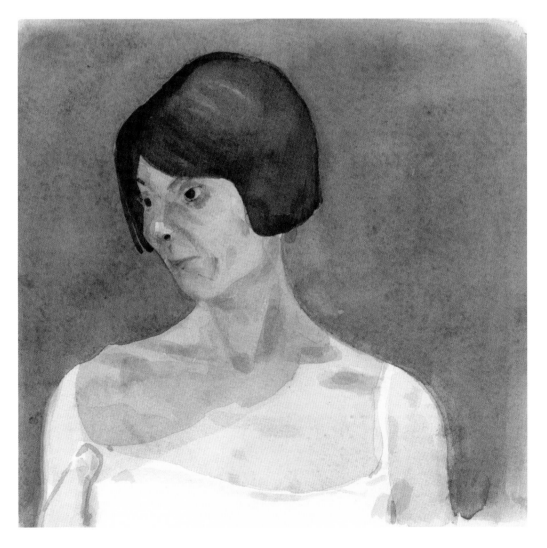

Portrait Study 2.

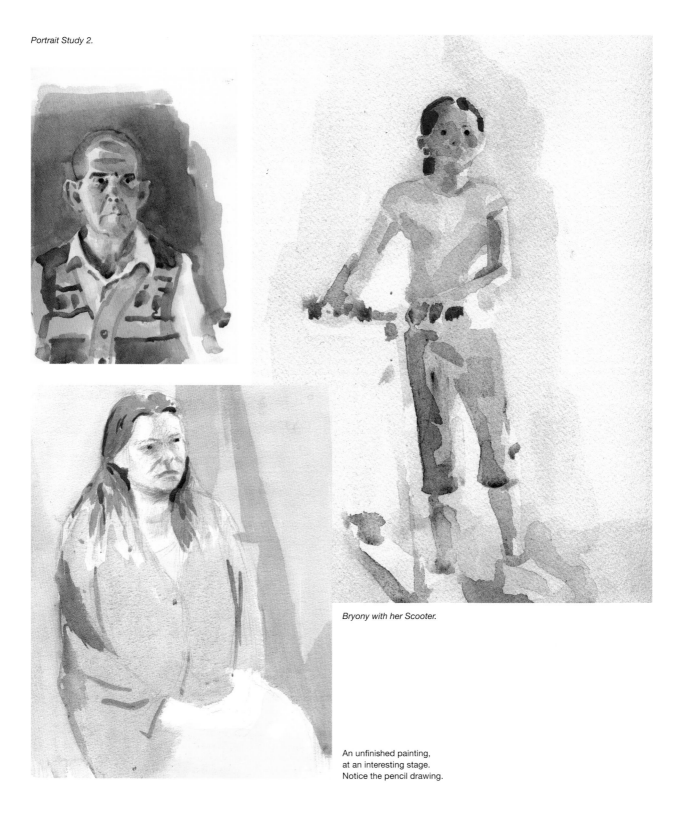

Bryony with her Scooter.

An unfinished painting,
at an interesting stage.
Notice the pencil drawing.

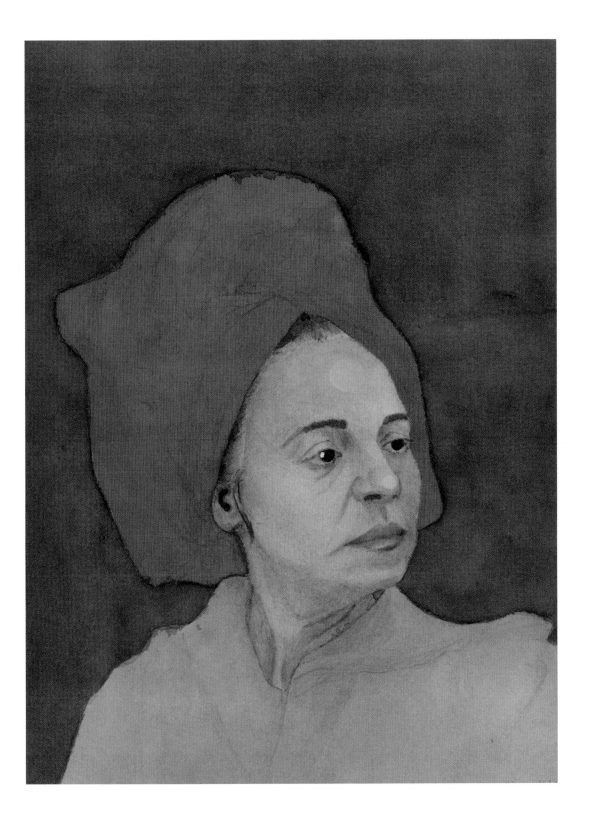

Coloured Paper and Opaque Paint

It is perfectly reasonable to use gouache paint, which becomes opaque when mixed to the consistency of single cream, in the same manner as watercolours – mix it very thinly and apply it in washes and it should work perfectly well. This method allows you to build up your layers so that you can apply the last details quite thickly – the opacity of the medium means that you are able to break the main rule of watercolour, which is reserving your lights.

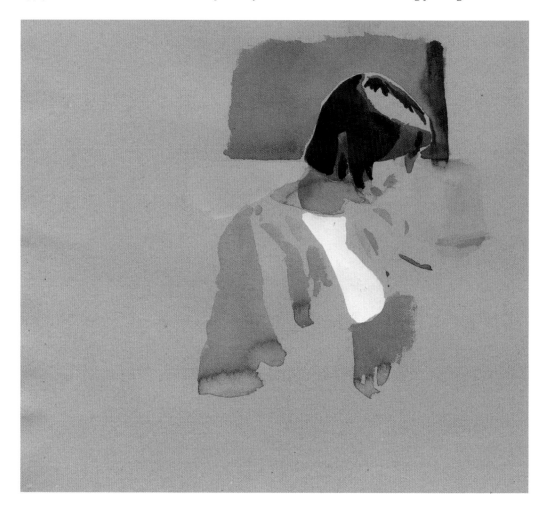

Perfect. Why didn't you say that before? For three reasons: the first is that this book is about watercolour technique, specifically, and the most difficult part of watercolour technique is understanding what seems counter-intuitive, i.e. working from light to dark and reserving your lights. Another reason is that gouache is even more unpleasant to correct than watercolour if you make mistakes, and learning the 'correct' watercolour technique first will help you to avoid mistakes. The final reason is that, actually, gouache is not as good as watercolour when used in thin washes – it can be a little more granular in texture and doesn't hold together quite as well. But otherwise, go for it. Knock yourself out.

I made these drawings of my friend Anna Reid on brown-tinted paper, using watercolour and gouache. I call them drawings because I made them from observation, while she was reading the paper in my sitting room, without making a pencil sketch or using a photograph. They are direct expressions.

Notice that the lightest parts are painted, using white gouache. Because of the brown tint of the paper, I had to use opaque paint to make things lighter. This is the opposite of drawing with a pencil, in which I would be shading-in dark areas and leaving light ones, or watercolour, in which I would be washing over the dark areas.

The trick is to work out the shapes of the light areas – to simplify an area in terms of tone

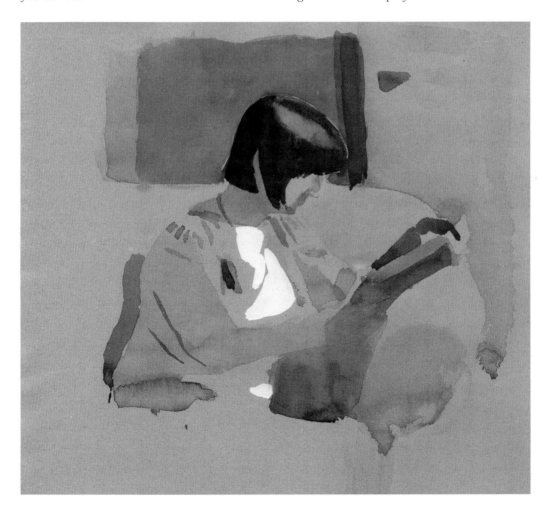

Anna Reid, watercolour and gouache on tinted paper.

*Nathan Roll On Blue
Paper.*

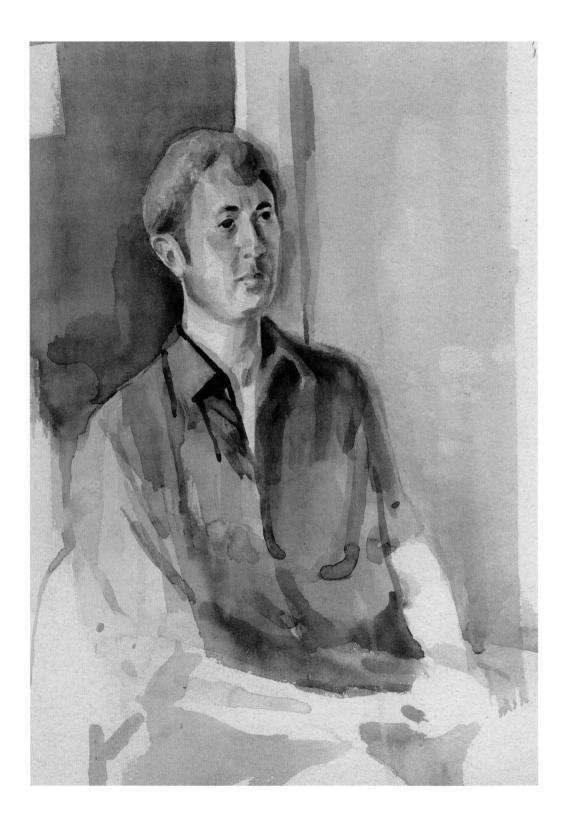

and texture and perhaps colour, recognizing it as discrete from another area – but not to simplify the shape. Don't turn an irregular four-sided shape into a square, for example.

In one of the drawings I have made the folds in Anna's white top by just painting the light areas; there is no progression of tones as the folds shade away from the light. I have simplified it into either light colour or untouched brown paper.

In the other drawing I have simplified her top by just identifying the shape and making it in white gouache. Undoubtedly there were small shifts in shading, but I ignored them for the overall effect. But I was very careful with the shape itself, otherwise the drawing would have lost its edge.

By this stage of the book I hope you will have reached a point at which you do not need an outline to fill in, and your brush can 'find' the edges of the shape by itself. The main thing here

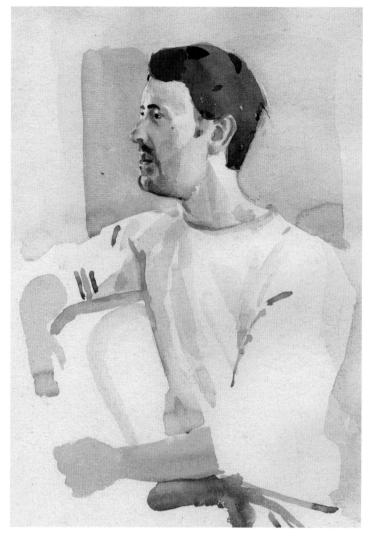

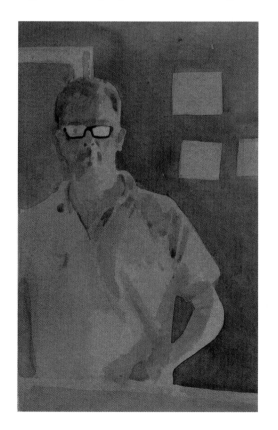

is not to overdo it, and this is where judgement comes into its own. In fact, that is the real reason why I put this chapter so near the end of the book; to give you time to develop your sense of judgement.

My painting of Nathan, on blue-tinted paper, started out very well, but somehow the fight with the paper's colour took over, and it ended up muddy and unpleasant. He doesn't look like that! I tried hard to rescue it, but it was not going to work.

The second time, I stopped before it got too muddy, but notice the use of thin white gouache

Nathan Roll On Blue Paper 2.

Self-portrait On Brown Paper. I should perhaps carry on with this one – the glow in the spectacles makes me look a bit spooky!

This spread I began this painting of a vase of South African flowers and some ceramic pieces on a white-painted, shiny semi-circular table against the wall with thin washes to establish the tonal distribution – where the darkest areas were, how the table stood against the wall, the loose shapes of objects and cast shadows. Then I dabbed in a rough idea of the colours of the flowers. Next, a thin wash of white gouache to sort out the table's structure, and get the highlights on the glass vase. Then a dark wash to tie up the flowers and sharpen the edges of the ceramics and their reflections, and finally a stronger application of the white gouache to brighten the highlights and bring the edge of the table forward.

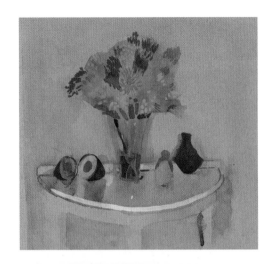

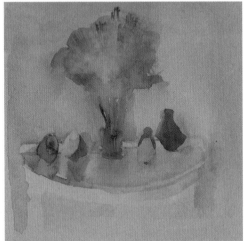

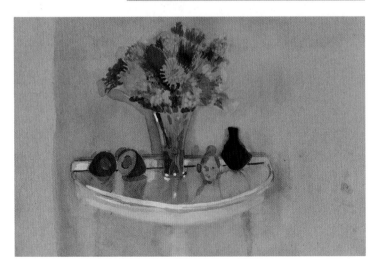

to bring out the light on the face. Read more about this in Stephen Moriarty's section in the next chapter. I should have carried this one on, and dealt better with the arms and hands, but I think I was a bit spooked after the struggle with the previous one. I do like the way the skin looks warm when you use this bluey-green paper. It's the contrast, and I think the eye expects a warmth somehow. But if you overdo it, you will lose it.

That is the problem with the tinted or coloured papers. You can't really work away on them because you are not starting with a light base. If you do layer colour on colour the dullness of the paper will dull the painting itself. You need to know when to stop.

Knowledge

By this stage, you should have a clear idea of the picture plane, of tone and colour, of working from light to dark, of the importance of drawing, of the importance of composition. You should understand negative shapes, and the fact that there are no areas of 'nothing' in vision – the implication of this fact for painting from observation being that, even if you compose a painting with a lot of 'nothing' in it, you will have accounted for it instead of using it as a stylistic trick to avoid difficult areas.

You might also have grasped that 'detail', 'truth', 'precision' and all the other words people use when what they really mean is 'make a painting that looks like a photograph' are all relative, ungraspable, indefinable words. To 'make a painting that looks like something' means something more than just taking a photograph of it.

You need to make judgements, to simplify, to compromise, in order to draw something that you can see in front of you, because you are translating a three-dimensional world onto a two-dimensional piece of paper.

The question is, what are you going to paint with all this knowledge?

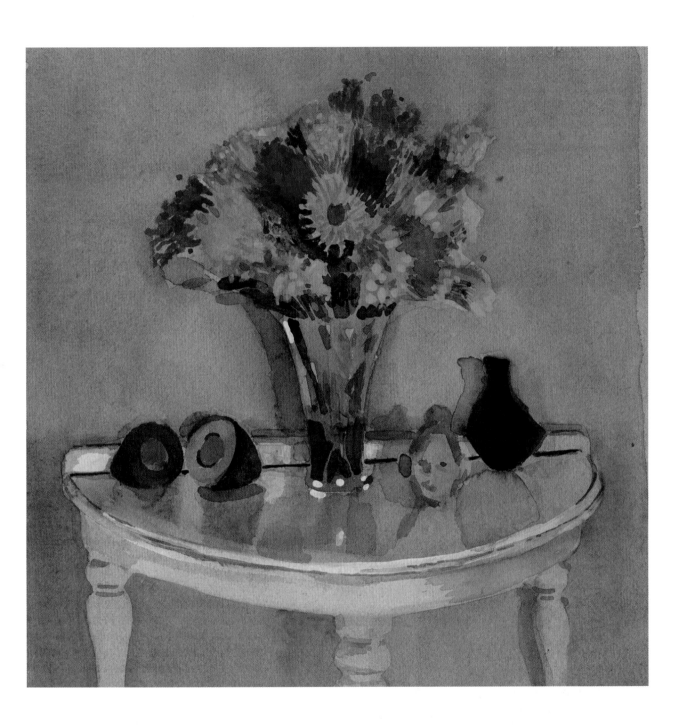

Contemporary Artists Using Watercolour

Watercolour, despite its lack of 'cool' and its almost amateur status, its association with childhood, the feeling that it isn't quite serious, the overtones of Victorian ladies and gentlemen diligently applying washes and the oddly pervasive and entirely erroneous notion that it is a bit impermanent and fragile and not worth as much as oil painting, is nevertheless used by many artists. I chose these six to include because they are good examples of different approaches, but there are many. Visit the Royal Watercolour Society's exhibition at the Bankside Gallery, or the Royal Institute of Painters In Watercolour at the Mall Galleries in London to see an enormous variety. Choose ones you like and copy them; it's as good a way as any to develop your own approach to looking at things, and it will help you to define what it is you like to paint.

I asked each artist some questions and had them send me images of their work; some gave me several types of painting; others were more specific about what they used watercolour for.

David Parfitt

David Parfitt was Head of Painting at the Royal Academy Schools when I was there, for the first year, I think. He left because the need to make his own work grew too strong for him to resist. A lot of artists teach – I do – and after a while it can get too much, especially in a place like the RA Schools, which is full of ambitious young things demanding your attention.

David is an artist with a very high level of integrity and seriousness, and an extraordinary breadth of knowledge and experience. The work he made as a younger man, in cold studios in Brick Lane and other exotic places, was abstract and highly considered. Since finishing with teaching, his work has been much more to do with observation; the concern with composition and the design of the painting is still there, although now the need to work from observation is added.

David's watercolour painting has a strong sense of continuity with his oil paintings; the intensity of observation is the same; the clear light, the crisp design, the uncompromising attitude. He is very clear that the watercolours are not planning, or 'lesser', work: they are 'just themselves'. Notice the awareness of and sensitivity to the support – the paper on which he is working – in the section on materials, and also his pointing out the need to 'work backwards' – the central difficulty with watercolour.

Later he talks about the attempt to think the composition and the method through, and keep in control, and then the muddle, and then the self-rescue. It's heartening to know that even someone like David has the same approach as I do.

The last line is very significant, I think. The idea of this book is to try to get people to use watercolour as a way of working from observation. It is a 'Ruskinian project', if that's not too pompous. David sums up its frustration and difficulty, but still 'the look of things' makes him 'want to paint'.

I have included the illustration of the oil painting to which he refers in the text to give an idea of the rest of his work.

How long did each piece take?
The sketchbook watercolours took about three hours each. *Herakleion Waterfront* took about six hours over two evenings. *Knossos Landscape* took about twelve hours over afternoons.

What went into the decision about what to paint?
The sketchbook watercolours were made for the pleasure of looking at a new place and subject. The Cretan paintings are different. I know the Villa Ariadne and the Herakleion waterfront well and had painted similar motifs in both places many times. *Herakleion Waterfront* was intended as a study for a larger studio painting. The area of wrinkled blue sea locked between stones and sea wall is what interested me. The fisherman just happened to walk by with his dog. I caught him and missed most of the dog!

There's an oil painting of the river I'm working on now – same sort of idea. The Thames (wrinkled too) at high tide jammed between railway bridge and balcony.

How do you refine the composition – is it a conscious decision, where the edges are, or do you work out from the middle, or what?
The composition is conscious. From the start I'm thinking of the shape of the paper, whether it's vertical (portrait) or horizontal (landscape) and what's going to feature between the two sets of parallel lines. The double page watercolours in the sketchbook are squarer and consequently feel more abstracted. The square asserts itself.

How much planning went into it? Did you do preliminary sketches? Is it a preliminary sketch itself?
Some planning. As I've said before, shape and size of paper matter. No preliminary drawings were made. The sketchbook watercolours are not preliminary sketches – they are just themselves. The images could lead to other things – they haven't yet. *Herakleion Waterfront* was a

study for a large studio painting that never happened. If I lived in Herakleion I'm sure I would have painted it.

What materials, colours, brushes, and other materials do you use?

I use Winsor & Newton Artist's Watercolours. I have a small W&N black japanned metal paint box which holds sixteen half pans of colour. I carry tubes of colour to top up the pans; to mix larger quantities of paint I have another palette.

I use two sets of primary colours: lemon yellow, alizarin crimson, pthalo blue, cadmium yellow, cadmium red, ultramarine blue, plus yellow ochre, burnt sienna, raw umber, cerulean blue, viridian green, Chinese white.

I have an assortment of flat and round brushes; none of them are sable brushes – moths ate all the sable brushes many years ago. I've never replaced them.

How did they affect the development of the image? For example, working from dark to light.

Only the choice and quality of the paper really affects the image. Brushes do too of course, but they only have to be workmanlike. It's the underlying drawing/design that matters, especially as you have to do watercolours backwards – leave space for the light bits at the start in order to wash in their colour at the end.

How did you know it was finished? Is it finished or are there things you'd like to change?

I get fed up and give in. There are always things I'd like to change.

Were you consciously thinking about things like light, form, edges? Or did you proceed in an intuitive and improvisational manner?

Yes, I consciously think of light – angle of, quality of, colour of – and aspire to seek out big simple forms and dominating colour relationships. Then I get in a mess and try to get out of it in an intuitive and improvisational manner.

What affected the development of how you draw? Teaching? Other artists? Something else?

I went to Newport Art School when I was sixteen. The first thing we had to do was to make a sketchbook. It was quite big, thirty-five sheets of imperial-sized cartridge paper (30 x 22 in) folded in half. When the book was ready we had to go out into the streets and draw in it. The drawings were then used as source material for paintings made in the studio. There were many influences on my drawing – Van Gogh, Sickert, Rembrandt; John Bratby, Peter Coker and the Kitchen Sink School; a kind of pen and ink drawing then much reproduced in the *Listener*, and a Newport style of drawing – heavy black lines and vertical shading. Many experiments took place in the sketchbook. But in the end it was the drawings of Thomas Rathmell, Newport Art School's Head of Painting, that most influenced my drawing style. The influence is there now.

Do you see the work as complete or is it part of an ongoing series?

No, not complete. The strongest most frequent feeling I have is that I don't know what I'm doing or why I waste my time trying to paint. And yet it's the look of things that makes me want to paint.

Looking towards Arran,
watercolour from
sketchbook 26.5 x 21
cm (10½ x 8¼ in).

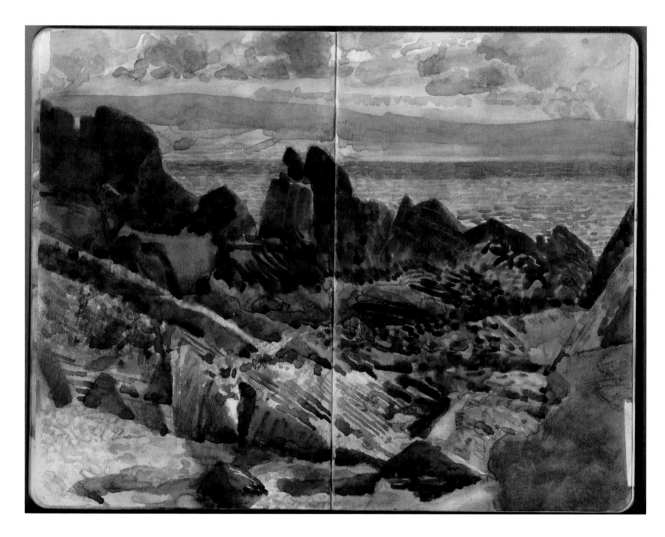

*Looking towards Arran
2*, watercolour from
sketchbook
26.5 x 21 cm
(10½ x 8¼ in).

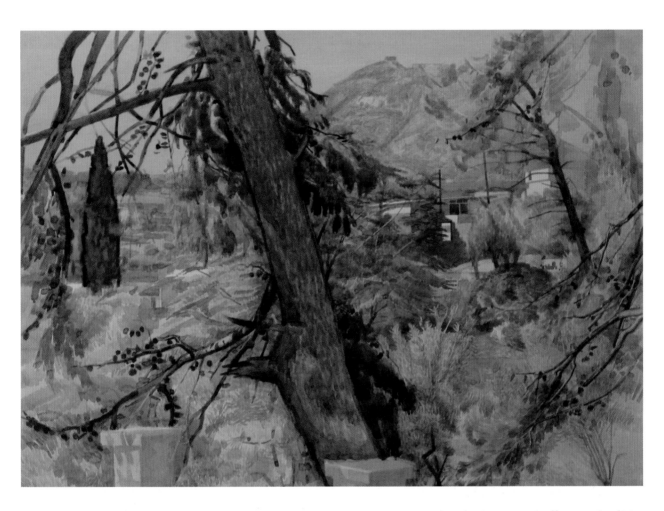

Knossos watercolour
on Arches (hot pressed)
paper,
19 x 28.7 cm
(7 x 11 in).

*Across the River,
February*, *Dusk*, oil
on canvas
121.8 x 91.4 cm
(48 x 36 in)
(by kind permission
of David Messum
Limited, London).

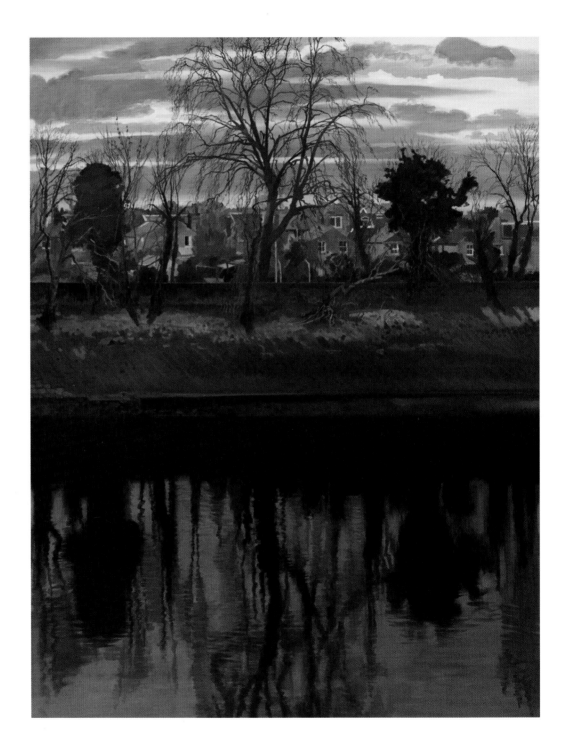

Julie Held

Julie Held's oil paintings are deeply coloured and rich, often with a dark tonality. She has an admiration for Titian, and her paintings seem, to me anyway, to aspire to a similar *facture* – apparently quickly, urgently painted and deeply felt.

Watercolour would not immediately spring to mind as the ideal medium for such a painter. The way I would paint, carefully building up layers, would not work for Julie. But perhaps in what artists often call the 'resistance' of watercolours – the fact that it is so hard to correct or have second thoughts using it – lies the attraction.

Julie's paintings could appear simple and unworked; they are anything but. They are made 'quickly, but after much thought and looking'. She uses the medium, like David Parfitt, not as a lesser thing, like a sketch for another painting, but for its own sake.

Another thing to note; she is dismissive of 'correctness'. This is because she is sure of what she is doing. The rules have been learnt and can be discarded.

How long did each piece take?

Paintings are often made quickly but after much thought and looking. Sometimes I put them away for up to a year or more and then go on with them either from memory or intuitively.

What went into the decision about what to paint?

I make paintings for multiple reasons, ranging from the simplest urge to capture a moment or more mediated ones concerning exploring an ongoing theme of mine.

How much planning went into it? Did you do preliminary sketches? Is it a preliminary sketch itself?

I often make drawings to explore the ideas and, when determined to go on with it, may work fast in watercolour with no other preparation.

What materials, colours, brushes, and other materials do you use?

I use sable brushes and watercolour paper which is sometimes stretched and sometimes not. I like to paint in whichever type of watercolours seems to suit the subject. Watery paint, cakes, etc. This in turn determines the development of the painting.

I never think of the 'correct way' to make a watercolour as this will inhibit me. Rules are there to be broken but understood only for chemical reasons so that the painting won't fade or last only six weeks after being done.

Were you consciously thinking about things like light, form, edges, and so on or proceeding in an intuitive and improvisational manner?

I go by instinct as to when I think a picture complete, i.e. does it express what I set out to do? Or has it taken a life of its own, which 'works'?

I do consider formal things too, such as edges and composition.

How did you know it was finished? Is it finished or are there things you'd like to change?

I see my work as part of an ongoing exploration of certain themes which have preoccupied me since the day I set out to be a painter. These are huge themes which one can only hope to touch upon in a meaningful way as they pertain to matters of life and death: joy, sadness, sexuality and death. All of which do sound portentous, I know!

Bouquet, watercolour
on paper
76 x 56.5 cm
(30 x 22¼ in).

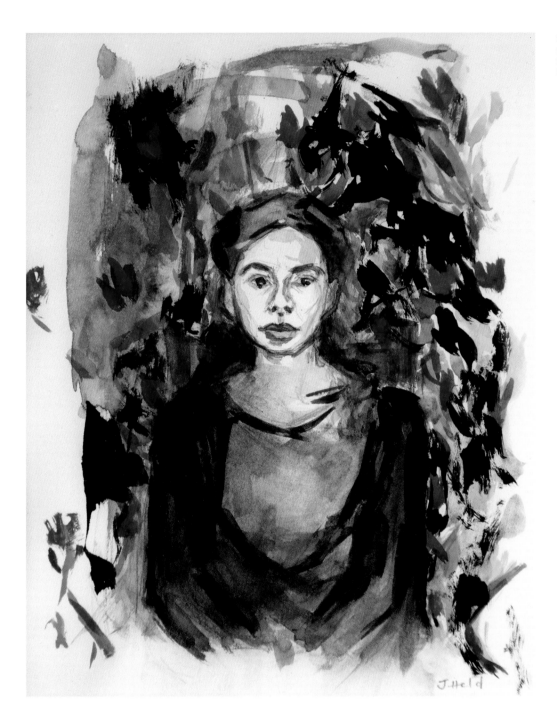

Chiara, watercolour on paper
24 x 19.5 cm
(9½ x 7⅔ in).

*Garden to be called
'Storm'*, watercolour
27 x 33 cm
(10⅝ x 13 in).

Florist, gouache and
watercolour on paper
55 x 40 cm
(21⅔ x 15¾ in).

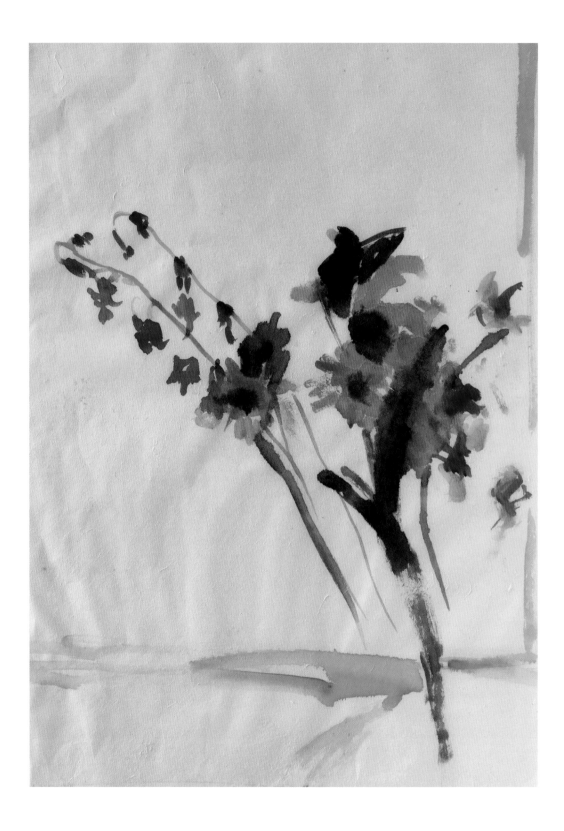

Paul Newland

Paul Newland's watercolour paintings are very delicately observed and highly visually sensitive, and Paul's way of talking about them seems to me to show the same detached, objective and ironic attitude. The oil paintings are treated in the same way, and there appears to be no difference in their importance in Paul's mind; they just pose different puzzles.

I have included some studies here, too, because they are interesting. The final paintings are, as you will gather, the product of a lot of contemplation, and the paintings go through a lot of changes.

Notice the passage about the painting *Port Fantasia* in regard to Chapter 10, where I talked about using a coloured ground. There is a long tradition of using these combinations – Watteau, Rubens, Chardin – and Paul, with his comprehensive knowledge of art history, is no doubt exploring it.

Paul does not say much about choosing a subject. My guess is that he is most interested in what we have to call 'formal things', which would be challenges to how to go about representing things. In the *Allotment* studies reproduced in Chapter 7, for example, the large shadowy areas would prove an intriguing problem to him, and *The Southern Suburbs*, with its vast panoramic space, would be forcing the question of how to make a large area composed of many small elements interesting.

These paintings demand to be looked at for a long time. I have one of his smaller watercolours, and it seems to change every time I see it.

How long did each piece take?

I find that pictures can take anything from forty minutes to ten years. The long, long working times are because I engage intermittently with the piece in question. There'll be several days of work, then something else, a few days again, then months of other things. And so on.

What went into the decision about what to paint?

I am not conscious of deciding what to paint. Rather, things crop up and demand attention. Dissatisfaction with the resolution of an old subject matter sometimes makes me look and try it again.

How do you refine the composition – is it a conscious decision, where the edges of the image are, or do you work out from the middle, or what?

Composing is an odd business. It's more putting off decisions than making them. With the outdoor studies it's never resolved. I try to work out something in the moments before I start but there are always bits that get left out that were intended to be in: whilst working on it I am conscious that I will probably have another go at it to get it sorted. I might mutter to myself, 'Ah … perhaps this should be in a vertical format … I could develop the space so as to get a sense of moving up and down through layers,' etc.

How much planning went into it? Did you do preliminary sketches? Is it a preliminary sketch itself?

If I've been thinking about an idea for a while I might develop all sorts of grand plans. There'll be loads of preliminary sketches. For instance *Woodland, Water, Pastures* is one of these. It was made two years back, along with several other studies, but the composition has not yet been painted.

What materials, colours, brushes, other materials do you use?

As a student I remember a friend saying of some grand artist (I cannot now remember whom), 'It doesn't matter what colours he uses, it's always the same colour.'

I always try to keep it simple, in terms of colours. I had a craze for a while of working with cerulean blue, light red, black and white on buff or cream paper. Watercolours that is,

and working directly from observation. I loved the opacity and the strange mixtures and the way this combination prevented me from being too imitative. However, in the *Port* watercolour here there are many more colours – it began life as an outdoor piece, along the Thames, but got developed and changed in the studio, and sort of went elsewhere. Shadowed areas became opaque while other bits remained very transparent. There are cadmium reds, rich yellows, cyan blue as well as the oxides and earth colours that I love.

How did they affect the development of the image? For example, working from light to dark in watercolour?

I'm not aware of working from light to dark in watercolour. Sometimes I start with very strong, very dark shapes. This does close down one's options rather and necessitates the use of body colour afterwards.

How did you know it was finished? Is it finished or are there things you'd like to change?

I knew that picture was finished – having returned to it after a few years – because I simply could not go on with it any longer. Somehow it had taken as much as it could. The idea, however, is not finished …

Were you consciously thinking about things like light, form, edges, and so on or proceeding in an intuitive and improvisational manner?

I constantly think about light and spaces – I'm especially critical of my ability to handle the latter. The rest is intuitive.

What do you think affected the development of how you draw? Teaching? Other artists? Something else?

The drawing process is, likewise, self-critical and this I suppose comes from earliest learning experiences in the 1960s, in provincial art school and then at the Slade. What contemporary artists do and say also has an impact. In spite of all these fine exemplars, I still allow myself to get away with things of which I do not really approve.

The following six paintings
All works watercolour and gouache,
sizes approx 40 x 60 cm
(15¾ x 23⅔ in).

Downs And River.

*From The Southern
Suburbs.*

Port Fantasia.

Woodland, Water,
Pasture.

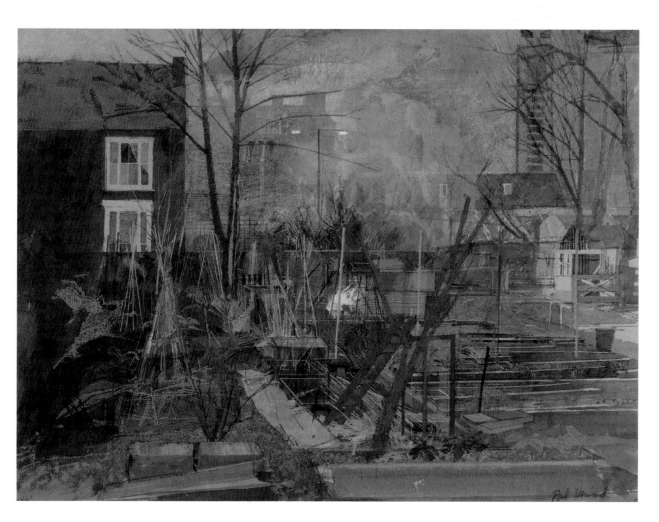

Bonfire In SW8.

Zinc Leaves And
Holograph.

Kate Wilson

Kate Wilson was a contemporary of mine at the Royal Academy Schools. Her clear-eyed vision was always distinctive, and her crisply seen paintings make their presence felt in any group show. We shared a lot of the same strong influences – Roderic Barrett, Norman Blamey, even David Parfitt, so perhaps I am biased.

Kate is an example of someone who makes a definite distinction between her work in watercolour, which is small-scale and intimately observed, and her oil paintings, which are often larger and always more 'compositions' than the watercolour work. This approach would be familiar to Ruskin, I should imagine. It seems to me perfectly reasonable to use watercolour as an observational tool and therefore as a 'lower-status' activity than painting the more sustained compositions. I have included three of her oil paintings, to give an idea of this process.

She is absolutely frank about this – watercolour for her is about 'simply looking'.

Notice that she uses three brushes, one medium round, one thin round and a big, flat wash brush, and that she works from light to dark; 'I tend to work in yellow to establish the shapes leaving areas of white paper where needed. I then work up the darks over the top.' She also works from the general to the particular; she notes that the 'rub-away' drawing she did on her foundation course changed how she saw drawing.

This is more properly called a 'reductive tone' drawing (as explained in my book *Basic Drawing*), and it is a way of demonstrating exactly what she says here; that you can work with shape rather than line.

How long did each piece take?
Although they are small, they are detailed and take several hours spread over a couple of days – as I review them and think about whether they need more work.

What went into the decision about what to paint?
These are from a series of watercolour studies of autumn and winter foliage called 'beautiful dead things'. I collect these bits and pieces as I cycle to my studio along the River Wandle – because I am currently making work based on this journey and the things I see. I also have a series of 'live things' based on spring buds and foliage. I'm painting them because I'm not quite sure why I like them or what I will do with them. These details are rather different from the other work about The Wandle I have made so far.

How do you refine the composition – is it a conscious decision, where the edges of the image are, or do you work out from the middle, or what?
These are made on offcuts of thick watercolour paper and I tend to try to place the image in the middle and work outwards. If I don't like the placement, I cut back the edges so it balances better.

How much planning went into it? Did you do preliminary sketches? Is it a preliminary sketch itself?
These are preliminary sketches – a chance to really look at the things and understand them and what it is about them I like.

Daisy, watercolour on paper.

Chestnut, watercolour on paper.

Rose, watercolour on
paper.

Stick, watercolour on
paper.

What materials, colours, brushes, other materials do you use?

I have a watercolour box with pans given to me when I was a teenager by my dad. I use these together with tubes of paint so that I can apply the paint more thickly and opaquely. The pans are good for washes. I use a colour palette based on two blues, two reds and two yellows – each warm and cool. So Prussian and ultramarine blue, alizarin and cadmium red, lemon yellow and raw sienna, plus violet and lamp black. I mainly use the recommended size 6 sable brush and have a size 2 sable rigger that I use for detail. I also have a flat brush for applying large washes – but tend to prefer drawing the wash out across the surface with a small brush as I find a larger brush tends to dilute the paint too much. The paper is important – the thicker the better so that I can wash the image out under the tap if it goes wrong.

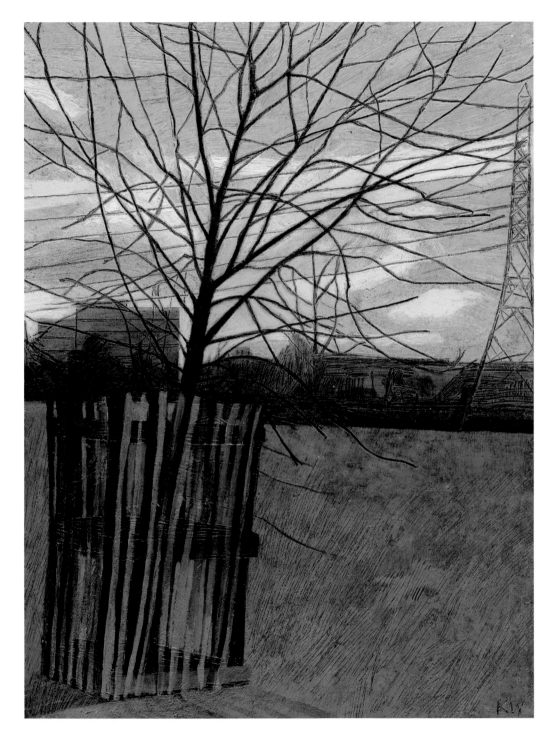

Two Trees, oil on board approx 50 x 40 cm (19⅔ x 15¾ in).

Nelson's River, oil on
board approx
50 x 40 cm
(19⅔ x 15¾ in).

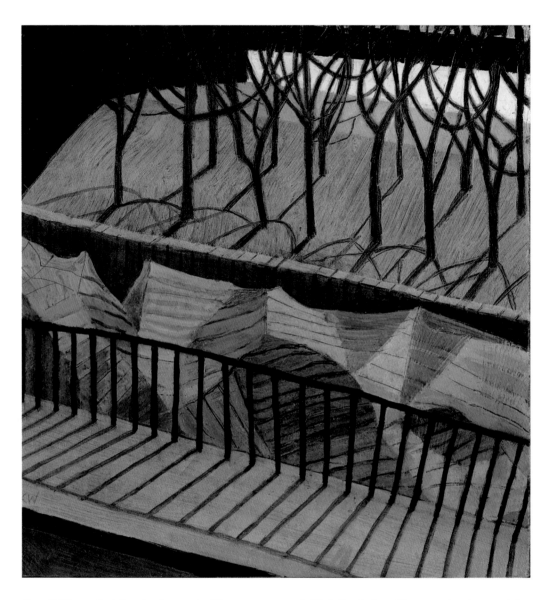

***How did they affect the development of the
image? For example, working from light to dark
in watercolour?***

I tend to work in yellow to establish the shapes,
leaving areas of white paper where needed. I
then work up the darks over the top. I try to
establish the darks with one or two layers at the
most as more tend to dull the surface. I will also
use paint straight out of the tube to get a strong
colour or a contrasting texture. If it goes wrong,
I wash the paint off and start again over the
ghost image.

How did you know it was finished? Is it finished or are there things you'd like to change?

These are finished. Though I am continuing to work on others and would like to show them as a group.

Were you consciously thinking about things like light, form, edges, and so on or proceeding in an intuitive and improvisational manner?

The enjoyable thing for me about these is that, unlike much of my other work, they are a simple exercise in looking. I mind about edges – but in this case, I can think about those at the end. So I suppose I'm proceeding in an intuitive manner. The only problem can be when I need more space around the image than I have allowed for. Then I have to start again.

What do you think affected the development of how you draw? Teaching? Other artists? Something else?

Making my first rub-away charcoal drawing on my foundation course was a revelation. I realized I could use shape rather than line. This is the key to painting I think. I also love Daumier – his scribble drawings and the way he starts pale and tentative and builds them up into a strongly contrasted tonal drawing. Also Bonnard – the way he sketched everything around him as a way of thinking about his subject matter.

Do you see the work as complete or is it part of an ongoing series?

Ongoing.

Blue Sky Over Weir Road, oil on board approx 50 x 40 cm (19⅔ x 15¾ in).

Stephen Moriarty

Stephen Moriarty is a thoughtful and determined painter. He limits his painting entirely to observational work, and is 'embarrassed at' it, claiming not to be 'creative'. But look at this series of studies of Canterbury Cathedral. They provide a masterclass in perspective, architectural and atmospheric painting, describing the vast vaulted ceilings and spaces, and, ironically, each drawn across two pages of a small, cheap sketchbook.

Again, notice Stephen's recommendation of ultramarine blue, burnt sienna and yellow ochre; like Paul Newland's colours on buff paper, he is keen to tell us how much can be extracted from a seemingly small group of colours. These paintings would have pleased Ruskin no end.

I particularly like Stephen's answer to the question about composition; that he does not 'contribute much'. He confirms Peter Brown's idea that looking for a good picture for a long time is a mistake – just find something you like, and get on with it. And, as Stephen says, being too clever about it won't really help.

In the section on the development of the image, Stephen more or less describes the method I have set out of painting with greys and then building up the colour, only he uses ultramarine and burnt sienna – an equivalent of my viridian and alizarin, and no doubt a better idea. I met his 'Uncle George' and know that he knew what he was up to!

I also like this bit: 'I definitely like to create the sense that the subject continues beyond "the frame" by making sure that lines and brushstrokes do not become faint-hearted at the edges of the picture.'

I do so agree. There is a tendency to lose the oomph of a line as you get towards the edge, and it weakens the illusion of the picture plane.

Look carefully at the way he paints architectural detail; the delicacy of observation in the ceilings; the play of light over the columns. This is the work of someone putting himself to one side, and using all his will to make exactly that which is before him.

A detail of *The Nave*.

How long did each piece take?

Some of the pieces only a few hours, but others involved going back over a period of weeks. Some pictures 'come off' quickly; others have to be beaten into submission!

What went into the decision about what to paint?

I find this an awkward question to answer. I have never felt myself to be a 'creative' person and feel a little embarrassed at only painting things that I see around me. I do, however, find that my interest is stimulated by the past. I don't believe that art is a good vehicle for ideas – words are better for that – but I am interested in history and sometimes that interest can be detected in my pictures. Mostly, however, I try to create an atmosphere of mystery, because that is a lovely feeling to experience.

A detail of *The Martyrdom*.

A detail of *The Chapter House*.

How do you refine the composition – is it a conscious decision, where the edges of the image are, or do you work out from the middle, or what?

Again I feel embarrassed because I do not contribute much by altering what I see. However, I am very careful about every brushstroke in the sense that I am always looking at a painting as a whole and working here, there and everywhere on it in order to keep it beautiful (in my eyes at least). Over time one develops an instinct about this and one thinks things like, 'not enough interest in this area', or, 'this is an irrelevant detail that is distracting so I'll leave it out'. If a picture is beautiful one has done one's job as a painter, especially if it is as beautiful as it could be, by

which I mean both that one should not stop too soon on a picture – sketchiness can be a vice of watercolourists in particular – nor too late – more truth does not always mean more beauty.

How much planning went into it? Did you do preliminary sketches? Is it a preliminary sketch itself?

These are all paintings from my sketchbook, done for their own sake. It can be a mistake to try to be too clever, for instance by taking a very unusual angle on something in the search for originality. With architecture, frequently the challenge is to take something 'head-on', because that is how the builders intended their building to be seen to maximum effect.

What materials, colours, brushes, other materials do you use?

These were all done in smooth cartridge-paper sketchbooks. I have found them remarkably robust and resistant to buckling. My palette is lamp black, ultramarine blue, burnt umber, burnt sienna, raw sienna, yellow ochre, yellow and red (it is very nice to use real cadmium yellow and red but a surgeon I met told me to avoid them as he had lost count of the kidneys he had removed from artists) and a tube of titanium white gouache. I prefer pans to tubes. You can do a lot with just ultramarine blue, burnt sienna and yellow ochre. Buy the best! You may notice that there is no green listed – I mix my own – and I avoid anything with a chemical in the title as they tend to be too strong and get everywhere. I use only one or two brushes, something like a size 8 round sable and a size 6 round nylon. I draw with the tip of the brush rather than using a pencil.

How did they affect the development of the image? For example, working from light to dark in watercolour?

The first thing I was shown by 'Uncle George' Maynard at school was to mix ultramarine blue and burnt sienna together to get a grey. You can then use this lightly to get going, 'knocking' it warmer (i.e. more sienna) or cooler (i.e. more blue) as you go. Watercolour is a more forgiving medium than some might say and it is practical to work out the general pattern of lights and darks and cool and warm areas with this grey, then go over with 'local' colours, and then finally beef up one's shadows with some denser grey (and I am not afraid to use black). Perhaps the following should bar me from a book on watercolours – but I also like to use transparent washes with white gouache to strengthen my lights. I take my hat off to 'purists' – it is a great skill to use only the white of the paper – but there is also something to be said for the great feeling of depth that can be achieved from a combination of transparent and semi-opaque washes (I keep the darks transparent).

A detail of *The North Aisle*.

How did you know it was finished? Is it finished or are there things you'd like to change?

All of these could do with a little more work. *The Martyrdom* at Canterbury could do with some more colour; *The Crossing* needs tidying up here and there and the other three need work where the verticals reach the ground. There are perspective construction lines in *The Nave* that would be better painted over. However I find that painting away from the motif never works for me so I will have to go back to make these changes.

Were you consciously thinking about things like light, form, edges, and so on or proceeding in an intuitive and improvisational manner?

I look for light and shade if they are to be had. The play of light and shade has effects beyond itself in that it gives conviction to the whole painting and makes the details 'work'.

I think that one should avoid drawing too much attention to composition (by self-consciously unusual choices) because this can be a distraction from the subject itself and hinder the creation of depth, but I do start with a good idea of the final composition and will abandon a painting the moment I realize a composition is poor. However, once I am working I work all over the picture by intuition. Again, I admire real watercolourists who are skilful enough to work systematically with washes, but I can't manage it. I definitely like to create the sense that the subject continues beyond 'the frame' by making sure that lines and brushstrokes do not become faint-hearted at the edges of the picture.

What do you think affected the development of how you draw? Teaching? Other artists? Something else?

I have already mentioned 'Uncle George' Maynard who taught me to paint and draw. The main thing he conveyed was the sensuousness of it (he obviously loved his job and used to paint or draw in front of us at every opportunity). With

A detail of *The Crossing.*

regard to watercolours, probably the greatest influence was a calendar of John Sell Cotman watercolours my dad brought home from work and hung on the wall of our kitchen for a year! That was his ambition for me to have a career in business done for!

Do you see the work as complete or is it part of an ongoing series?

Obviously these are a series. There is no message in them, except that I believe our aesthetic sense is always telling us something.

Right *The Martyrdom*,
watercolour and
gouache
58 x 21 cm
(22⅘ x 8¼ in).

Far right *The Crossing*,
watercolour and
gouache
58 x 21 cm
(22⅘ x 8¼ in).

Far left *The Nave*,
watercolour and
gouache
58 x 21 cm
(22⅖ x 8¼ in).

Left *The North Aisle*,
watercolour and
gouache 58 x 21 cm
(22⅖ x 8¼ in).

The Chapter House,
watercolour and
gouache 58 x 21 cm
(22⅖ x 8¼ in).

Iain Nicholls

Painting from observation is a difficult and challenging thing to do, but if you grasp the way watercolour works, the challenge becomes more important than the desire to make an acceptable, pretty picture. David Parfitt's response to the last question I asked him makes that clear; he may find it hard, but he still comes back to 'the look of things'.

There are ways to make things simpler; approaching drawing by using a viewfinder, for example, understanding the picture plane, being aware of the direction and quality of the light, noting perspective. As David says, though, these things can soon be forgotten in the panic of trying to record. There are also ways of simplifying the painting process: not trying to record the exact colour straight away, but building up to it, being aware of the relativity of colour. A coloured ground can help with this, sometimes, too.

Using gouache, an opaque medium, can make a good compromise if you find watercolour too annoying. The technique might seem more natural to you if you crave immediacy, but you will find that it has its limitations.

Iain Nicholls breaks all the rules that I have set out in this book, but I have included his work because he is a good example of where it is possible to take observational painting.

In looking at and painting things we are making choices. To start with, the choices are easy; we look for exemplars, by which I mean that in following the suggestions in this book you will be finding examples of particular visual phenomena – the light falling this way, that kind of vegetation or a figure posed like this. After a while we develop particular interests: like Kate Wilson we might use watercolour to investigate small, complex objects, or, like Paul Newland or Stephen Moriarty, watercolour might be used as an alternative to oil paint but with the same subject.

Iain began these observational paintings after a long time of making work in a very different way – 'a starting point of abstraction' – and has developed them as a way of clarifying his ideas about what 'could make a painting'. In other words, he is trying to find a valid, satisfying and (his words!) 'God forbid, enjoyable' way to paint.

He quickly forgot the questionnaire form I sent him – his replies are set down below more or less verbatim.

Each of these took about two hours. Most were done in one sitting but a couple were done in two sittings and probably took two to three hours.

My work previously has been from a starting point of abstraction and making work from my imagination, involving personal decisions in terms of composition, colour, subject matter, etc. But increasingly I was finding that a good painting often gets made irrespective of these decisions and the work of other painters I admire has no common threads to link them in terms of certain colours, compositions, subject matter, etc. so why tear my hair out struggling with these problems when perhaps choosing an almost arbitrary subject matter could make a painting that was just as beautiful and exciting to look at and more importantly was, God forbid, *enjoyable* to paint!

This line of thought when written down like this sounds very prescribed but it wasn't – it came over years of thinking, often sometimes in places and at times when my mind wasn't on the lofty subject of 'art' but on other things such as doing the washing-up, watching television or just sitting around chatting. At times like this there were often things I was looking at – the television, some cups, a telephone, etc. – things that I had looked at for years which are so familiar, that you don't see them any more. Why not use them as starting points for paintings? Can I make a painting about the seemingly mundane and familiar that feels like my previous work but done using an approach which takes away all the unnecessary decision-making which actually often results in an overworked painting and a bored painter? [This, I think, is about the question of what to paint, and I think Ruskin would have approved. Iain is talking about making paintings not from the already accepted 'picturesque', but the everyday.]

I think that these thoughts and ideas came together when I was sitting watching television, looking down at my knee and thinking that it was an interesting shape, so why not paint it?

I also have an unwritten rule that it should be possible to make a great painting from any subject matter however mundane and the knee seemed to fit that challenge well. I have a reproduction of a Morandi painting on my wall who I love for his ability to do this – his fantastic paintings are just bottles and jugs on a shelf or table (I have included the Morandi in one of the still-lifes as a kind of homage to this thinking).

As I had this *Television Knee Eureka!* moment I also looked around the room and everything seemed interesting and a possible starting point for a painting – and still does! Cups stacked up; my wristwatch next to a crumpled tissue; some clothes piled up on a cupboard with a bit of the Morandi behind them; a radiator, its shadow on the wallpaper and the curtain; a telephone and the numbers on the buttons – they were all up for making paintings from.

I wanted to paint them without being bored or worrying about any problems which to me weren't important. What was I interested in *specifically* about my knee, the telephone, the wristwatch, etc?

I knew that they had to be painted accurately but I wasn't interested in gaining this accuracy through preparatory sketches, measured observation – the traditional way of drawing and painting from an observed subject. I just needed a starting point of accuracy but my actual interest was the next part – to then allow myself to do whatever I wanted.

How the paint was applied, the shapes and colour, is the thing that interests me the most, but with these paintings there is now an anchor point – the subject.

So I took photographs and cropped them and used the computer to crop them into a composition I liked and which had as its main focus the aspects of the subject I wanted to concentrate on. I then used a digital projector to project the photograph and quickly and accurately sketch in the basics of the painting. I have also done

this by straight copying of the photograph using a grid. This takes about thirty minutes at the most – just the essentials are placed down. From that point on I work from memory and a print-out of the photograph to work from and most importantly the painting itself and what it's telling me.

I use gouache with sometimes a little acrylic white added, on card. This has all the qualities of watercolour but also can be worked wet into wet quite quickly allowing the brush marks to remain, much like oil paint, which I like.

I am an impatient painter so watercolour techniques of layering are not for me – but I love the quality of washes as well so I get the best of both worlds with gouache and occasional acrylic white.

As I start painting it's basically copying the colours and tone of the subject from the photograph but what happens – what has to happen – is the painting starts to suggest what I should emphasize and what I am not really interested in. Working in this slightly detached way from photographs makes it easier for me to be in charge, rather than the subject and its need for accuracy – it's my painting after all!

Two descriptions follow of how specific paintings were made and how the subject gave rise to its own subject. Once this happens the painting quickly finishes itself.

Phone Book. I loved the colour and shape of this phone and the slight shiny but curved edge to it as well as the numbers on the buttons. Also when I cropped the photograph the address book by chance cropped to just the word 'Book' and I thought that was quite funny and would make a title which has a double meaning, which is something that always interests me in painting. The rest of the painting apart from the shadow didn't really interest me so it was only painted in to indicate and ground the phone and book in the space around it (a bedside table).

Television Knee. I liked the fact that this object (my knee) is something that is always there when I watch TV at night. I have watched a lot of TV at night over the years without really seeing the knee and one evening it just seemed an interesting shape to paint with the rest of the chair I was sat in. As I was painting though I got annoyed with part of the chair and table to the right and so I just left these irritating parts out – the thinking was – it's my painting, I'm not going to be bored or annoyed and if that's not 'accurate' then that's not my problem because for me, with my own set of criteria for why I'm painting this, it works.

We disagree on a lot of things, and Iain's paintings are anything but pure watercolours, but we agree on the essential point; the mundane look of the everyday world, even if it's just your knee between you and the TV, is just as important or significant as anything else. Like Ruskin, we both say 'Look at the world you have around you, look at it long and carefully.' Whether it's 'art' or not is for someone else to say, but painting it is a good thing.

Bathroom View,
gouache and acrylic
on card 28 x 35 cm
(11 x 13¾ in).

Television Knee,
gouache and acrylic
on card 28 x 35 cm
(11 x 13¾ in).

Clothes And A Morandi, gouache and acrylic on card 35 x 28 cm (13¾ x 11 in).

Computer And Rubble,
gouache and acrylic
on card
28 x 35 cm
(11 x 13¾ in).

Phone Book, gouache
and acrylic on card
28 x 35 cm
(11 x 13¾ in).

Cat Hill Burnt Tree,
acrylic and oil on board
90 x 60 cm
(35½ x 23⅔ in).

Index